MULTIPLE CHEMICAL SENSITIVITIES

FIBROMYALGIA

ALLERGIC/INFLAMMATORY ARTHRITIS

CHRONIC FATIGUE

CHEMICALLY INDUCED IMMUNE SYSTEM DISORDERS

LEAKY GUT/IRRITABLE BOWEL/COLON DISORDERS

PRESCRIPTION DRUG WITHDRAWAL SYNDROME

GLORIA GILBÈRE, ND., D.A.Hom., Ph.D.

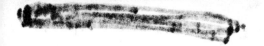

Disclaimer: This information is presented by an independ-
ent medical expert whose sources of information include
studies from the world's medical and scientific literature,
patient records, and other clinical and anecdotal reports.
The material in this book is for informational purposes
only and is not intended for the diagnosis or treatment of
disease. Please visit a medical health professional for spe-
cific diagnosis of any ailments mentioned or discussed in
this material.

ISBN 1-893910-20-2
Second Printing September 2002
Printed in the United States
Published by Freedom Press
1801 Chart Trail
Topanga, CA 90290
Bulk Orders Available: (800) 959-9797
E-mail: info@freedompressonline.com

DEDICATION

To my "invisible" support system and all the individuals, around the world, who having benefited from my personal experiences, research and writing, encouraged me to write again in my continuing quest to understand and reverse the causes of "invisible illnesses" that so profoundly changed millions of lives, including my own.

To the millions of "invisible illness" victims who are viewed with suspicion, hostility and anger in a world and consciousness that demands scientific evidence and double-blind studies before acknowledging the condition is "real." This book will provide some of that much needed scientific evidence to facilitate validation of our syndromes.

Science very often interferes with discovery and humanity—its observations are often made without regard to the potential impact on the human psyche.

I dedicate this book to all the victims of the disorders described within, and encourage them to recognize that *they* are the new group of scientists, embarking on a journey of discovery to find the causes of their distress (through experience and research), rather than merely accepting the status quo or drug therapy for symptom-care.

CONTENTS

Contents

Contents

ACKNOWLEDGEMENTS

The writing of a book does not magically appear someday—it evolves in the midst, and in spite of, daily life. During this undertaking I have been fortunate to be surrounded by friends, my chosen family and colleagues, people who generously supply me with large doses of love, support, encouragement and patience and, most of all, belief in my work.

Sharon Wiseman—It's because of your confidence in my ability to lick an invisible illness that I'm even alive to acknowledge your generosity of spirit. Without your enduring support and love, this project could have never become a reality.

My publisher, *David Steinman* at Freedom Press for believing in the value of my work and encouraging my inquiring mind to keep writing. A publishing company must become a literary "family" in consciousness in order for harmony of spirit and respect to prevail. It requires creating a balance of careful hard work, risk-taking and, most of all, understanding and belief in the subject matter. David, you recognized the value of my work and the need for it to be shared—you forged the project forward with integrity... and in record speed, thank you.

Bonnie Lambert—for your skill, professionalism and enthusiasm in creating a brilliant, unique and easy-to-read book design.

Sharon Francis—for organizing my writing, assisting in research and, most of all, your treasured friendship.

Beata Golau—For once again creating visual images to help illustrate the mechanics and impor-

tance of the lymphatic system and, most importantly, for keeping my body "in-tune" to facilitate my recovery.

Dr. Sylvester Yong—My heartfelt appreciation for your valuable contributions to my work, your generous counsel and specifically your dedication to integrative medicine principles. It is an honor to have the opportunity to work with you and witness your strong sense of duty and courage in bringing forth the importance of integrative medicine for the benefit of the global community.

Dr. Rick Malter—Thank you for widening my horizons to the importance of TMA in invisible illnesses. Your expert guidance, research and graphs are an integral part of this book. I also extend my appreciation for the many hours reviewing my manuscript, gathering data and introducing my readers to this extraordinary testing method.

Owen Marcus—Thank you for opening my eyes, heart and spirit to the power that lies within each of us; and teaching me that the tools necessary to tap into the infinite reservoir we each possess...are there simply for the asking.

Virginia Taft—A special note of thanks for helping to spread the word about a valuable therapy modality that is not commonly known or understood.

Dr. Marshall Arbo—It is indeed a rare opportunity and honor to be able to work with a dental professional who understands the importance of providing "safer" dental work procedures and environments for chemically sensitive individuals, including myself. Your support, dedication and sensitivity are truly a gift, thank you.

Stan Meyerson—My appreciation for your invaluable source of help and inspiration on this

and future projects and for providing the items to fill our NEEDS. Your product line provides a "one-stop" source for those with invisible illnesses; enabling them to create a healthier and safer environment in which to live and restore health. Your willingness to share, generous encouragement and support for my work is a treasured gift.

Brenda Watson—I identified a specific detoxification "need," especially for chemically sensitive individuals, and you found a way to "fill it." You then proceeded to manufacture those specialty items and make them available in record time. I extend my heartfelt appreciation for your professionalism and dedication to providing a unique line of products in keeping to your high professional standards.

Heather Clarke—You are amazing! You took my abstract of conceptional "invisible illnesses" and birthed them on paper. Your ability to expand and create "something" out of my transparent ideas is a testament to your artistic talents; I am honored.

Vicki Glassburn—for permission to reproduce the photo of *Candida*, as it appeared in "Who Killed Candida?"

My heartfelt appreciation to my administrative staff, Jamie Schnuerle, Kathleen Taylor and Patty Nelson for organizing and managing my multifaceted life, enduring my impatience and quest for perfectionism and, most of all, providing extraordinary support and sensitivity to my clients, especially in my absence. I am enabled to be the best I can be because of your support, unwavering loyalty and team effort; thank you, I am truly blessed.

FOREWORD

The pursuit of health, wealth, and happiness remain the ultimate aim of every individual. Most individuals place the virtues of wealth *above* health...until stricken by a health malady. This book is a 'wake up call'....the realization that there is *NO wealth without health*; "Invisible Illnesses" have NO boundaries, they exist in every economic, ethic, educational and religious sector.

As a practicing physician for the past 30 years, I am acutely aware that hard-core academics and scientists who uphold the virtues of evidence-based medicine dominate current mainstream medicine. Granted, it is crucial there be a concrete regulatory control in place to maintain professionalism and standards for the public's protection. However, the issue needing to be addressed...and just as pressing, is whether modern medicine on its own can fulfill the wide range of community health needs.

Medical progress has provided new, innovative and valuable medication, research and equipment to sustain a degree of sophistication in the arena of modern medicine. The mapping of the genome has created renewed excitement in the scientific world with promises of breakthroughs in therapeutic solutions. New chemical entities are constantly introduced by major pharmaceuticals to cater to the growing demands of the medical world. These well researched, scientifically endorsed, and professionally marketed products contribute significantly to the demands in medicine, but are they able to provide the complete solution? Unfortunately the answer is "*NO.*"

In spite of the usefulness of new products in mainstream medicine, there remain limitations, side effects and adverse reactions that can pose a greater risk than the original health problem. These risks are compounded, especially if prescribed indiscriminately, or prescribed to chemically sensitive individuals and those who are already frail and immunologically compromised. Such individuals require an integrated approach, one that combines the best modern medicine can offer along with other therapeutic options that have withstood the test of time, however, may not have yet been scientifically endorsed or accepted. What must be of primary importance is the outcome of therapy...re-gaining a better level of health and well-being.

Increasingly, it is the individual, who is afflicted or confronted by health problems, who takes the *bold leap* to explore options and seek out alternatives that can provide a better outcome in their search for health. The advent of the Internet has provided everyone, who has a computer and a modem, ready access to a library of information. Improved literacy and effluence are allowing individuals to seek out new information on therapies, remedies and alternative health measures, especially when conventional approaches cannot offer a justifiable solution.

Increasingly, too, are the many stories and testimonies professed by individuals who have overcome chronic health problems and illnesses, even terminal cancer, by non- conventional approaches. Yet, such approaches remain suspicious to the eye

of the conventional medical professionals. This may, in part, be due to the training received by medical doctors; making them doubtful about approaches that are not evidence-based. It is recognized too, that even though medicine has progressed by leaps and bounds, medical education and its delivery system for new medical information to the medical professional remain lopsided....dependent on giant pharmaceuticals with budgetary related agendas to convince the doctors.

There are now a growing number of doctors who are becoming more receptive of the need to discover and employ new therapeutic options. They are taking steps to sieve out, from a mountain of information, those relevant approaches and therapies that may be useful in supporting conventional approaches. It is heartening to realize that such a conscious awakening is taking place as more and more medical professionals are opening their mind to reach beyond convention.

Dr. Gloria Gilbère's book contains a repository of information and advice on many of the "Invisible Illnesses" confronting modern day society. One of the major health threats discussed is the issue of 'chemical toxicity'....its silent infiltration into the living system manifesting as health disorders that may be insidious but definitely ominous. Maintaining a conscious alertness to the presence of such an occult 'invasion', which can adversely affect our health and quality of life, will prevent the consequence of prolonged helplessness, pain and suffering.

Gloria knows. She has treaded the path of conventional wisdom (through her own medical chal-

lenges), subjected herself with blind faith to the medical profession, suffered the consequences (side effects) of modern day medication, and emerged to tell a story of how 'she saved her own life'...through research, conscious awareness and taking responsibility for her own health.

She has detailed her own health odyssey (in her first book—*I was Poisoned by my body*), after sustaining an accident, which required her to undergo a period of treatment in a conventional medical setting. In spite of doing everything right, according to conventional medical recommendations, the trauma and damage wrought by ill-health, as well as the medical solutions, remain a nightmare she aspires to help others avoid.

I am privileged to have been invited to write the foreword for the publication of *Invisible Illnesses*—authored by Dr. Gloria Gilbère. Her book provides readers with a sound exploration of many of the *Invisible Illnesses* currently baffling our society. The book utilizes natural and holistic approaches in her discussions and recommendations for managing, and reversing, the invisible illnesses. She takes a simple and practical approach, with clear illustrations and sound advice on the rationale behind her recommendations.

Granted, some of her views and recommendations have yet to be scientifically endorsed, however, there exists a rich reservoir of wisdom, understanding, experience, and research backed by clear discussion and explanation that *should not be ignored*. More significant are the results that have poured forth from her clients, healthcare profes-

sionals, and physicians, whose health problems, and that of their patients, have been improved by her recommendations.

I am confident that every reader will find many of the practical recommendations useful for adoption in their own evolution towards a better level of health and well-being. Realizing, recognizing and understanding the danger signs and knowing how to avoid the risk and traps will ensure a healthy and smooth passage through life.

Conventional medical approaches will continue to take a scientific approach in therapy, with the recommendation of medication to 'counter' the symptoms. One cannot fault the medical professionals; they are prescribing what they have learnt. Individuals can make their own choices on how to address a problem, what is necessary though, is to be in a position to make a prudent decision by learning about the various approaches available...*Invisible Illnesses* discusses many of those choices.

Very few books are available on this subject and this perspective. Dr. Gilbère has taken a *bold step* in providing a sound outline regarding disorders of such great relevance in our times. I believe this book is an invaluable asset to not only the individual, but also every medical practitioner, both traditional and modern, to help them appreciate some of the rarely addressed critical issues in health care today.

Wishing you all greater wisdom and better health.

—Dr. Sylvester Yong
Member of the Royal College of Physicians (UK)
President Holistic Health Society, Singapore

AUTHOR'S NOTE

This book introduces natural therapies and life-style modifications for over-coming the disorders referred to as "invisible illnesses." It is also a guide for those who choose a pro-active approach to health; those that understand "an ounce of prevention is worth a pound of cure."

It is written to assist you in understanding, assessing and deciding the appropriate treatment for a given disease or disorder. The author does not intend to make comparisons between conventional, traditional or integrative medicine, other than in the context of personal experiences and research.

Therapies and life-style modifications in this book are based on the training, experience, and research of the author. Because each individual is so unique, the therapies may or may not be appropriate for you. This book is not intended to replace proper medical care; it is a tool to assist you in making informed health-care choices. If you seek the advice of a health-care professional who will not, or cannot, order the tests or products you request, seek one who will.

It is your constitutional right to educate yourself in health related issues, available options, and medical knowledge. It is also your right to seek information and make use of it for your own benefit, and that of your family—*YOU* are the one responsible for your health. In order to make the best possible decisions in health matters, there is no substitute for education. You must be informed of the available

alternative options to drugs, un-necessary surgeries and invasive testing methods. Modern conventional medicine performs miracles and saves lives, especially in the case of injury or trauma—I am a prime example; clot-dissolving drugs saved my life after injuries sustained from a traumatic fall. Doctors perform daily miracles by repairing physical damage and removing (and often replacing) diseased organs. However, conventional medicine has little to offer an individual with digestive diseases, environmental illness, and chronic disorders. Conventional physicians are trained to "turn-off" a reaction with drugs for symptom-care, but in the process, can perpetuate a self-destructive cycle masking the root causes.

This book describes therapies and life-style changes advocated by a new breed of health-care practitioners and integrative medical doctors; a new breed resurrecting and employing an ancient philosophy advocated by Hippocrates—"first do no harm." They emphasize diet, supplementation, non-toxic therapies, environmental modifications, and therapies that encourage the healing process—reserving drugs and surgery as a last resort. With this book, and the guidance of a naturopath or integrative medical doctor, you will learn what is needed to achieve optimal health, naturally.

This book is not intended to diagnose, treat, or cure disease, nor to prescribe or be a substitute for medical care; it is intended to share experience, research, and as an educational tool that will assist *you* in taking responsibility for your health-care.

Those individuals taking pharmaceutical prescription drugs will want to discuss their health

choices with a health care professional to assess
any negative effects that the drugs can have on
herbal and nutritional supplements, before com-
bining them.

INTRODUCTION

"Disease enters and leaves man as through a door," wrote French philosopher Geroges Canguilhem more than half a century ago, illustrating the notion that disease is a distinct "thing" that exists apart from the human body. This view prevails today toward the millions afflicted with the invisible disorders stemming from chemical exposures, health depleting dietary choices and toxic intestinal ecology.

With multiple chemical sensitivities/environmental illness (MCSS/EI), fibromyalgia, chronic fatigue and chemically induced immune system disorders, a not so different opinion has emerged among most conventional physicians, families, insurance companies and employers. An opinion that those suffering the symptoms of these disorders have some sadistic demon that brings on these "invisible" symptoms, therefore the illness cannot demand recognition in a traditional world that must have double-blind studies and a scientific name for the illness in order for it to be recognized. The generalizations and varied symptomatology makes for a confused, depressed, and angry patient.

With MCSS/EI and most of the invisible illnesses, a very different opinion is finally emerging—that disease is *not* a separate entity, but a changed state of the organism, a disturbance of the natural equilibrium or harmony of the body systems. This is not a novel idea. Since the time of Hippocrates, the father of Western medicine, various remedies were prescribed to restore the body's natural balance.

Although these two views of disease appear to be incompatible, both are valuable in understanding how to reverse and manage these invisible illnesses.

What is equally important to note is that the insight of the past decade declares all diseases are both *genetic* and *environmental*.

Most individuals who have acquired the invisible illnesses are looked upon as chronic expostulates (complainers). What is grossly overlooked is the importance of detoxifying the internal organs of the liver, intestines (large and small) and lymphatic system of toxic substances. Equally as important is the purging of often-repressed emotions of pain, grief, anger and un-resolved traumas—the true essence of Wholistic medicine—the whole person as mind, body, and spirit. Only when detoxification of these organs and emotional issues are addressed, can there be true lasting reversal of symptoms and return to natural equilibrium of the body systems. As expressed by the late Dr. Hazel Parcells, "Cleanse the body and mind, give it the right building materials, and nature will heal and re-build."

This book is intended to assist you in understanding and repairing damage to your body systems, manifesting as reactions to the foreign allergens that we're subjected to as a result of living in the toxic world of the 21st century. It deals with health-care (causes) not symptom-care (quick-fixes) providing you information to heal from the inside-out, the essence of true health-care, naturally.

The suggestions and therapies recommended are presented based upon personal and professional experience and the author's research.

This book will act as the architect for better health, giving you, the victim, the tools necessary to re-build, Naturally.

Imagine

An accident nearly takes your life. You survive only to be tormented by constant debilitating pain in your neck, shoulders, hips and legs; icy numbness seems to pour through the veins of your legs; chronic insomnia robs your body of restorative sleep and eludes you for weeks at a time. You struggle and keep looking to your physicians for answers, all they offer is more prescription drugs for muscle pain and spasms, anti-depressants because they're convinced most of your symptoms are psychological and sleeping pills because you're exhausted and the bags under your eyes look like your mascara permanently ran after watching a sad movie—it has, and that movie is an unending episode of pain, frustration and fear—one you see everyday in the mirror.

Imagine: Months later you're on the road to wellness and suddenly while sitting in a theatre, you're struck by a pain so intense you can scarcely breathe. Months pass. You exist in unceasing pain, every breath an agony. Medical experts conduct extensive and expensive tests. Complimentary medicine experts, of varied healing modalities, provide therapy with little or no relief. Finally you seek medical experts again; echoing the same theme telling you there is no "evident" cause, and the only diagnosis for your pain and acute inflammation is "thoracic outlet syndrome." They again offer you anti-inflammatory, pain and anti-depressant drugs; you

reluctantly agree to only the anti-inflammatory drugs because you no longer have quality of life. Six weeks go by and nothing is helping, so they keep changing the anti-inflammatory drugs and add a pain medication. A swelling becomes visually evident under your right rib and now you also develop a pain in the region of the right shoulder blade. The swelling is so intense it is swollen beyond your right breast. You cannot tolerate any tight fitted underclothing without excruciating pain, especially bearing a bra. You cannot use your right hand, or raise your arm or shoulder to perform daily tasks so normally taken for granted: combing or shampooing your hair, cooking, holding onto the steering wheel of your car, zipping and buttoning your clothing, brushing your teeth or simply holding the telephone.

Imagine: Six weeks after agreeing to a stronger anti-inflammatory medication suddenly every morsel of food causes a violent allergic reaction. Your throat swells closed, you can scarcely swallow or breathe, you break out in welts, and your face turns scarlet like a bad sunburn and your eyes swell shut. You're so hungry; you're starving for something you can tolerate without a violent, and at times, life-threatening reaction.

Imagine: You suddenly begin reacting to familiar cosmetics you've used for years, other people's perfumes or anything fragranced, the exhaust of cars on the road, refueling your car, the furnishings and rugs in your home and office, even the simple act of entering a store to buy groceries, being in the same building as your new computer, all trigger the same life-threatening, terrifying

response. You *know* anaphylactic shock can kill; will the next allergic attack be your last?

Imagine: You're a doctor. You have a busy practice. You've consulted for over 20 years in environmental health, sick buildings, and chemically induced immune system disorders; you recognize your symptoms have been echoed previously by many of your clients. You cannot stay home and avoid all the allergens that make your life a living nightmare. Home is not the haven it once was. Everything there has the potential to turn into an enemy, launching an attack on your immune system and sending you into an allergic reaction. You cannot retire to a wooden or metal shack away from civilization, like many of your MCS/EI clients have had to do to survive. Your entire life and career is staring you in the face; you remember all the clients that you've consulted with and the horror stories of how their lives were shattered. You vividly recall the ones that have recovered and the strategies and recommendations you made, *and they followed*, that allowed them to restore their health and quality of life. You also recall the ones that continue to worsen, because they reverted to drug therapy or they decided it was too much effort to make major life style changes in order to repair their immune systems. Or, they were so busy blaming everyone and everything for their condition; they lost sight of their body's needs to be cleansed, physically and emotionally, before long term healing can occur.

Imagine: You now have the opportunity to turn a life-threatening challenge into a positive, although painful, life experience to not only repair *your* life, but to truly understand your clients' frustration and pain through your own personal odyssey. You also have the

opportunity to turn this drama of your life into a stage in which to teach those who are affected, those who care and provide care to the affected, and those not yet affected, by sharing the necessary tools needed to rebuild and maintain health. Modern civilization, medical techniques, and prescription drugs that are destroying your health and your life, can also save it, however, you must understand the consequences of your choices and available health building alternatives.

Imagine: People depend on you to be there to help them and provide healthy options. You cannot show the crushing fatigue, the draining pain, the gnawing hunger, the terror inspired by the first suspicion of your throat beginning to close due to something you ate a few minutes before, or the fact that you haven't eaten in two hours and your body is now reacting to itself, or an unsuspecting smell in your vicinity that you're not always sure what it is—it doesn't matter, it still causes a reaction.

This is not science fiction. It is a life, my life. This is my odyssey from pain and near starvation to recovery. It has been a long, arduous road, but a journey well worth it for many reasons. My odyssey, as described in detail in my book *I was Poisoned by my body* (Lucky Press 2001), has taken me from fibromyalgia, chronic fatigue, chronic insomnia, leaky gut, food allergies, environmental allergies, prescription drug withdrawal syndrome, anaphylactic shock and near starvation, to a doctor who can travel worldwide and live a semi-normal life. No, I still can't dance with a gentleman wearing newly applied aftershave (even though ballroom dancing is one of my passions), but I can again dance. I cannot go down the isle of a

store with perfumes, scented candles or cleaning products without some consequences—however, I now get a headache rather than an anaphylactic attack. I practice conscious awareness and take the necessary precautions that again afford me quality of life, a busy successful private practice, and a demanding schedule to lecture, teach and speak around the world.

It's only been 3 years since my odyssey began, some changes implemented are life-long lifestyle changes; others were modifications necessary to facilitate my healing. Whatever the circumstance, I'm healthier because of the changes. I only eat organic when I'm at home. I avoid food groups that specifically cause me discomfort, as discussed in detail in later chapters. While traveling, I use caution when ordering my meals and ask *specific* questions as to ingredients and preparation methods. I wear a mask with a disposable charcoal filter when flying or entering a hospital or healthcare institution; precautions that should be taken by anyone choosing to preserve their health, especially in a highly concentrated, toxic, germ ridden environment with re-circulated air.

Imagine: Living a full, healthy life and thanking your creator for showing you how to plan your day around your life, instead of around your pain and fear of what you might react to.

Imagine: Sharing your knowledge and experience with all who will listen, including your children and grandchildren to spare them ever having to write a story like this.

Imagine: Being able to assist and educate those you love, those you barely know and perfect strangers about how to stay well instead of get well.

*There is tremendous satisfaction in helping others, despite our own challenges. Remember, shared pain is half the challenge! When health, wealth and happiness are shared, it's doubled. Live in the moment; don't look at small improvements as failures. No matter how small the gift of victory, it's building towards your immeasurable wealth of health; after all, **today is a gift, that's why it's called the present**—take it, pat yourself on the back and just say "thank you."*

Don't despair you are not alone. I'm not saying it will be an easy road, what I am saying is the end destination will be well worth the journey. It takes determination and patience, the ladder of which is a personal challenge. However, armed with the knowledge in this book and your personal commitment to wellness, you're well on your way to victory in the grandest of battles, restoring your life, Naturally.

A Personal Note to Victims of Multiple Chemical Sensitivities

As a doctor, author, medical researcher, and victim of MCSS/EI, it is my goal to provide you with the necessary tools to re-build your health and spread the word about how to prevent "walking in my shoes." I know, first hand, how devastating it is to suddenly face a life of isolation, fear, stigma and pain when traditional medical experts keep echoing, "everything is within normal range." It is equally, if not more challenging, to have those you love and respect discount the legitimacy of your symptoms. Questions are constantly being asked as to why suddenly we react to substances we've lived with for years.

Before experiencing symptoms of MCSS/EI, the thought never occurs to us that ordinary household products in our home, office and public places could be affecting our health. Increasing numbers of victims have become so acute that they resort to living outdoors or in their cars. Multiple Chemical Sensitivity forces it's victims to endure multiple losses—of family and friends, employment, mobility, hobbies, tolerance of foods, inability to participate in public, community and religious events.

It is humbling to me as a practitioner of natural health, to have many of the people I've helped through various stages of their illnesses, share their knowledge, lessons learned and "safe" options. I believe the true making of a "healer" is one who learns as much from her clients as she contributes.

MCSS/EI knows no economic, ethnic or geographical boundaries; it's a group of disorders affecting multiple body systems that changes its victim's life forever.

This book is written to provide you with non-drug solutions to reversing your illnesses by means of detoxifying and repairing damage from prescription or recreational drugs, years of health depleting choices and exposure to toxic substances, Naturally.

A Personal Note to Victims of Fibromyalgia, Allergic Arthritis, Chronic Fatigue and Myofascial Pain Syndrome

"I hurt all-over" is the phrase most often used by victims of these disorders. It is a phrase I used on a daily basis for many years after a life-threatening accident and the subsequent chemically induced immune

system disorder leading to multiple chemical sensitivity syndrome. It is difficult, if not impossible, to convey to an observer that your pain is "real" not imagined—even though invisible. To quote Dr. William Wong, "Fibromyalgia is misdiagnosed, misunderstood and mistreated." This book details with non-drug solutions to correct the underlying causes, while alleviating the pain and inflammation that keep eroding the quality of life of its victims. It offers two methodologies for the causal effects—fibrosis and toxicity of the soft and connective tissues. It describes clinically tested long-term solutions for healing from "the inside out," Naturally.

A Personal Note to Victims of
Psoriasis and Allergic Skin Responses

According to the National Psoriasis Foundation (NPF), there are 6.4 million Americans affected with psoriasis; of these, more women than men. There are 150,000 to 260,000 new cases reported each year. Outpatient costs are estimated between $1.6 to $3.2 billion annually. It is this author's belief, and experience has proven, that psoriasis can only be reversed when the organs of detoxification are cleansed and dietary changes are implemented. Many of my clients with chemical sensitivities are also challenged with the devastating effects of psoriasis and varied allergic skin responses. Only when the "gut" causes of this disease are understood can there be a true reversal of symptoms—with wellness being the only side-effect, Naturally.

A Personal Note to Victims of Leaky Gut Syndrome, Irritable Bowel, Colon and Digestive Disorders

If you're one of the over 62 million people, in the U.S. alone, who suffer from digestive disorders, this book will shed new light on the many probable causes of your illness.

As a doctor and victim of leaky gut syndrome, I, only too well, understand the challenges when conventional medical experts continue to prescribe drugs for symptom-care, and then proceed to, at times, even deny the existence of the disorder and it's probable causes, unless, of course, it's a conventionally diagnosed disease like cancer. They insist on toxic therapies, without recognizing there could be natural options to assist the body in repairing.

I also understand the frustration when your entire life changes because your gut is now literally running your life. There *are* non-drug solutions to digestive disorders; this book offers you natural solutions and life-style changes that will not only assist you in overcoming these disorders, but also serve as a guide for sustained wellness and prevention, naturally.

A Personal Note to Victims of Prescription Drug Withdrawal

Whether you're a victim of prescription drug effects or you're the spouse, the son or daughter, the in-law, the neighbor, the co-worker, the spiritual/religious leaders or the concerned friend...this book will "shine" a light on the invisible illnesses caused from long-term use of tranquilizers, anti-inflammatory and pain medications, sleeping pills, anti-depressants and muscle

relaxing drugs. These drugs are extremely effective short-term, however, long term produce a barrage of symptoms that alters it's victims lives forever.

This book addresses the physical and psychological challenges caused by legal and widely prescribed substances. I believe the information contained will comfort and reassure victims going through withdrawal that it's not an imaginary journey but a legitimate group of disorders caused by the damage and toxicity of the substances that make up the likes of case histories in books such as *Addiction by Prescription* (Joan E. Gadby), *The Accidental Addict* (Di Porritt and Di Russell), *Benzo Junkie* (Beatrice Faust), *Prozac: Panacea or Pandora* (Dr. Ann Blake Tracy) and *I was Poisoned by my body* (Dr. Gloria Gilbère) and many more.

Do not despair, yes, the road to recovery is paved with some rough terrain that makes the journey longer, however, I'm a prime example that most of these disorders can be over-come. I appeal to you as a kindred spirit and as a doctor who has traveled the same road, both personally and with thousands of clients, DO NOT give-in to drug management—there are professionals out here that can guide you.

Recovery *does* require commitment to the 3-D approach—Determination, Detoxification and Discipline. Do not accept the symptoms that are robbing you of quality of life as the "norm." It takes courage to find natural, non-drug solutions and then compounded courage to follow the guidelines of your naturopath or an integrative medical doctor. This book is your "blue-print," you're the builder and your health professionals the sub-contractors— the completed project will be health, naturally.

Defining the Invisible Illnesses

MULTIPLE CHEMICAL SENSITIVITY SYNDROME

Because individuals are bio-chemically different, there are tremendous individual variations in the response to chemical allergens—both those we're externally exposed to and those our body creates.

No two people will exhibit the same reactions. Multiple chemical sensitivity syndrome (MCSS), also known as environmental illness (EI), is difficult to diagnose because of the varied symptomatology. Routine blood tests frequently indicate no problem exists. Fortunately there are more and more health care professionals and integrative physicians who *do* recognize that MCSS/EI usually has a "gut" connection. Many patients are treated with conventional drugs for digestive disorders, allergies and anxiety, only to be given more drugs when multiple sensitivities develop.

All victims of MCSS/EI have liver dysfunction, and most have high cholesterol to some extent. Most of my clients have never made the connection between high cholesterol and liver health. The liver, in most healthy people, assists the body in controlling cholesterol. In a person with varied sensitivities, the original toxic load most probably caused the sensitivities and toxic liver, and then the liver became overburdened with an extraordinary amount of toxins to filter—adding to heightened sensitivities. This is the start of the destructive pattern caused by having too many **mis**ses in their lives—**mis**informed, **mis**diagnosed, **mis**treated and **mis**understood.

When people become sensitized to chemicals, they react at levels not detectable by others. Life is no longer ordinary, even though visibly we may *appear* normal. MCSS/EI demands learning to cope with multiple losses; a safe home, career, hobbies, public access to events and places, transportation, tolerance to foods and personal care products, social life—in and out of your home. The most profound losses are those experienced with our loved ones, who want to understand, yet in their frustration and lack of understanding, draw away instead of being supportive or taking the time to learn about the disorder.

People with MCSS/EI can react to the least amount of fragrance, barely detectable by others. They can, and do, react to anything but especially, cleaning products, plastics and petroleum based products, fabric softeners, tobacco, candles, mold, new or recently remodeled or painted buildings. One whiff of fresh paint, newly applied perfume or aftershave, can send some MCS'ers to bed for weeks, along with a myriad of painful symptoms as their bed partner.

There is definitely a connection between the mind, the immune system and allergic responses. This does *not* mean the immune system's reaction is "psychological." In allergic responses to emotional stress, the immune system responds by activating protective mechanisms (reactions) to warn of impending danger. Fear and anger act on the autonomic nervous system, controlling the functions of internal organs, blood components, and lymph vessels. In severe cases, emotional stress in a person

with multiple sensitivities can perpetuate anaphy-laxis, the systemic allergic reaction where airways swell and close; the person may even go into shock and die.

It is *naïve* to think we can live in today's world without being exposed to some toxic chemicals. However, it is *realistic* to educate ourselves on why these syndromes develop and how to keep our immune system in optimal health to avoid, *yes, I said avoid*, the syndrome in the first place. The secrets lie within the following pages.

FIBROMYALGIA SYNDROME / ALLERGIC INFLAMMATORY ARTHRITIS

It's NOT all in Your Head! It is estimated that between three and six million people in the United States and Canada suffer from Fibromyalgia Syndrome (FMS). Eighty percent of those afflicted are women between the ages of twenty and fifty. This accounts for more than 5 percent of a doctor's prac-tice and, for the most part, leaves the conventional medical profession perplexed, to say the least.

Fibromyalgia (FMS) is a syndrome, meaning that it involves varied symptoms in multiple body systems. Nearly 100 percent of FMS victims report they'd had some type of life event or life stressor (accident, surgery, loss of job, divorce, loss of loved one, relocation etc.) just prior to the onset of their symptoms: chronic pain and debilitating chronic fatigue, sleep disturbances, generalized muscle and joint pain, intermittent flu-like symptoms, depression, anxiety, digestive disturbances, gener-al malaise and cognitive impairment.

Patients of FMS get referred from doctor to doctor; most of them saying its all in their heads—just learn to live with it. Conventional medical doctors continue to refer FMS patients to psychiatrists and/or prescribe drugs for depression, anxiety, pain, inflammation, constipation, heartburn, digestive distresses and all other manifested symptoms.

Natural health care practitioners and integrative physicians, take a completely different approach. They seek to find the *cause* of the distress and educate the patient in lifestyle changes necessary to reverse this complicated syndrome—all without drugs that compound their varied symptomatology, unless absolutely necessary for short periods of time.

Conventional medicine offers *no* cure for Fibromyalgia, however, natural therapies combined with life-style and nutritional modifications do, all without dangerous drugs that bring on additional side effects and do *not* get to the original causes.

Fibromyalgia is a type of arthritis, although not specifically osteoarthritis, which is a degenerative joint disease. According to the University of Florida, Division of Rheumatology, there are more than 100 different types of arthritis. The following indicate the identified categories:

1 in 10 adults have osteoarthritis

1 in 33 adults have fibromyalgia

1 in 100 adults have rheumatoid arthritis

1 in 1000 children has juvenile chronic arthritis

1 in 1000 people have ankylosing spondylitis

1 in 2000 people have systemic lupus erythe-matosus

1 in 10,000 people have scleroderma

- According to the U.S. Centers for Disease Control and Prevention and the Thurston Arthritis Research Center at the University of North Carolina, arthritis and arthritis type conditions affect an estimated 43 million Americans. Nearly 50 percent of people 65 or older have some form of arthritis. About 250,000 children acquire arthritis.

- One million new patients develop arthritis each year, and by the year 2020 that number is estimated to be 60 million people.

- Arthritis limits the activity of over 7 million people and tops heart disease as the leading cause of work disability.

- Women account for 70% and people younger than 65 for approximately 26%.

- Arthritis accounts for 427 million days of restricted activities, 156 million days in bed and 45 million workdays lost annually.

- Estimates place the direct medical cost of arthritis at $15.2 billion per year, with total costs of medical care and lost wages exceeding $64 billion.

According to Dr. Paavo Airola, a pioneer in finding biological causes for arthritis, "European medical thinking is fast moving toward the new biological era of medical science, based on the philosophy that most diseases are of man's own making and are the result of health-destroying living habits, wrong nutritional patterns, and other harmful environmental factors. American 'official' medicine and governmental health organizations continue to cling to an outdated medical philosophy based on the Pasteurian assumption that all diseases are

caused by bacteria. Consequently, the main effort of present medical research is aimed at identifying the bacteria considered pathogenic and developing specific drugs to destroy the suspected bacteria."

It is evident that the conventional symptomatic drug approach including corticosteroid therapies, has sadly failed to show positive results in management or reversal of the disease. Hopelessness, uncertainty and drugs given for symptom-care color the whole present-day conventional medical approach to the disease. Drugs may provide temporary relief, but mostly serve to cause more symptoms through their toxic side effects. A time is long overdue to completely re-evaluate conventional thinking and consider a return to the fundamental Hippocratic nature-cure principles, as those affirmed by the practice of basic biological medicine approaches—correcting the root causes.

CHRONIC FATIGUE SYNDROME/ EPSTEIN-BARR/MYALGIC ENCEPHALOMYELITIS

In 1988 the disorder was officially recognized in the United States as Chronic Fatigue Syndrome (CFS), but the name preferred by most scientists is Chronic Fatigue Immune Dysfunction Syndrome (CFIDS). In the United Kingdom and Canada, it has become known as Myalgic Encephalomyelitis (ME).

It has been difficult, to say the least, for patients of these disorders whose doctors and family members either didn't believe the disease existed at all, or believed that if it did, it was most likely an end product or symptom of some mental disturbance, therefore, the patient was referred to a psychia-

trist, albeit with good intentions. Part of the reason CFS was thought to be a psychosomatic disorder is that different patients reported different symptoms. One might complain of coldness and headaches, another fevers and leg pain, and yet another, extreme fatigue, weakness and depression.

One of the most common symptoms, and possibly the most life altering, is the intense pain—generalized or localized. The most common pain is experienced in the head, neck, shoulders and upper back. The headache can mimic a migraine; continuous sharp bursts that seem to echo around your skull and down your spine, often accompanied by extreme light sensitivity and nausea.

The muscular pain is almost identical to that expressed in Fibromyalgia patients; muscles that become sensitive to pressure—the lightest touch can be extremely painful. Chest pain and spasms is also common, and may feel like a heart attack. CFS victims also experience the following symptoms, each with varying degrees of intensity: tremors, temperature abnormalities, low grade fevers (and sometimes intense fevers at the onset), intense night sweats that leave you wringing wet, physically exhausted and emotionally demoralized.

Secondary infections are common, as the relentless attacks on your body's immune system continue to erode its reserves. *Candida* and thrush seem to flourish in people with CFS, as well as in all the invisible illnesses described throughout this chapter.

This disorder, not unlike all the invisible illnesses, is equally stressful to its victims because of its "invisible" nature and the opinions of families,

friends, co-workers, employers, and insurance companies. If you look "just fine," and all the barrage of medical tests come back "within normal range," then the illness must be psychological in origin—otherwise there would be outward manifestations or a test to validate its existence.

It's difficult to understand that while living in this age of modern medicine, doctors are unable to find a cure for this disease, let alone understand why it is so difficult to diagnose.

Very little is known as to the actual cause of CFS. It is theorized that a virus of the 80 or more viruses known collectively as the "entero" virus group, which enter the body though the digestive system and affect the brain, nerves and muscles, is at the root of the disorder. It is now generally recognized that the Epstein-Barr virus does not, in fact, cause the disease, so it's causes remain specifically unknown in conventional medicine. What we have learned, in traditional and integrative medicine, is that in order to reverse the disease, the body must be detoxified and the digestive and immune system supported. When these actions are taken, you *can*, in most cases, *completely reverse CFS*, or at least, regain quality of life and prevent the downfall of re-occurrence, naturally.

COLON AND DIGESTIVE DISORDERS
(CONSTIPATION, HEARTBURN, DIARRHEA,
IRRITABLE BOWEL SYNDROME,
CROHN'S DISEASE, COLON CANCER,
LEAKY GUT SYNDROME)

It is estimated that 62 million people, in the United States alone, suffer from digestive disorders. Most of the prescription drugs used for the illnesses described in this book cause some type of disturbance or damage to the intestinal ecology of the digestive system. There are generally two causes for the digestive disorders described herein.

Toxic Colon—Most often occurs as a result of taking drugs that have a constipating effect. It also occurs as a result of our modern day diets low in fiber, high in sugar and carbohydrates, preservatives and synthetic additives.

Leaky Gut Syndrome—A clinical disorder associated with increased intestinal permeability. A leaky gut is one in which the intestinal lining is more porous than normal. In other words, large spaces develop between the cells of the gut wall, *usually* the small intestine. These spaces represent damage to the digestive filter that now allows bacteria, toxins, fungi, parasites, undigested protein, fat and waste material to enter the bloodstream.

This condition is brought about by inflammation and damage to the gut lining. In a healthy gut, these substances would be broken down into much smaller pieces before absorption through the small spaces in the small intestine. When the large intestine (colon) is toxic, it also develops leaky walls and

now the waste material can seep into the liver (through the hepatic portal vein), and the lymphatic system (through the cisterna chyli).

The immune system starts making antibodies against the larger molecules because it recognizes these as foreign, invading substances. These antibodies are suddenly being made against proteins and previously well-tolerated foods. These food antibodies usually get into tissues and trigger inflammatory reactions, as in fibromyalgia and chronic fatigue. If this inflammation occurs in a joint, autoimmune arthritis develops. If it occurs in the blood vessels, vasculitis (inflammation of the blood vessels), another autoimmune disorder develops.

Most victims of leaky gut syndrome also develop celiac sprue (gluten intolerance), intolerance to lactose (dairy products), and immune system disorders such as multiple chemical sensitivities. It is imperative, at this juncture, to consult with a naturopath or nutritionally aware medical doctor for a diet and therapy program specific to your needs. This book will provide general guidelines to follow which have been found beneficial to victims of the disorders herein described.

SYSTEMIC *CANDIDA*/YEAST: IMMUNE SYSTEM DESTROYER

Candida is a yeast-like fungal microorganism known as *Candida albicans*. *Candida* lives naturally in our bodies, however, when the intestinal ecology becomes toxic the *Candida* multiples at a rate that causes chronic problems in the gut. Systemic over-growth of *Candida* is stimulated by poor

dietary habits consisting of excessive amounts of sugar and carbohydrates, overuse of antibiotics, birth-control pills and many prescription drugs. Constipation is another symptom that complicates, if not causes, all the other symptoms.

- Yeast is a fungus, a microscopic-size parasite type organism. *Candida* lives and thrives in a dark, moist environment—especially in the mouth, digestive tract and vagina. *Candida* is a single-cell microorganism that has feeding tubes called *hyphae* that seek nourishment from its human victim. The following is an electron microscope photograph of *Candida albicans* in the human gut magnified 1,000,000 times.

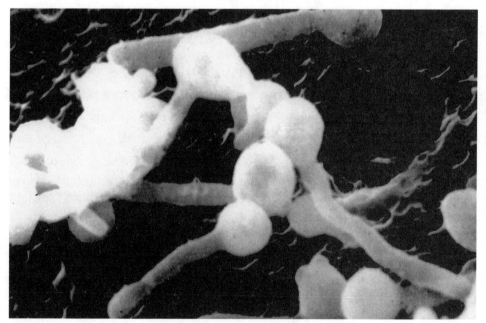

(photo used with permission by its originator, Victoria Glassburn, author of *Who Killed Candida?*)

During the growth process of *Candida albicans*, toxic materials are emitted, spreading throughout the body and producing symptoms, but not limited to, the following:

- *Digestive System*—bloating, gas, cramps, diarrhea, constipation, inability to lose weight
- *Nervous System*—chronic fatigue, anxiety, mood swings, memory loss, brain-fog, depression and chronic insomnia. *In children*, hyperactivity, autism, quick anger "short fuse," short attention span
- *Skin*—hives, eczema, psoriasis, profuse sweating without physical exertion, acne, nail fungus
- *Genito-urinary Tract*—*in women*, mild to extreme PMS symptoms including: depression, mood swings, fluid retention, cramps, recurrent vaginal or bladder infections, loss of sexual desire, crying for no unknown reason. *In men*, chronic rectal or anal itching, recurrent prostatitis, impotence, genital and inner thigh rashes.
- *Endocrine System*—thyroid dysfunction, adrenal "burn out," pancreatic disorder. These disruptions cause symptoms of extreme fatigue, muscle weakness, low body temperature, tingling and numbness in fingers, feet and toes, sugar and carbohydrate cravings.
- *Generalized Immune System*—recurrent infections, especially ear, nose, throat, respiratory and vaginal/genital.

Candida causes no problems when the immune system is strong. It's when drugs, such as antibiotics, are used repeatedly that the damage usually occurs. These drugs kill the friendly germs in the digestive tract, thus allowing the over-growth of the yeast fungus since they're not destroyed or affected by the antibiotics. This also occurs without the use of antibiotics in cases where the following conditions exist: chronic constipation, excessive

sugar and carbohydrate intake, lack of sufficient fiber and chronic use of prescription medications.

Children are especially susceptible to yeast over-growth and the resulting behavioral and learning disorders. Medications, like Ritalin, are beneficial as a "quick-fix" for the child who is impulsive, overactive, inattentive, irritable, depressed and angry. These children usually manifest chronic physical symptoms such as: *headaches, bedwetting, recurrent ear infections, stomach aches, muscle and joint pains, daytime sleepiness and non-restorative sleep, recurrent sinus and respiratory infections, chronic post-nasal drip, and cravings for sweets and high carbohydrate foods (potatoes, pasta, breads, corn etc.).* His parents, teachers and neighbors welcome the relief when drugs are prescribed. However, results of clinical trials have proven that most children with Attention Deficit Hyperactivity Disorder (ADHD), and the accompanying immune system disorders, were sensitive to ingredients in common foods. Treatment with an elimination diet and a restricted sugar and carbohydrate diet showed 73% responded favorable. This study supports the validity of dietary changes for the control and elimination of ADHD, rather than the pharmacological drug therapies for symptom-care of this condition.

In July 1995, William Shaw, Ph.D. reported that they found fungal metabolites in the urine of 18 autistic children; over 75% of which had a history of frequent infections treated with antibiotics. Following oral antifungal drug therapies, laboratory

findings returned to normal and the children showed significant improvement. However, if dietary life-style changes were not initiated and adhered to, the infections and behavioral problems returned, only to again be treated with antifungal drugs.

Dr. Ralph Golan accurately defined the seriousness of this fungal infection, "At one extreme, it can cause skin rashes and vaginal infections. At the other extreme, in individuals whose immune systems are severely compromised, yeast can invade the bloodstream (candidemia) and cause death." Your present condition may not yet reached life-threatening proportions, but nonetheless present a *major* roadblock on the road to wellness.

PSORIASIS AND ECZEMA:
VISIBLE EVIDENCE, INVISIBLE CAUSES

According to the *Merck Manual of Medical Information*, psoriasis is a chronic, recurring disease recognized by silvery scaling bumps and various-sized raised patches known as plaques. This condition is clinically explained as an abnormally high rate of growth and turnover of skin cells, leading to eventual scaling. Conventional medicine does not have an explanation for the rapid cell growth, however, it is implied that a major factor is an immune system malfunction.

Psoriasis usually starts out as a small dry patch that becomes excessively flaky. Although the name of the disease is derived from the Greek word, *Psora*, meaning "the itch," it usually develops as small bumps, and not all victims develop acute itching, though most experience itching to some degree.

Psoriasis, for many, is accepted as a hereditary disease because it's been experienced generation after generation. It appears the tendency for psoriasis is inherited, but not necessarily the disorder. What you might have inherited can more likely be categorized in three areas:

First, the inability to properly utilize fat.

Second, the tendency to be an over-achiever or a high stress individual.

Third, the genetic make-up setting up the perfect scenario for constipation and digestive disorders, leading to a build-up of toxic substances that erode away at your immune system.

Eczema, another troublesome skin disorder, is almost always accompanied by chronic, and sometimes acute, itching. Usually the underlying causes of psoriasis and eczema have the same common denominator.

Psoriatic victims may also develop symptoms very similar to rheumatoid arthritis, clinically labeled psoriatic arthritis. Eczema patients do not usually manifest arthritic symptoms.

Psoriasis and eczema are strictly a degree of toxicity, most commonly, toxic colon, Candida, leaky gut and/or parasites. The recommendations provided in this book will deal with correcting the above *causes*, as well as dietary modifications necessary to promote healing and elimination of symptoms.

Managing and Reversing the Invisible Illnesses

HEALING STARTS WITH CLEANSING

Introduction
by Dr. Sylvester Yong MD

Colon Hydrotherapy—A Clear Passage to Health

*"Every organ, gland and cell of the body is affected by
the condition of the large intestine—the colon"*
—Edgar Cayce, father of Holistic Medicine

Clearing your colon of years of toxic build-up could be the *first*
and *most important* step in facilitating improvement of *physical
energy, mental clarity and for relief & prevention of a variety of
common health problems* i.e. Constipation, Flatulence, Hemor-
rhoids, Laxative dependency, Yeast infections (Candida), Parasitic
infections, and the invisible illnesses described in this book.
Colon cleansing is also one of the best therapeutic tools for a
pro-active approach to health-care; maintenance and preserva-
tion of health.

Colon hydrotherapy is a safe procedure that clears the
colon of stagnated waste. Improper elimination, not just outright
constipation, lead to a state of auto-intoxication (self-poisoning);
the basis of many modern day illnesses with a toxic colon as
the underlying pathology. Therefore, in many instances,
cleansing of the colon helps to resolve chronic illnesses not
helped by other therapies.

Colon Hydrotherapy offers a natural approach for the relief of many health conditions by improving the over-all function of elimination. The advantage of this type of therapy is that it offers both immediate and long-term relief for symptoms, as well as addressing the underlying health problems caused by auto-intoxication.

As a therapeutic procedure, colon hydrotherapy is gaining global popularity, mostly due to its simplicity and ability to offer relief and improve bowel function *naturally* without the use of drugs or chemical agents.

Although the primary function of the colon is storage and elimination of solid waste, there are many other functions related to the colon that are yet to be fully understood and appreciated.

Colon hydrotherapy, when carried out by an experienced therapist and accompanied by the appropriate complementary measures, will improve colon function. The potential benefits of colon hydrotherapy are:

- **Physical**—Facilitates the Clearing of solid, stagnated waste
- **Chemical**—Eliminates and reduces the internal 'toxic load'
- **Functional**—Improves and maintains good colon function
- **Muscular**—Stimulates peristalsis and intestinal motility
- **Metabolic**—Harmonizes and balances endocrine functions
- **Nutritional**—Re-establishes vitamin production in colon
- **Therapeutic**—Relieves symptoms, assists in overcoming underlying cause of many health problems

- **Preventive**—Maintains good colon health (avoids leaky gut syndrome and auto-intoxication)
- **Detoxification**—repairs damage from drug intoxication, facilitates fasting & cleansing programs

Direct result of the cleansing action of colon hydrotherapy include:

- clearing of stagnated waste, parasites and yeast
- the washout of harmful bacteria population
- elimination of mucus and gaseous colon build-up
- over-all reduction in toxic load

Indirect effects of the cleansing action of colon hydrotherapy include:

- reflex point stimulation
- state of autointoxication
- impact on immune function
- functional changes that have yet to be scientifically accepted. New research findings are forthcoming that explains these effects. Only time will tell when these effects will be scientifically explained.

There still remains some degree of controversy regarding the value of colon hydrotherapy. Debate will continue to argue the validity of this therapeutic recommendation as a step towards health. However, those who have benefited from this therapy will testify as to its positive effect on their health.

It is imperative that individuals performing this therapy be properly trained/certified to assure competency, knowledge and professionalism. When these standards are met, the client gains the best outcome from the procedure, and the practice of colon hydrotherapy can achieve the level of creditability it deserves.

THE COLON: THE ROAD TO WELLNESS
IS PAVED WITH GOOD INTESTINES

What does the colon have to do with invisible ill-
nesses? *Everything!* The colon is your personal
"toxic waste station," containing two main pipelines
(pathways) through which toxins flow. The manu-
factured toxins in the colon affect the remainder of
the body because they are transported from the
colon through the hepatic portal vein to the liver.

It is remarkable that this cavity, with its toxic
contents, can be so close to the bloodstream without
causing even more trouble. Whenever *there is* trouble
in the intestine, a leak of substances into the
bloodstream is one of the first consequences.

In order to better understand this process, we
need to consider overall blood circulation. Blood
circulates through the body via two kinds of blood
vessels. The **arteries** carry fresh, oxygenated blood
(red blood) from the heart, supplying all the organs
and tissues of the body. The **veins** carry waste
materials away from the organs and tissues. Venous
blood is blue in color, does not contain oxygen, and
returns to the heart. From the heart, blood passes
to the lungs to become re-oxygenated, and becomes
red blood again. It then re-enters the heart before
circulating once more through the arteries.

Even in *seemingly* healthy individuals, thou-
sands of substances originating from the colon can
escape across the colon's mucosal border, which is
only about the thickness of an eyelid. The liver
however, the largest organ in the body, is designed
to be the processing plant to neutralize toxic sub-

stances. When the liver is over-burned with the colon "dumping" substances quicker than it can neutralize them, disease sets in. This process is clearly described in an analogy by David Webster, researcher in colon health.

The colon and liver are analogous to the oil pan and the oil filter in an automobile motor. As in auto maintenance, we must ensure that the filter is clean at all times in order to preserve the life of the motor. To purge the liver while allowing the colon to continue polluting the bloodstream is like replacing the oil filter and not changing the oil.

The colon is currently the main source of pollution in our system. This is not the function nature intended. If intestinal putrefaction is excessive or if the liver cells have been challenged or fail to function, toxic by-products enter general circulation and produce the condition known as autointoxication.

Since blood circulation is constant, the liver does its best to detoxify anything coming into it from the colon. When the liver is overworked because the colon is abnormally congested, it is challenged beyond its capacity, the bloodstream is polluted, and internal infections manifest.

As described in detail in my book *I was Poisoned by my body*, autointoxication is the process by which the body literally poisons itself by maintaining a cesspool of decaying matter in the colon. The toxins released by the decay process get into the bloodstream and every cell is affected. This process weakens the entire system, thus the origin of many forms of "invisible," "incurable" and "mis-diag-

nosed" diseases get their start and the fuel to perpetuate the destruction in the colon.

It is important to understand that a person can suffer from intestinal toxemia without constipation, as in cholera morbus, but it is impossible to have constipation without intestinal auto-intoxication.

Millions of people suffer a myriad of health problems, without any consideration that a toxic, sluggish colon can be at the root of the cause. This is not surprising when we consider conventional treatment of health disorders, disease symptoms, and disease management using pharmaceuticals and surgery, which completely obscure the root cause of chronic health problems.

Healing "Inside-out"
by Cleansing and Maintaining

It's amazing to me that North Americans are so adverse to even thinking about colon health, unless of course, they have diarrhea or constipation. With this antiquated consciousness, it is even less likely they'd discuss their colon health with their health care professional, much less their families and friends. However, famous people, like a well-known female talk-show host, allowed a colonoscopy to be performed on national television. She endorsed the public viewing for the sake of awareness and education, after she lost her husband at a very young age to the "invisible illness" of colon cancer. A U.S. Congressman is airing television commercials endorsing a pharmaceutical drug for erectile dysfunction, in order to help break the stigma of the disorder.

In my grandmother's generation, the discussion about breast, colon or prostate cancer, menopause, and vaginal and genital infections were *never* discussed, except *maybe* between husband and wife or mother and daughter. Today, us North Americans especially, are still in the "dark ages" when it comes to acknowledging the importance of a healthy, clean colon. However, countries like Singapore, Spain, Taiwan, China, Australia, Germany and Greece, to name a few, are actually creating colon hydrotherapy centers in their hospitals and medical centers—it seems to me that the most powerful nation in the world, and most of its conventional physicians, are still in the dark—maybe it's the "brain fog" from prescriptions drugs and our North American diets? It couldn't possibly be that our physicians and medical schools are "brain-washed" by drug manufacturers because there's more profit in illness than wellness, could it?

Colon Hydro-therapy:
"It saved my life and it may save yours!"

Our minds are first educated to observe external objects and forces and the resulting effects upon mankind—the external still continues to engross our attention as if we were a child in a kindergarten class. We are fascinated by things *without*, and ignore the *within (out of sight, out of mind)*. However, marvel of marvels, disease appears and comes to enlighten us concerning the world within. Disease gradually acquaints us with the fact that within us are organs and functions corresponding to the objects and forces in the external world. Disease

makes us aware that by ignoring the claims of our *inner relations*, we have been converting that which we ingest into insidious and formidable poisons. This brings forth the notion that one's duties (healthy elimination and bowel health) cannot be neglected without disastrous consequences. When colon health and nutrition is ignored or neglected, the conditions that manifest represent the break-down of the organs of life—they wither, waste and weaken, until life goes out like a fire unfed.

We have been slowly learning to take the necessary sanitary precautions and hygienic measures to provide comfort in our surroundings for everything conducive to stabilizing our health. Through the years, we've learned, by experience and science, of the many changes that inevitably occur in such perishable nutritive substances such as milk, meats, vegetables, fruits, etc., when not properly stored or refrigerated. Through this knowledge, we've learned the law of decomposition—putrefactive and fermentative changes that occur.

Substances confined and stagnant—ponds, cesspools, sloughs etc., are everyday lessons to us of the fact that chemical changes occur that furnish the perfect conditions for breeding bacterial poisons. If we consider the analogy between the decomposition of substances in idle vessels or pools, the decomposition of food in the reservoir called the stomach; its further decomposition in the long canal of the small intestine connecting the stomach with the other receptacles of the colon and sigmoid flexure; and then the decomposition of their contents; we will readily comprehend the chemical putrefactive or fer-

mentative changes or bacterial action that take place in the organism if for any reason the contents are confined, as in a stagnant toxic environment (constipation). Without complete, regular elimination, we are literally creating and feeding a toxic waste dump within our internal ecosystems. This condition is especially a disorder of western civilizations—a consequence of eating food devoid of healthy fiber and a "modern" consciousness of rushing through life *and* ignoring our natural urge to eliminate. Isn't it ironic that man, composed almost entirely of water, is constipated!

Ideally, food should take ten to twelve hours to pass into the colon. Most western (low in fiber) diets have an average transit time of sixty-five to one hundred hours (three to ten days, or nine to thirty-six meals). This undigested back-up body waste is absorbed into the bloodstream and causes autointoxication, the invisible underlying cause of many disorders. Just image the volume of thirty-six digested meals composting in your digestive system—or should I say in your toxic waste station? The volume of that much waste material could fill a three to five gallon container. Keep in mind, if your consuming three meals or more per day, and only eliminating once, the remainder is becoming toxic waste, and your body is the receptor—is it any wonder our modern society is so toxic?

What to Expect from a Colon Hydro-therapy Session

As described in detail in my book *I was Poisoned by my body*, colon hydro-therapy saved my life. Colon Hydro-therapy is the safe, gentle infusion of water

into the colon via the rectum, administered by a certified colon hydro-therapist. No chemicals or drugs are involved and the entire therapy is safe, relaxing and effective. During therapy, the client lies on a custom treatment table in complete comfort. From the hydrotherapy equipment, a small disposable speculum is gently inserted into the rectum, through which warm, filtered water passes into the colon. Modern state-of-the-art colon hydrotherapy units employ multi-stage water purification systems and individual disposables, eliminating any possible contamination to the client from any previous treatments.

The client, and therapist, is able to view the eliminated matter via a lighted, enclosed viewing tub. These systems are completely enclosed to allow waste to be discretely transported into the sewer line without offensive odor and without compromising the dignity of the individual. The unit is thoroughly cleansed and disinfected after each therapy session.

A skilled colon therapist will use several fills and releases of water, as well as light massage techniques, to assist the body in dislodging toxic waste matter adhering to the colon walls. Some clients may experience initial gas and bloating, depending on the level of colon toxicity. This can be counter-acted by herbal supplements recommended by your health care professional. Clients may feel concern at experiencing gas, bloating or minor cramping. What must be kept in mind is that your internal compost is being "stirred." Just as a garden compost pile that has been allowed to rot, when stirred, creates gas and, at times, sufficient

heat to ignite a fire, so does the stirred decomposing matter in the colon.

Each colon hydrotherapy session lasts approximately forty-five minutes to one hour. Initially, a series of anywhere from six to twelve separate sessions is normally recommended in order to achieve maximum initial cleansing benefits. The length of each session, quantity and frequency of sessions should be coordinated between the colon therapist and your naturopath or integrative physician. In individuals with multiple chemical sensitivities, it is of utmost importance to have your therapist and doctor communicating—your doctor has all your history. If you have sensitivities to fragrances, candles, essential oils, etc., be sure to discuss your needs with the therapist **before** your therapy session at the time of scheduling. Many clients, including myself at the onset of my illness, attempted to enter a center for colon therapy only to be forced to leave (along with an allergic reaction) because of heavy scents in the center. Colon therapists must be educated in the special needs of chemically sensitive individuals, do your best to explain your needs, they're not mind readers—better still have them contact a doctor familiar with chemical sensitivities.

Why Colon Hydrotherapy Instead of Enemas, Suppositories or Laxatives?

In colon hydrotherapy, the entire large intestine (approx. five feet) is cleansed and the therapeutic benefits are much greater than those achieved with an enema. Enema cleansing is effective mostly in the

rectum area and, due to the body's natural desire to expel, is limited in duration.

Our ancestors knew more about the importance of colon irrigation than most medical professionals today. *The British Medical Journal,* in the late 1800's, describes the invention of the enema apparatus as an epoch in pharmacy *as important* as the discovery of America in the history of human civilization. Prior to World War II, it was common for physicians to recommend colon cleansing by enemas for their preventive and therapeutic value. In the 1920's the benefits of colon irrigation through enemas was widely written about internationally. Until 1977, coffee enemas were listed in the guidebook of medicine, *The Merck Manual of Medical Information*—enema therapy was removed, at that time, simply because the space was needed to list all the new drugs; drugs have a substantially higher profit margin than an enema kit! Coffee enemas were used for generations as a way to purge the colon, liver and gallbladder. However, I do not personally recommend coffee enemas to most clients, especially the chemically sensitive, because they can have the same reaction to the coffee enema as ingesting coffee. Furthermore, with leaky gut syndrome and a damaged liver, the coffee can trigger an immediate allergic reaction—I know, I'm always my own best double-blind study. I had someone administer the enema with and without coffee on several occasions, each time not knowing when plain water or coffee was being administered. As soon as the coffee entered my rectum, my face got red, hot,

flushed, my eyes and throat swelled. The coffee used was even certified organic and water-processed, therefore, there were no added chemicals to be blamed for the reaction—for my conventional medical friends, in my book, this classifies as a double-blind study. Several of my chemically sensitive clients tried the same experiment after reading about the touted effects of coffee enemas—all experienced varied degrees of negative allergic reactions. When these same people had colon hydrotherapy, some experienced bloating, gas, minor cramping and fatigue, but shortly felt the benefits of this type of deep detoxification.

Suppositories, over-the-counter or prescription, stimulate the expulsion of the contents of the rectum but contribute to dehydration, which may exacerbate a constipated condition.

During a typical colon hydrotherapy session, about twenty-five to thirty-five gallons of water are transported in-to and out-of the colon. Using a combination of abdominal massage (if consented), reflexology, breathing instruction, and relaxation techniques, the colon therapist is often able to promote great volumes of elimination of toxic waste, not otherwise possible through enemas or individual efforts. *Just* **one** *colon hydrotherapy session may be equivalent to having twenty or thirty regular bowel movements!* Eliminations during subsequent therapy sessions can be even more substantial as older, hardened, impacted feces are dislodged from the colon walls, especially if assisted with cleansing fiber products.

Will I be Tired or Energized
After a Colon Hydrotherapy Session?

At the onset of therapy, especially for those clients with chronic conditions or multiple chemical sensitivities, you *will experience* fatigue. This is to be expected as toxic matter is "stirred" and released. I find most people are so apprehensive about the mere idea of colon therapy they are unable to relax the first session, adding to their fatigue. Once they experience a session and realize that it is discreet, easy, comfortable, and they understand how the equipment operates, the subsequent sessions produce more results because the apprehension is diminished. Most clients comment "if I would have known this is all there is to it, I would have come much sooner."

It usually takes several sessions before you start actually feeling energized, as I now do. Therefore, plan your first few therapies so you don't have a demanding schedule afterwards. When I was experiencing anaphylaxis several times a day and having to have three colon therapies per week, I was exhausted. I would consult with clients until early afternoon, have therapy and go directly home to bed. These were the days at the onset of my leaky gut and chemical sensitivities when the *only* thing that stopped my anaphylaxis was colon therapy. I will not say it was easy, I will say it was worthwhile. It took diligence to repair my immune system—I did it and so can you! The next morning I felt the benefits of detoxification, clearer thinking, reduced liver pain, increased energy, and most importantly for me, elimination of or alleviation of allergic reactions.

What are the Benefits of
Colon Hydrotherapy?

Colon hydrotherapy provides a proven way to cleanse the colon, thereby propelling the healing process and maintaining optimal health. It is important to remember that maintaining good health is an ongoing process requiring diligence— your health, more than likely, did *not* decline over night, don't expect an immediate return to health. What you *can* expect is a steady improvement and reduction of symptoms.

Millions of people suffering a myriad of health problems may *never* consider the source of their problems as a toxic, sluggish colon. This is not surprising if you consider traditional treatment of health disorders, disease symptoms and disease management using pharmaceuticals and surgery that may completely obscure the root cause of chronic health problems. The following list represents the beneficial effects of colon hydrotherapy:

• Stimulates the immune system
• Allows freer passage of nutrients into the blood
• Increases prevention of toxic absorption from the colon by creating healthy mucosa
• Provides a favorable environment for digestive bacteria and mico-flora
• Promotes a return of normal, regular bowel movements
• Strengthens peristaltic activity in the colon and rectum
• Restores the balance of pH in the body
• Clears the colon of old, hardened waste material and harmful toxins

- Reduces liver stress by reducing toxic load in the colon
- Reduces allergic reaction by reducing liver burden
- Assists in removal of accumulated toxins from soft and connective tissue by reducing toxic load of the lymphatic system via the liver (fibromyalgia type symptoms)

Prebiotics

By definition, a non-digestible food ingredient that beneficially affects the host (you) by selectively stimulating the growth and/or activity of one or more type of bacteria in the colon, and thus, improves health. Most of us have heard about the "friendly" bacteria called **Pro**biotics, "pro" meaning to add. In other words, if you've taken a round of antibiotics, known to kill all the bacteria—good and bad—then afterwards you take a **pro**biotic product like acidopholus to add, or re-inoculate, the intestinal ecology with "good bacteria". However, many people have never heard of **pre**biotics.

In my practice, I use a **pre**biotic product called Inuflora® containing Inulin. As described by Aftab J. Ahmed, Ph.D., "Inulin is the natural fiber isolated from various vegetables and fruits. The main feature of inulin is their structure: Naturally occurring individual fructose units linked up with one another in a linear array. This structure confers unique properties to inulin, and distinguishes it from FOS." FOS is the acronym for fructo-oligosaccharide. These FOSs are a subset of inulin.

Dr. Ahmed's research has shown that FOSs contain the same linear array of fructose molecules,

but the number of individual units is smaller in FOSs as compared with inulin. What does this mean? It means that FOSs are inulins, but not all inulin are FOSs. These substances are both soluble fibers that are not broken down in the digestive tract. They are taken up "intact" in the colon, where they multiply the beneficial bacteria, which keep the gut healthy. What this means is that its function is to selectively feed the beneficial (good) bacteria of the gastrointestinal tract, helping the body's own resident "friendly" bacterial populations to re-establish their rightful territory in the intestinal ecology of the body. When you add a probiotics, it means you are actually introducing bacteria to assist the friendly population. In contrast, a prebiotic does not add bacteria, but rather assists the existing bacteria to multiply, therefore, promoting efficient metabolic functions.

Among the most commonly known properties of inulin is its ability to stimulate the immune system via normalization of the bowel flora; thereby it's also a detoxifying agent and helps reduce the production of free radicals. Even though it's a natural sugar, it **does not** contain the adverse effects of refined table sugar (sucrose); therefore, it **does not** affect blood sugar levels.

Basically, inulin serves as "food" for bacteria in the colon. Studies have shown that inulin is utilized by the "good" bacteria such as bifidobacteria. Inuflora is a proprietary soluble fiber extract taken from the Jerusalem artichoke. It has become Europe's #1 prebiotic fiber to enhance intestinal health, immunity and digestion. Inuflora comes in

three forms: tablets, a delicious mix-in powder that can be added to cereal, fruit or juice, and sucrose-free chewables made with real cocoa. The chewables are especially valuable for children, who are developing digestive disorders at an alarming rate. Many of my patients that cannot tolerate products containing FOS, can tolerate Inuflora. Being derived from the Jerusalem artichoke, it provides a beneficial mix of short-chain, medium-chain and long-chain molecules. FOS contains only short-chain molecules. Inuflora does not need to be refrigerated, so it's more convenient than standard probiotics. It's a healthy way to supplement your fiber intake while feeding your beneficial bacteria instead of feeding your carbohydrate and sugar cravings that in turn feed the yeast.

Detoxifying Fibers
Intestinal "Deep Cleaning"—
a Strong Foundation for Health

All building projects start with clearing the site, grading the land and preparing the terrain; building your health is no exception. The foundation on which to build wellness must start with brushing away all the layers of mucoid plaque, yeast, parasites and accumulated toxic matter in the colon walls. The process of cleansing is like peeling an onion—one layer at a time. Some of the matter has made its house in the colonic walls for years, becoming thicker and thicker until the layers resemble rubber. Within those walls live toxic bacteria and parasites that are invisible by most conventional testing methods.

After developing leaky gut, liver dysfunction and chemical sensitivities, it became exceedingly clear that a line of colon cleansing products had to be developed to address cleansing on three levels. First, a cleaning powder that was strong enough to "brush" the layers off the colon walls. As a doctor and victim of colon toxicity due to damage from prescription medications, I knew what needed to be in the product but could not find just the right formula. Heretofore I used a professional product for a couple of years, with great success, but certain ingredients made it prohibitable for a majority of my clients with acute sensitivities and woman who were pregnant or lactating. Finally, a product was developed to my specifications, *Intestinal Ecology: Deep Acting Colon Cleanse*® made by Advanced Naturals™, available only through your healthcare professional. This product is easily tolerated if you're not sensitive to psyllium. It assists in removing the old toxic layers, allowing them to be easily eliminated. It contains herbs to soothe the mucous membranes, which can become irritated as fiber is introduced. It also contains herbs to assist the body with adequate peristalsis to facilitate the passing of fecal matter. It is a vital part of the initial deep cleansing, and thereafter a necessary tool in maintaining health through quarterly "spring cleaning" of the colonic walls. Your specific cleansing routine, including dosages, should be under the direction of your health care professional.

Intestinal Daily Maintenance—
the Colon's Insurance

As your building project for wellness progresses, the ground has been graded and smoothed, the foundation is completed and the walls are erected. The clean-up crew has swept the debris from the floors, but once is not enough. As debris continues to accumulate, a large push broom can be used to clean the center of each room (Intestinal Deep Cleansing), however, in order to get every nook and cranny clean, you must use smaller brooms to do the job effectively; this is the job of the daily maintenance fiber product. After years of accumulation, you cannot sweep the colon with a deep cleanser and assume your job is completed; you must constantly work at maintaining a clean environment. The colon is the "workhorse" of the body, yet it's vital function is taken for granted, abused and misunderstood.

Everywhere you look, from magazines and newspapers to radio and television, fiber and fiber products are widely talked about and highly advertised. We are literally bombarded with commercials and advertisements telling us that eating more fiber is not only the right thing to do, but will solve practically all of life's problems. Fiber is essential; however, all fiber and fiber containing complexes are *not* created equal. Know the facts, *not* just the "sales pitch." One widely promoted and used fiber product contains artificial sweetener, flavoring (natural and artificial) and coloring (FD&C Yellow #6 or #10)—a combination with potentially life-threatening implications for many, especially those with chemical sensitivities. Yet, this over-the-counter product boasts in its marketing and packaging "Doctor

Recommended with 100% Natural Psyllium Fiber." Yes, the psyllium may be all-natural, however, the remainder of active and in-active ingredients prohibit it from being an overall "natural" product.

The product I recommend is *Intestinal Ecology®: Daily Colon Maintenance* by Advanced Naturals™. This product contains ingredients that keep the colon "brushed" clean without the intensity of a deep colon cleanse, yet gentle enough for daily use. It *does not* contain anything synthetic—NO colorings, fillers, or artificial sweeteners.

**Detoxifying Fibers: Psyllium Free
for Hyper-Allergic Patients**

Deep cleansing and maintaining is fine for people that are not hypersensitive; for those that are, very few products exist. Now there is a colon cleansing formula made without psyllium and the ingredients less tolerated by individuals with chemical sensitivities, acute food allergies and a low tolerance to most fiber complexes. *Intestinal Ecology®: Colon Cleanse for Sensitive People*, made by Advanced Naturals™. This formula does not contain any synthetic ingredients, corn, wheat, gluten, nightshades, artificial sweeteners, coloring or FOS.

It is powerful enough to provide the much-needed fiber to activate the elimination of colonic debris, yet gentle enough for most people with inflammatory bowel disorders. It contains herbs to soothe the mucous membranes and assist in passage of waste material.

It is available only through your health care professional.

Natures Elimination Aid

Often times when embarking on a routine of colon cleansing, we need "a little help from our friend, nature." As the accumulated layers of waste material are loosened, they can literally "clog" your intestinal plumbing, especially if the body does not possess sufficient fluids or adequate peristalsis (the ability of the muscles in the rectum to push the waste material for elimination). The product I use and recommend is ColonMax™ made by Advanced Naturals™. It is a combination of herbs and natural ingredients that help stimulate elimination, a type of natural stool softener. This can be taken alone, such as after an initial period of deep cleansing, or in addition to deep cleansing. ColonMax™ contains ingredients that help hydration and softening of stools, soothe the intestinal system, and support healthy gastric mucosa.

Betrayal of Our Defenses
Homeostatic Soil Organisms:
Nature's First *Probiotic* (HSOs™)

The term "probiotic" literally means "for life," in contrast to "anti-biotic," which means "against life." As early as 1899, Eli Metchnikoff applied what he called "replacement therapy" when he experimented with implanting Lactobacillus bulgaricus, a beneficial lactobacteria, in the colon to eliminate harmful disease-forming species. Ever since that experiment, replacement therapy has been a major area of interest in the quest for intestinal health. Today there exists a product superior to that available in Metchnikoff times, *Primal*

Defense™ made by Garden of Life™. It is a natural whole food probiotics blend of HSOs™ (Homeostatic Soil Organisms) designed to optimize the health of the human digestive tract and the immune system.

Beneficial soil and plant-based microbes use to be ingested as part of food grown in rich, unpolluted soil. Since after World War II, we have been sterilizing our soil with pesticides and herbicides, destroying most bacteria, both bad and good—did you ever consider "if the bugs won't eat it, why do we?"

Our modern lifestyle, including over-use of antibiotic drugs, chlorinated water, chemical ingestion, dental materials and procedures, environmental pollution and poor diet, is responsible for eradicating much of the beneficial bacteria in our bodies. A lack of beneficial microbes lays the foundation for disease in the intestinal tract and weakens the immune system, contributing to a wide range of symptoms and invisible illnesses. The following symptoms can result from lack of probiotics "good bacteria" in the intestinal tract.

- Gas, Bloating and Indigestion
- IBS (Irritable Bowel Syndrome)
- Diarrhea and/or Constipation
- Skin disorders i.e. Acne, Eczema and Psoriasis
- Bad Breath and Body Odor
- Delayed development in children
- Candida Yeast Infections
- High Cholesterol Levels
- Chronic Fatigue and Fibromyalgia
- Frequent Colds and Flu
- Chronic Ear and Respiratory Infections

- Vaginal and Genital Infections
- Crohn's Disease
- Colitis and Inflammatory Bowel Diseases

The main component in Primal Defense™ is the HSOs™, which have been used for over 22 years by thousands of nutritionally aware medical doctors and health care practitioners. The naturally occurring colony arrays of probiotics are non-mutated from the original cultures found in unpolluted soil and plants. They are now cultured in U.S. laboratories using the discoverer's proprietary methods. The HSOs™ are in a carrier of rich superfoods providing vitamins, minerals, trace elements, enzymes and proteins. The probiotics are then made dormant using the Microflora Delivery System™, which protects the probiotics and delivers them directly to the GI tract where they multiply and flourish.

How do HSOs™ Work?

The microorganisms move through the stomach to the intestinal tract where they form colonies along the intestinal walls. They multiply in the intestines and actually compete with harmful bacteria and yeasts for receptor sites, crowding out the pathogens and taking up residence. Once established, the organisms quickly begin producing the proper intestinal ecology to absorb nutrients and help to re-establish the proper pH. According to early research and anecdotal evidence, the following is a summary of the actions of HSOs™.

- **They work from the inside of the intestines** dislodging accumulated decay on the walls and assisting to loosen waste.

- **They break down hydrocarbons**, a unique ability to split food into its most basic elements allowing almost total absorption in the digestive system. This increases overall nutrition and enhances cellular development and repair.
- **They produce specific protein** that act as antigens, encouraging the immune system to produce huge pools of un-coded antibodies. This increased production of antibodies may significantly boost the body's ability to ward off diseases.
- **They are very aggressive against pathological molds**, yeasts, fungi, bacteria, parasites and viruses.
- **They work in symbiosis** (meaning "in harmony") with somatic tissue and organ cells to metabolize proteins and eliminate toxic waste.
- **They stimulate the body to produce natural alpha-interferon**, a potent immune system enhancer and an inhibitor of viruses.
- **They provide critical Lactoferrin** supplementation. The microbes produce lactoferrin as a by-product of their metabolism. Lactoferrin is an iron binding protein essential for retrieving iron from foods.

The Difference Between Primal Defense™ and Other *Pro*biotics:

Most **pro**biotics supplements have a difficult time implanting in colons that are pH imbalanced or have too many harmful bacteria, even if they manage to get through the destructive stomach acids. HSOs™ are designed to implant in any colonic environment, even in cases of extremely

toxic, and unbalanced intestinal ecology. The Microflora Delivery System™ makes sure that the probiotics colonize throughout the digestive tract where they can work their "magic." A special process allows the bacteria to thrive on their long journey through the GI tract. Many **pro**biotics have included fructooligosaccharides (FOS) in their product. FOS is an indigestible sugar that may cause digestive disturbances in many individuals, especially those with leaky gut syndrome and acute food sensitivities. This product contains *no* FOS.

Other **pro**biotic products contain live cultures, therefore, making them temperature and age sensitive and requiring refrigeration. If room temperature can begin to degrade these products, imagine what the warm human body does to them. These HSOs™ are dormant in a caplet and are activated by fluids. They require NO refrigeration. In addition, they are designed to resist heat, cold, stomach acid, chlorine, fluorine, ascorbic acid and bile.

The efficacy of a **pro**biotic should be based upon the ability of the product to "ferment" foods. If you'd like to test the viability of a **pro**biotic product, simply drop a few caplets in 2-4 ounces of milk and leave at room temperature for 24-48 hours. If the **pro**biotic is viable, the milk will change to a thick yogurt-like consistency. This measures the ability of a **pro**biotic to produce enzymes and break down or pre-digest food. If a **pro**biotic cannot pass this simple test, do you think it will be capable of doing an effective job of implanting beneficial bacteria in your body? We tested over 12 **pro**biotic products at our health and research cen-

ter, *Primal Defense*™ has met, or exceeded, all our testing criteria.

Defining Probiotics

The term probiotics refers to lactobacteria and other bacteria that help the host, you, by promoting health. Probiotics are generally known as naturally occurring live enzymes that re-colonize our intestinal ecology such as lactobacilius, acidopholus, bifidus etc.

Most people have heard of acidophilus; probiotics recommended as supplementation by nutritionally aware medical doctors and natural health practitioners. They are especially recommended after a course of antibiotics or a bout with diarrhea, to re-establish the "friendly" bacteria in the intestinal tract. "Acidophilus" is used as a generic term for all lactobacteria, however, it is technically the beneficial bacteriu, Lactobacillus acidophilus, that is the most recognized species.

According to *Mosby's Medical & Nursing Dictionary*, "*Lactobaccillus* means any one of a group of nonpathogenic, Gram-positive, rod-shaped bacteria that produce lactic acid from carbohydrate." *Bifidobacteria* belong to the Actinomycetales subbranch of Gram-positive bacteria. These and the other bacteria that produce lactic acid are considered the beneficial bacteria.

Primal Defense™ is an adjunct therapy product to detoxifying fiber colon products. It provides probiotics and beneficial HSOs™, working together to loosen the encrusted, decayed material in the walls of the colon, preparing the terrain for the fibers to be swept away.

In many of my clients sensitive to psyllium based fiber products, they simply cannot tolerate any fiber composition for colon detoxifying; Primal Defense™ has enabled them to restore good elimination and reduction of symptoms from excessive yeast and food sensitivities. In victims of multiple chemical sensitivities or leaky gut syndrome, as I was, I recommend you start out with maybe half a caplet daily on an empty stomach. After a few days, increase to 1 caplet morning and evening, as tolerated. The goal should be to take two caplets three times a day, always on an empty stomach—this maximum therapy has been an invaluable asset in my personal healing. If at any time, you experience any discomfort or adverse reactions, discontinue and consult with a nutritionally aware health professional.

As a preventive measure and insurance policy for good health, I continue to take two to three caplets daily. It's especially convenient for persons like myself who travel extensively, because I can keep it in my luggage without concern as to stability in temperature variations.

Candida—"The Slow-Poisoning Fungus"

Candida overgrowth in your intestines is one of the major factors of a condition called "leaky gut;" another is damage from prescription drugs. The resulting inflammation of the intestinal wall allows substances to permeate the protective lining of the gut. When this delicate lining becomes damaged, toxins and food particles pass easily through the membrane and overburden the entire system. You may obtain a complete description and illustrations of leaky gut

syndrome in my book *I was Poisoned by my body*. It contains the story of my personal odyssey with leaky gut and the resulting fibromyalgia, chronic fatigue and multiple chemical sensitivities. It also takes you step by step through the drug-free therapy routine that facilitated my healing, naturally.

As shown in the microscope photograph of yeast on page 23, the *Candida* fungus has the ability to completely change in the gut from a single-cell yeast into a branching fungal form, able to burrow beneath the surfaces of the mucous membranes.

This fungus is extremely self-serving—it makes its victims crave what feeds it (carbohydrates and sugars), and leaves its bi-products for the host, *you*. I have *never* had a case in my practice of food or environmental allergies, leaky gut syndrome, fibromyalgia, chronic fatigue, psoriasis, eczema, ADHD, irritable bowel, chronic sinusitis, rheumatoid arthritis, lupus or reoccurring infections that does not have excessive yeast as a contributing cause. The existence of excessive yeast has been verified scientifically by such techniques as live cell blood microscopy.

Yeast can be eliminated in practice by implementing dietary changes to "starve" the yeast and by natural therapies, such as supplemental colon cleansing fibers and colon hydrotherapy, to cleanse and support good intestinal health. I'm not inferring that yeast is the only cause of all the described disorders, however, it is most definitely at least a huge contributing factor that inhibits the healing process. Specific dietary and supplementation guidelines for "killing" the "fungus among us" are discussed in the section "Diet and Nutrition."

THE LIVER: YOUR LIFE FORCE

The word "liver" comes from an old English word meaning "for life." The Chinese call the liver "the father of all organs," and the Russians practice a common greeting interrupted to mean "How's your liver today?" Liver is truly our life force and it's the ONLY organ that can regenerate itself when damaged. It is also ONLY the liver that purifies the bloodstream. The liver is the largest organ of the body, located just above the stomach under the diaphragm.

The liver's job is to constantly accumulate and distribute blood. It circulates about 1.5 liters of blood per minute, and 70% of this blood flow arrives from the portal vein. Waste products and toxins from the colon, not properly detoxified by the liver, can go on to affect all body tissues and organs.

Anatomy books clearly state that both nutrients *and* waste products are carried into the liver from the hepatic portal vein along with various toxic substances harmful to the tissues of the body. This illustrates how the health or toxicity of the colon affects the condition of the blood. Just because you're not having specific liver symptoms, doesn't mean you shouldn't practice preventive liver and colon detoxification and support. Toxins can escape across the colon's mucosal walls, all of which need to be detoxified by the liver, presuming it is not already overloaded.

The main source of pollution in our body systems *is* the colon. If intestinal putrefaction is excessive, or if the liver is overworked or damaged, toxic by-products enter general circulation and produce the condition known as autointoxication (self-poisoning).

In modern civilization, we are exposed to higher levels of toxins from all arenas; cleaning agents, prescription drugs, petrochemicals, personal care products, food additives and preservatives, pesticides, herbicides and many products containing formaldehyde. It is vital to life, or at least quality of life, to maintain a healthy liver in order to process/neutralize toxic substances. The liver's job is to remove toxic substances from the blood and store them in its own cells until it is capable of dumping them into the lymphatic system for eventual elimination. However, for the liver to perform its important detoxifying duties, it must not be over-burdened with existing toxins. When the level of toxins being "dumped" into the liver exceeds its ability to process, it will begin re-absorbing them into circulation or attempt to hold-on to the toxins to keep them from re-circulating; causing symptoms of swelling, pain and even auto-intoxication.

Liver: The Allergy Connection

A toxic liver is a huge factor in allergies since one of its principle jobs is to deliver food particles from the portal blood system to the liver. The liver will then proceed to select, remove, synthesize and detoxify the final products for digestion. Any undigested foods, usually as a result of poor digestion and over-consumption of fats, will stimulate the immune system to increase histamine production. The liver produces an exceptionally effective antihistamine to neutralize an allergic response, however, if its over-burdened dealing with more toxins than it can process, histamines will build up and trigger even

more allergic responses. In most cases, individuals experiencing an allergic symptom assume antihistamines (prescription or over-the-counter) are the preferred course of therapy. However, antihistamines can cause more liver damage, further decreasing the livers ability to handle histamines—causing more allergic responses.

Your Biological Clock *Is Not* Your Age

Did you know your liver has the ability to tell time? Yes, inside of you is a biological clock programmed by its creator to operate with the precision of a Swiss clock. Every morning, at approximately 2 am, it begins its task of sorting out nutrients received from its last meal. If you eat an exceptionally fatty dinner, your liver will have to continue its job way into mid morning hours, requiring extra work for a job that could be simplified by eating a light, easy to digest dinner. Is it any wonder we're exhausted in the morning and proclaim that we're "not morning people?"

Natural Liver Cleansing

It's interesting to note that we understand our vehicles and equipment need to be serviced and cleaned, yet our most important organ for maintaining the body, the liver, gets very little, if any, maintenance.

Liver Facts:

- It performs at least 650 different functions
- Spread out, end-to-end, it would cover the surface of a tennis court
- It is the largest organ in the body
- It filters toxins, bacteria, and chemicals for elimination

- Depressed liver detoxification has been connected to brain chemical disturbances, chronic fatigue, multiple chemical sensitivities/intolerance, chronic yeast infections, and multiple allergies
- It is the *only* organ that can purify the bloodstream
- The liver is the "nutrient delivery system" for every cell, muscle, brain, tissue, organs, glands, hair, nails
- It's the only organ that can regenerate even if 80% destroyed, given the necessary detoxification and support
- It's a "fat burning" machine that moves excess fat through bile and into the small intestines
- It gets twenty percent of your blood
- It only weighs about four pounds

Just as you would normally do "spring and holiday winter cleaning," the liver needs to have a bi-annual cleaning. The time frame I recommend is early spring (Feb) and early fall (Aug). If these cleansing times are adhered to, you can cleanse the liver, your organ of detoxification, *before* the allergy season in the spring and *before* flu season in the fall. Some of my clients have waited until September to do their cleanses at the start of the school year. Experience in my practice has shown that this schedule *does not* provide the same level of protection, perhaps because flu type viruses/bacteria generally initiate with the commencement of school.

It is not advisable to do any sort of liver cleansing if you haven't addressed colon health. If you perform any type of liver detoxifying cleanse with a

toxic bowel, you will add to the liver's already toxic over-load, guaranteeing a "healing crisis"(flu-like symptoms) from an increased toxic load.

Foods That Detoxify and Support

- Organic green leafy beet tops (cut into salads, steamed just like spinach, or stir-fried) [tonic]
- Fresh squeezed warm lemon water first thing in the morning [tonic]
- Organic beets (juiced, steamed) [cleansing]
- Radish [stimulant]
- Carrot, cabbage, celery, spinach [tonic]
- Wheatgrass Juice [blood cleanser] (See chapter "Your Personal Surveillance System: Win The Battle and The War on Disease")

Help From "Bitter Herb"

Ancient civilizations have long used bitter herbs for liver cleansing. Peoples in climates with long, cold winters harvest wild herbs in the spring such as dandelion greens, endive, artichoke, onion, garlic, radicchio and lettuce, which they dry for use later in the year. These cultures understand that all bitter herbs aid liver function and secretion of bile. The unfortunate consequence of our modern society is that our cultivated herbs have been bred through hybridizing, therefore the "bitters" have been depleted by breeding. An excellent example of devoid, hybrid foods is iceberg lettuce; it has a long shelf life, but is almost completely devoid of nutrients. I've found in my practice, and through personal experience, that people with the invisible illnesses, cannot digest iceberg lettuce. In most cases of digestive or gastroin-

testinal conditions, iceberg lettuce produces abdominal gas, cramping, heartburn and even diarrhea. The following is a list of bitter herbs that are specific for cleansing the liver:

- Equal parts of fennel, anise, and fenugreek: [Use as a tea for a cleansing tonic]
- Goldenseal, milk thistle, wormwood and rue: [This combination works synergistically for cleansing]
- Milk Thistle (*Silybum marianum*): [Herb of choice to detoxify, heal and regenerate the liver], be sure it is at least 70 percent potency. Especially indicated if pain extends up and under right shoulder blade
- Berberine-Containing Plants: goldenseal (*Hydrastic Canadensis*), Oregon grape root (*Berberis aquifolium*), and barberry (*Berberis vulgaris*). [These herbs have been used for centuries to treat afflictions of the liver. There benefits include: increased secretion of bile, reduction of generalized inflammation, aids gallbladder inflammation, balances liver metabolic imbalances].
- Dandelion (*Taraxacum officinale*): [Detoxifies the entire system, including the liver. Also induces flow of bile from liver and improves digestion. Used for centuries by European, South American and Indian herbalist to treat liver diseases].
- Picrorrhiza (*Picrorrhiza kurroa*): [An Indian herb used for centuries in Ayurvedic medicine for liver disease and immune disorders. Many tests have shown it comparable or superior to silymarin, the active ingredient in milk thistle].

The Swedish have known for centuries the benefits of bitters; the famous Swedish bitters, a combination of eleven herbs—available at health food stores. Using bitter herbs as part of your liver cleansing and maintenance routine is truly the essence of a preventive program for liver health.

Therapeutic Support and Detox

As a health care provider, and victim of compromised liver function, I am always interested in products that provide detoxification and support for this vital organ. One such product is BioCleanse®. This product serves as a medical food and can be mixed with water or any tolerated beverage. It is designed to assist your body in ridding itself of toxins, both metabolic and xenobiotic (environmental). These toxins may be your own metabolic waste, or environmental toxins such as, heavy metals, pesticides, herbicides, solvents, drug residues, etc. Bio Cleanse® medical food powder is designed to remove toxins from your nervous system, connective and fatty tissues.

FYI—The next time you feel morning sluggishness, especially after a heavy dinner and over-indulgence of rich foods, unusual fatigue or achiness, consider making a tea of bitter herbs to assist your liver—a kind of "morning-after" potion.

If the taste of bitter herbs is too hard to handle, add ginger, fennel seed, cinnamon or peppermint, which adds flavor and aids in digestion. NOTE: Do not use peppermint, or an herb from the mint genus, if using homeopathic medicine—it will negate the effectiveness.

After removal of accumulated toxins, BioCleanse® assists the liver in neutralizing and removing the toxins from the body. It does this by assisting the livers detoxification pathways. These pathways are

called Phase 1 and Phase 2. In other words, BioCleanse® helps the liver convert an insoluble toxin (difficult to remove from the body), into a soluble toxin (more easily removed).

The whole therapy routine is smooth and relatively easy to accomplish because it can be used as a meal replacement. It contains balanced proportions of protein, carbohydrate and fats to help keep your blood sugar level and energy up! Each serving contains 170 calories, 12 grams complex carbohydrates and 5 grams single, 14 grams protein, 5.5 grams fat and 0 cholesterol. It contains nutrients, backed by science, for detoxification support.

BioCleanse® also comes in capsules, for those who simply do not wish to use a medical food powder. This may be a good option for those traveling and carrying a large medical food container is not practical. In specific circumstances of extreme liver damage, your health care provider may suggest using capsules and medical food powder for an initial short period of therapy. The capsules provide a more intense cleansing because the ingredients added to the powder to make it palatable are not present. However, in highly sensitive individuals, and those whose dietary intake can be enhanced by the addition of a medical food, the powder is best.

What Makes This Medical Food Unique?

Biologically Active verses Biologically Inactive "B" Vitamins—B vitamins, in their biologically *active* forms are taken up and used "as is" by the cells of the body. They place no burden on the liver to phosphorylate them (take up) or on the kidneys to

eliminate them. In contrast, biologically *inactive* B vitamins must go through an activation process that takes place in the liver. Unfortunately, most products supply their B vitamins in the *inactive* form. These are rapidly removed from the blood stream by the kidneys and excreted from the body leaving little time for the liver to convert them into active forms. Biologically active B vitamins play an important part of the chemical processes, including detoxification.

Other Specialty Nutrients—BioCleanse® provides clinically relevant levels of the following:

N-acetyl L-cysteine (NAC)—This amino acid is necessary for the production of glutathione, an important antioxidant and detoxification molecule. NAC protects against lipid hydroperoxides and hydrogen peroxide.

Taurine—Assists the liver in Phase 2 detoxification by contributing to conjugation of xenobiotic compounds—essential in neutralization and clearance of toxins.

Sodium Sulfate—Provides essential sulfur for sulfation conjugation detoxification processes in the liver. Specifically vital for individuals with compromised detoxification capacity (toxic liver), who cannot convert organic sulfur (cysteine, methionine, etc.) into inorganic sulfur (sodium sulfate) efficiently.

L-cysteine and Methylsulfonylmethane (MSM)— Supply additional organic sulfur for sulfoxidation support and as a source for additional inorganic sulfur production.

Calcium D-Glucarate—Supports the process by which healthy cells eliminate waste and foreign

elements. It does this by regulating the activity of the enzyme Beta-glucuronidase. In this way it supports the cellular detoxification cleansing process.

Silymarin—Has been shown to increase glutathione and superoxide dismutase levels. It protects the liver from free radical damage and enhances repair and regeneration of liver cells.

NOTE: Minerals are critical to your health and the body's ability to properly detoxify. However, for minerals to be of any therapeutic benefit you must absorb them! Unlike many products, BioCleanse® contains only fully bonded mineral transporters. These carriers provide the highest absorption and transportation to key sites in your body where each mineral can support your cells health and detoxification capacity.

An initial typical detox program is anywhere from 30 to 90 days, depending on your level of toxicity and tolerance. This program should only be used under the direction of a qualified, knowledgeable, naturopath, integrative medical doctor or health care professional. It is available only through health care professionals and selected pharmacies. Your health care professional will provide you with a specific diet for your special needs. The diet is designed individually to enhance the detoxification process, while keeping in mind any food sensitivities and overall tolerance levels.

Incredible Facts—Your entire body has the capacity to totally rebuild itself in less than 2 years, 98% in less than 1 year. A NEW BRAIN in 1 year, NEW BLOOD in 4 months, SKELETON in 3 months, DNA in 2 months, LIVER in 6 weeks, SKIN in 1 month and STOMACH lining in 5 days!

Are You still Creating the Same Body?

BioCleanse® is free of wheat, rye, oats, barley, corn, dairy, egg and peanut. No fillers or artificial colors/flavors are ever used. It is in a rice protein base, therefore, is tolerated by most highly allergic individuals.

After the initial detoxification period, those individuals with chronic health conditions and those exposed to a toxic environment, should be advised by their health care provider about a maintenance program with BioCleanse®.

THE LUNGS: WITH EVERY BREATH YOU *DON'T* TAKE

In addition to deep breathing described in the chapter "Heath-care, Not Symptom-care, Naturally" there are several supplements that can assist in removing toxins, mucous, and assist in repairing damage to the lungs.

1 **Wheatgrass juice**—This miraculous "live food" brought to recognition by the late Ann Wigmore, founder of the Hipprocrates Institute, adds oxygen better than any other plant. Plants "inhale" carbon dioxide and "exhale" oxygen, whereas humans and animals exhale carbon dioxide and inhale oxygen—a perfect symbiotic relationship according to Wigmore. She studied the research of Dr. Hans Fischer et al, a Nobel Prize winner for his work on red blood cells. During their research, the scientists noticed that human blood, which carries oxygen to the cells, is practically identical to chlorophyll on the molecular level. In the human body, red blood cells are characterized by the oxygen-carrier, hemoglobin, which has as its central nucleus the mineral element iron. However, most green plants, like wheatgrass, are

characterized by chlorophyll, which has magnesium as its nucleus. The study showed the two molecules are strikingly similar in makeup.

Many respiratory infections are caused in part by anaerobic bacteria than cannot live in the presence of oxygen or oxygen-producing agents such as chlorophyll. Wheatgrass juice de-activates these anaerobic bacteria and promotes regeneration of the damaged area. Wheatgrass juice is a good source of iron, a mineral essential for red blood cell formation and the transport of oxygen from the lungs to the cells.

2 **Mullein capsules**—contains beneficial mucilage. It acts as a magnet by attracting excessive mucous, and as an expectorant. It soothes inflammation hence facilitating ease of breathing. If mullein capsules are taken at the first sign of bronchial congestion or build-up of phlegm, the condition can be easily corrected before it escalates into an infection. In my practice, I have found that mullein oil or tea *does not* have the same expectorant properties. The usual dose is one to two capsules taken 3 to 4 times daily until congestion ceases. For children, it's best to open a capsule and disguise its flavor and consistency in a nut butter, juice or smoothie. I've had clients who were victims of viral pneumonia that traditional antibiotics could *not* help. Within 48 hours of taking mullein capsules, mucous was expelled, providing them relief from chronic coughing, chest pain and essentially all symptoms of pneumonia.

THE KIDNEYS: YOUR OTHER FILTERING SYSTEM

If you're the typical North American, you not only consume extraordinary amounts of salt (sodium chloride), but also salty foods like potato chips, corned beef, luncheon meats, bacon, salted nuts etc. Is it any wonder that heart disease is the No. 1 killer in North America? The only other country that exceeds North America in salt consumption is Japan. The Japanese are known to be the world's highest consumers of table salt. A Japanese farmer who lives to age 60 eats approximately 2 ounces of salt every day, and filters up to 2,735.5 pounds or 1.36 tons of salt through his kidneys in his lifetime! This type of excessive salt intake is equivalent to writing one's death sentence, or at least reducing ones life span.

Kidney disorders are on the rise in most industrialized countries, and salt intake is mainly to blame. There are third world countries that have traditionally not consumed salt, and their rate of heart and kidney disease is extremely low, as is the incidence of inflammatory disorders like arthritis.

The liver and kidneys are both filters for the blood. They distinguish between unwanted toxins and needed nutrients. The kidneys conserve water and balance electrolytes by re-absorbing the exact amounts required and sending the excess out through the urinary tract. If you consume too much salt, the body's tissues retain excess water and cause swelling of the extremities, not to mention the stress on the kidneys themselves. However, according to Dr Batmanghelidi, researcher in the health benefits of water, patients

should keep in mind that loss of salt with increased water consumption without sufficient salt intake can result in muscle cramps at night; an indication you are becoming salt-deficient.

The following are recommendations for cleansing and supporting kidney function:

1 If you are not accustomed to drinking at least 8 glasses of filtered or spring water a day, start doing so, but at a slow steady pace. Begin by adding one to two glasses a day to your normal intake. The ultimate goal is to increase your water consumption to half of your body weight in ounces. Example: If you weigh 150 lbs. you would ultimately consume 75 oz. of water daily. Do not attempt to increase your water intake to half of your body weight in ounces in the first week. If you suffer from hypertension or any disorder of the kidneys or bladder, check with your health care professional before exceeding 8 glasses daily. Keep in mind; if you are loosing excessive body fluids from perspiration, your water intake must increase along with supplementation of minerals and electrolytes.

2 Parsley has been used for centuries as a purifying herb for the kidneys. It is best taken as a tea. Bring water to a full roaring boil, add a handful of organic parsley (stems and flowers), remove from heat and steep for 5 minutes. Drink several cups per day, hot or cold.

3 The normal color of urine should be colorless or light yellow. The urine should never be dark yellow, dark brownish yellow or orange. If this occurs, the body is attempting to rid itself of accumulated toxins,

from whatever source, even excessive vitamin consumption that it cannot assimilate. If you experience any of the abnormal urine colors, it's a good indication the body is dehydrated; increase your water intake immediately.

4 If you've experienced the symptoms of kidney stones, you'll benefit from drinking one quart of marshmallow tea daily. It strengthens the kidneys and bladder by cleansing and assists in expelling kidney stones.

5 Diets high in animal protein cause the body to lose calcium, and when this is excreted, it passes through the kidneys and can cause painful kidney stones. The liver and kidneys break down protein, therefore, an accumulation of protein can result in uremia, a toxic condition caused by the build-up of protein waste. Stay on a diet of low animal-protein for best kidney health.

6 If you're experiencing bladder infections, drink three glasses of *unsweetened* cranberry juice daily until all symptoms are gone, then continue for an additional 3 days. Cranberry juice inhibits the growth of bacteria by acidifying the urine. You may also use concentrated cranberry capsules, however, be sure to consume plenty of water. Those that experience allergic reactions should use extra caution in adding cranberries to their diet. Test your tolerance. You may need to literally place 1 tsp. of juice in a full glass of water and check for allergic reactions. If taking capsules, open the capsule and sprinkle a small amount of the contents onto a known tolerated food such as applesauce or milk alternative (rice, soy or nut).

7 If you have a history of kidney stones, avoid the amino acid L-cystine; it builds up and can crystallize in the kidneys and form large stones.

8 If you experience water retention (edema) and *do not h*ave sensitivity to watermelon, it can act as a natural diuretic. NOTE: You must eat watermelon alone, not with any other food. When it's eaten alone it has a cleansing effect; when it's consumed with other foods it will sour and become toxic.

THE SKIN: YOUR LARGEST ORGAN OF ELIMINATION

Methods of Detoxifying the Skin

- **Detox baths**—Mix $1/2$ cup of Epsom Salts and Dead Sea Salts. Dry skin brush before your bath.
- **Dry sauna**—Increases number of leukocytes in the blood, strengthens immune system, therapeutic sweat to flush out toxins. Generally 30 to 40 minutes is needed for maximum benefit. Use **caution** if you have MCSS/EI, as many times heat cannot be tolerated until the liver has been successfully cleansed.
- **Steam baths**—Works quicker than a sauna, cleansing the body in about 15 minutes. Only use steam under the supervision and guidance of your health care professional.
- **Thalassotherap**y—An ancient Greek term for the sea, this method of therapy includes: sea-

Did You Know?

▶ *The skin is the largest organ of elimination*

▶ *It plays a major role in ridding your body of toxins and impurities*

▶ *The skin eliminates over one pound of waste per day*

▶ *The skin excretes bodily toxins and poisons, as do the kidneys and bowels*

weed body wraps, seaweed facials, inhaling sea-water, and hydrotherapy sea water pools. Seawater and seaweed have exceptional cleansing and health restoring properties.

- **Alternating Hot and Cold Hydrotherapy**—The benefits include: increased lymph drainage, increased metabolic activity, tones muscles, relaxes the bowel and bladder, improves blood flow and is a natural energy booster. Use alternating showers of hot and cold for three-minute intervals.

- **Baking-soda bath**—Use one cup per bathtub. The benefits include: alkalizes an over-acidic body, promotes relaxing sleep, reduces stress, and assists in detoxification from over-medication or allergic reactions.

THE LYMPHATIC SYSTEM: MEDICINES "LOST CHILD"—A THERAPISTS VIEW

*by Beata Golau, LMT
Specialist/Instructor—Lymphatic Massage
Instructor—Medical Assistant
Instructor—Structural Alignment
Cranial Sacral Therapist*

Historical Perspective

The lymph system has only recently received the attention is so deserves. The word "lymph" is said to have come from the word "limpa," meaning limpid, or transparent. It was largely unrecognized by the medical community until the 17th century, when Gasparo Aselli, an Italian physician, discovered the "milky veins" in a dog after dissection. Olauf Rudbeck, a Swedish scientist, was the first man to

be recognized for his discovery of the lymphatic system as a complete and specific system in the human body, comparable to the venous circulatory systems.

A surgeon from Belgium, Alexander de Winiwarter, introduced hospitals to the use of manual techniques for draining lymphatic edemas (swellings). Another of his contributions was the use of heavy manual techniques for lymphedema, as well as modalities of skin care, hygiene and bandaging. Crediting Dr. de Winiwarter for initiating manual lymph techniques is appropriate, however, most lymph techniques taught today use a much lighter pressure due to the now recognized delicate nature of the lymph system.

In the early 1900's a group of osteopaths became the fathers of many important healing modalities used today. Among those was William G. Sutherland, founder of cranial osteopathy (cranial sacral work), and Frederic P. Millard, an osteopath from Toronto who in 1922 published *Applied Anatomy of the Lymphatics,* one of the first great works on the specific mechanics of the lymph system.

Estrid Vodder, a Danish massage practitioner and doctor of philosophy, and his wife Estrid, developed the precise manual technique for lymph drainage (MLD) between 1932 and 1936 while in the South of France. However, they were unable to publish their findings until forty years later because the scientific world was not yet ready and would not accept their hypotheses and empirical evidence.

In 1967, the German physician, Johannes Asdonk, M.D., established the medical effects, indi-

cations/contraindications of the lymph drainage technique in a clinical test of 20,000 patients.

Today, European medical doctors, hospitals and insurance companies use and recognize lymph drainage as a valuable therapy. Fortunately in the U.S., a few hospitals are now incorporating lymph drainage massage, most particularly post-operatively. It is interesting to note that the study, and acknowledgement of the importance of the lymph system, *did not* go much beyond the early 1900's in the U.S. A.G. Walmsley, an osteopath and medical editor, speaks of this in his editorial preface in *Applied Anatomy of the Lymphatics* in the following quote:

> The attitude of the average physician toward the subject of lymphatics is one of aloofness. It is too intricate for him; it would require more study than he could afford to devote to it, he thinks. Now, this is not so; it only SEEMS so.
>
> The past few years have witnessed what might also be termed a revival of faith or belief in the principles on which the science of osteopathy is founded. There were those who faltered, who were carried away by the siren call of other systems, especially the drug system.

Lymph Characteristics

First there are pre-lymphatic pathways which are unorganized pathways or canals in the intercellular environment (connective tissue). These spaces have the function of transporting proteins from the bloodstream quickly to the lymph capillaries. Next are the lymph capillaries that begin in the connective tissue like the fingers of a glove. Unlike the pre-lymphatic

pathway, lymph capillaries are enclosed and highly organized. These fragile vessels have no valves and form a spider net covering-over most of the body organs. Physiology text teaches that lymph circulation is a one-way transport system as opposed to the closed loop circulation of the venous system. Once the pre-lymphatic liquid leaves the interstitial spaces and enters the lymph capillary it is called lymph. From the capillaries, lymph travels to larger vessels that possess valves and eventually reach larger vessels called collectors. These collectors have valves and muscles and carry the lymph fluid to the lymph nodes.

The lymph nodes are small round glands placed strategically in the body and linked to the immune system. The average human body has 400-700 nodes, about half of which are located in the abdomen. The main areas where nodes are concentrated are the head/neck, axillary (under the arms), thoracic duct/cysterna chyli, groin, ankles, behind the knees and, of course, abdomen.

The lymph nodes filter and purify the lymph fluid, capture and destroy toxins, concentrate the lymph and reabsorb about 40% of the liquids present in the node. These nodes also produce leucocytes that, by the way, increase when the flow of lymph is increased thus supporting the importance of lymph drainage and massage. Nodes are also part of the lymphoid organs—organs that determine *self* from *non-self* (*foreign substances*). Nodes also transport this most important fluid to the lymph trunks, ducts and terminal lymphatic pathways, the largest lymph collectors. The thoracic duct (10-18 inches in length) is the main one of these col-

lectors, residing directly behind the breastbone (sternum). Located at the lower end of the thoracic duct is a reservoir, the cysterna chyli.

As we know, water is the most abundant element in living beings. Sixty percent of average total body weight is water. Forty percent is divided into two areas, water that's inside ourselves and twenty percent that's outside the cell compartment (between cells). Of that, twenty percent is blood, lymph and interstitial fluid (fluid in the spaces of connective tissue). In other words, lymph constitutes fifteen percent of our total body fluid.

One convenient way of looking at how lymphatic massage works for the lymph system is to observe Starling's theory of fluid equilibrium. This English physiologist likened the fluid balance in the body to a full bathtub. We have fluid balance in the tub when in-flow and outflow are equal. The contents of the tub represents our connective tissue. If the drain clogs

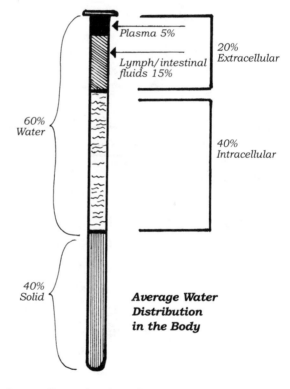

Plasma 5%

Lymph/intestinal fluids 15%

20% Extracellular

40% Intracellular

60% Water

40% Solid

Average Water Distribution in the Body

from overload of fat cells from diet, dead cells, excessive intake of animal protein, or more water is going into the tub than the drain can handle, (lack of exercise/movement, congestive heart failure,

compromised kidney function) edema (swelling/fluid retention) results—the lymph system not able to process the load put upon it by the connective tissue. The following diagram illustrates this theory.

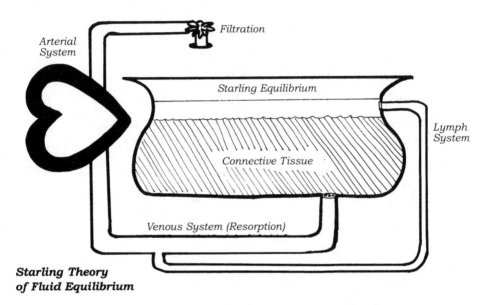

**Starling Theory
of Fluid Equilibrium**

What to Expect During
a Lymph Drainage Massage

This bodywork technique is used with great sensitivity, is soothing and gentle and in *no way* should feel invasive. The Lauren Berry method of lymph drainage is the one I most often use, incorporating the Vodder technique as well as the Bruno Chikly method.

The basic objective is to work from the center of the body out, creating a space for lymph to flow. Since the colon is the last organ of elimination, it is the starting point. Using specific hand movements (cats paw—an undulating movement) and light pressure the direction is always clockwise, up the

ascending colon, across the transverse colon, and down the descending colon. Special attention is paid to the "plumbers corner" in the descending colon, where fecal matter can accumulate and inhibit elimination.

With gentle, circular pumping action the axillary (under arm) nodes are stimulated to facilitate further drainage later in the session. Nodes in the intercostals (between ribs), groin, neck and clavicle are massaged in the same manner. The left side of the lower abdomen, for reasons not yet understood, accumulates a large amount of lymph fluid, therefore it is progressively "stroked" to facilitate drainage.

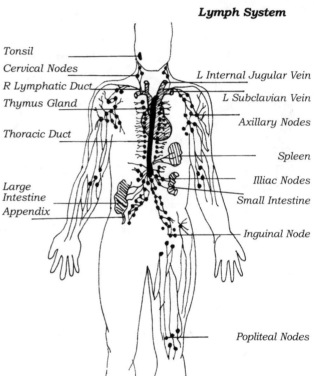

Lymph System

Tonsil

Cervical Nodes

R Lymphatic Duct

Thymus Gland

Thoracic Duct

Large Intestine

Appendix

L Internal Jugular Vein

L Subclavian Vein

Axillary Nodes

Spleen

Illiac Nodes

Small Intestine

Inguinal Node

Popliteal Nodes

Lastly, but surely not less important, is the massage for the periphery of the body, namely the extremities. Once again, it is imperative to work from the center of the body out, taking lymph *to the nodes* **never** through the nodes. This work can never be too slow, giving lymph nodes all the time they need to process the fluid.

The above illustration shows concentration of main lymph node areas.

THE "IGNORED" SECONDARY
CIRCULATORY SYSTEM

The lymph system is closely related to the cardio-vascular system, although its major function is as a defense mechanism. It filters disease-causing organisms, manufactures white blood cells, and generates antibodies. Without the lymph system the body cannot exist, however, it is misunderstood, abused, and its complex work is not widely understood.

Your body tissues are bathed in lymph, a colorless, watery fluid containing lymphocytes, a type of white blood cell. Lymph fluid seeps through capillary walls to fill tissue spaces with its clear and watery substance.

These cells assist the body in fighting infection and other diseases such as cancer. The lymph travels along tiny channels called lymph vessels or lymphatics, which, like blood vessels, join together to form larger channels. Eventually the lymph is filtered through a number of lymph nodes before going into the bloodstream.

Lymph nodes, or glands as they are frequently referred to, are situated throughout your body. They are made up of a round fibrous capsule containing lymphocytes of various sizes—some being as small as a pinhead, others about the size of a baked bean. They also vary in number—in some parts of the body just a few are present, other areas, as in your armpit, there are generally 30-50 small nodes.

The main job of the lymphatic system and nodes is to collect and filter-out, through the bloodstream, any matter that the body's cells do not

want or recognize, such as bacteria and other infectious organisms and "invaders" like cancer cells. These are then carried in the lymph through the nodes, where the lymphocytes will generally attack and break them down before they are carried away by the bloodstream and filtered out along with other body waste.

If the lymph nodes trap an infection or abnormal cell (cancer), they will usually swell. With infection, the swollen nodes are usually hot, painful and tender to touch. With cancer cells, however, the nodes are often painless and do not cause any discomfort when touched. The fact that this type of cancer is generally painless is of great concern. If you experience *any* swollen node that is painless, be sure to see your physician—it may not be cancer, but you cannot afford to be complacent about it. When a node swells as a result of cancer, it is because the cancer cells trapped by its "filter system" continue to divide and produce new cells within the node. The cancer can originate in the lymph glands themselves (lymphomas) or they may be cancer cells that spread from other sites (breast, lung, bowel, etc.).

Also, as part of the lymph's job description, is the responsibility for distribution of fluid and nutrients to drain excess fluids and protein left behind by capillary circulation. Without this function, tissues would swell with excessive fluid buildup. Swelling and fluid build-up most commonly exists in patients with fibromyalgia and myalgic type inflammatory disorders. In conventional medicine, instead of gently "moving" the accumulated fluids

through lymphatic massage, anti-inflammatory medications are often prescribed. However, when the lymph is gently guided to the "node transfer stations" the body is enabled in its elimination of excess fluids *without* the aid of medications.

The lymph system includes: lymphatic capillaries, large vessels, lymph nodes (processing stations), glands, spleen, tonsils, and thymus. Lymph vessels are more numerous than blood vessels—the inner excretory mechanism of the body, four times larger than the blood system. It provides the vital function of waste disposal for each individual cell. Substances resulting from cellular metabolism are extruded from the cell and removed through the lymph; however, lymph is designed to handle only cell wastes. If blood is also "dumping" waste toxins from the intestinal tract into the lymph system the lymph becomes overworked and its filtering/neutralizing function is decreased.

Unlike the blood system that uses the heart as a pump, the lymph system, like veins, relies on skeletal muscle contractions to pump the lymph along.

For illustrations and an in depth discussion of the importance of lymph drainage massage, refer to my book *I was Poisoned by my body* (Lucky Press, 2001).

Methods of Stimulating Lymph Flow

- **Lymphatic Drainage Massage**—Should be performed by a trained professional. This massage technique should always be "gentle" in nature, never a deep tissue type of therapy.
- **Physical Exercise**—Valves of the lymph system transport waste-filled fluids for flushing and fil-

tering; exercise is a vital part of moving lymph flow. Lymph has no pump, as does the heart, therefore physical exercise or massage must take place to induce lymph circulation.

- **Dry Skin Brushing**—Use a *dry* natural bristle brush and brush starting at the extremities towards the center of the body—brushing only in *one* direction. This action allows lymph to move and be transported to the organs of elimination. Dry brushing is advised before your bath or shower and at bedtime. *Never* use a brush that has also been used wet.

- **Mini-trampoline Jogger**—This form of exercise is superior for stimulating lymph flow because of its pulling and circulation stimulating action. Lymph flow is accomplished when the larger body muscles contract with exercise and lymph vessels are squeezed. Start out slowly, two to five minutes, once or twice a day; increase up to ten minutes as tolerated.

Herbs That Support
Lymphatic Detoxification

- **Burdock** (*Artium lappa*)—Historically this herb has been used as a purifier for the blood, liver and lymphatic system. It is very helpful in purifying the system when skin disorders are manifesting from the toxicity.

- **Ginseng** (*Panax ginseng*)—This is also referred to as Korean or Chinese ginseng. It aids detoxification by helping the body remove toxins and debris from circulation and protects the liver from chemical damage.

- **Gravel root** (*Galium aparine*)—This herb has been used for centuries for its unique ability to "flush" toxins from the lymph system. It should be used during any liver cleansing routine as well as periodically to keep the lymph system clean and easy flowing. Note: This herb is *not* recommended if you have been diagnosed with hypotension, as it may lower blood pressure.

The "Gut" Has a Mind of Its Own—Literally!

YOU HAVE MORE "BRAINS" THAN YOU REALIZE: BIG BRAIN AND LITTLE BRAIN

The anatomy of our gut can be likened to that of a computer; they both contain internal operating systems or "brains." The miniature computer-like processing system in our gut contains an excess of 100 million nerves; more that those in the spinal cord.

The gut consists of layers of padding (much like the layers of an onion) harboring multitudes of hidden "toxic by-products", as well as an internal brain equipped with hidden cellular memory capable of being self-sufficient. The study of this new form of science is called "neurogastroenterology;" the nine-syllable word for the study of the nerves entrenched in the lining of the esophagus, stomach, small and large intestine (colon).

According to Jackie Wood, a neurobiologist at Ohio State University, "What Mother Nature did, rather than packing all of those neurons in the big brain in the skull and sending long communication lines to the gut, is distribute a microcomputer, the 'little brain,' right along with the gut."

Dr. Paul Trendelenburg, a German scientist and pharmacology in 1917, proved that within the multi-layers of the gut is a self-contained, self-regulating nervous system capable of functioning *independent* of the brain or the spinal cord. In other words, the gut has a mind of it's own, therefore it can be said, "you have more brains than you realize."

Scientists have now indeed dug into the hidden and miraculous functions of the gut, and have uncovered the "little brain"—as it's known to experts of this new science. "You have a lot of guts" takes on a new meaning as we discover the little brain is able to run itself, independent, without instructions, from the big brain.

The "little brain" (in your gut), although capable of running itself, stays in close contact with the "big brain" (in your head) via 1,000 or more nerve fibers.

The physician credited for the re-discovery of this science is Dr. Michael Gershon. He clearly states, "Neurogastroenterology began when the first investigators determined that there really is a second brain in the bowel. I have made discoveries in my scientific career, but the basic principles on which my work is based are about to celebrate their one-hundredth anniversary. Rediscovery is every bit as good as discovery, if what is rediscovered is important and was forgotten. It is better still when the rediscovered information has the capacity to improve the lives of those around us." In 1917 Paul Trendelenburg performed the experiment that validated what his scientific forefathers had suspected for years—embedded within the wall of the gut, was a self-contained, self-regulating nervous system that could function on its own.

According to Dr. Gershon, the existence of the enteric nervous system had been discovered in Germany while the Civil War was still raging in America. Working with a primitive optical microscope, a German scientist by the name of Auerbach had found that the bowel contains a complex net-

work, or *plexus*, of nerve cells and fibers. This plexus, wedged between the two layers of muscle that encircle the gut, is still called Auerbach's plexus, as if he owned it. Scientists do not like to include a person's name in referring to body parts, Auerbach's plexus is also known as the myenteric plexus, derived from the words my = muscle; enteric = gut. After Auerbach's discovery, another smaller plexus was found in a layer of the bowel called the submucosa. The *submucosa* gets its name from its location, which is just beneath the lining of the gut's internal cavity.

THE GUT BRAIN CONNECTION

This new science has been valuable to those victims of the invisible illnesses that have been told, "it's all in your head." Now with the knowledge of the "second brain," those same victims can respond, "I've got a gut feeling it's in my brain, I'm referring to the second brain in my gut, of course." So the next time you get that "gut feeling" listen to the messages it's projecting in you, it's your early warning system. Dr. Gershon has devoted his career to understanding the human bowel (the stomach, esophagus, small intestine, and colon). His groundbreaking book, *The Second Brain* fills the gap between what you need to know—what your doctor should know or has the time to tell you.

According to Gershon, our two brains—the one in our head and the one in our bowel—must cooperate. If they do not, then there is chaos in the gut and misery in the head—everything from "butterflies" to cramps, from diarrhea to constipation. Gershon's work has led to radical new understandings about a

wide range of gastrointestinal problems including gastroenteritis, nervous stomach, and irritable bowel syndrome. His research and writings represents a quantum leap in medical knowledge and is benefiting patients whose symptoms were previously dismissed as neurotic or psychosomatic.

WISDOM OF THE GUT—
YOUR OWN "SECRET SERVICE"

Inside the lumen (walls) of the large intestine (colon) there exists life, lively bacteria that are constantly competing for territory. It's like two armies competing for more and more ground in the hope it can overcome the other guys. The "guts secret service" is the cells that reside deep in the connective tissue under the lining of the colon. These secret service cells constantly monitor the army's position and number, and keep inventory of the normal bacterial *flora*—our defense system. This inventory consists of large numbers of cells that are immune-competent— meaning they enter into their "gut brain memory" the information necessary to know their opponents. This "gut brain" orchestrates an attack on those bacteria that attempt to over-take the guts natural flora balance. In other words, these cells learn to recognize any invader that ventures beyond the designated "safe" zone—the lumen of the large intestine.

This same "brain" learns to recognize the toxins produced by bacteria in the colon, and they too are neutralized before they inflict any casualties. The gut wisdom is like a huge super computer keeping inventory to make sure the gut flora remains unchanged and our intestinal life is not subjected

to undue stress. We go on day-by-day, unaware of the massive armies of warring germs in our large intestines that march through life protecting us and keeping our intestinal ecology in balance. We don't want to even think about our colon, except on those occasions when it is ready to expel itself of its contents. The least amount of stress from our intestinal armies can upset our entire equilibrium. We expect the invisible armies to handle the situation and not produce a battlefield "progress report" (diarrhea or constipation).

One disadvantage of the gut having such a good memory, even though a positive protective mechanism, is the "progress report" it delivers when it is exposed to "unknown bacteria"—like those we experience while on a trip away from our normal environment. If the organisms the body is having to deal with are unrecognizable to the "gut brain," the bacteria undergoes a through orientation and is accepted into the force, and the body will attempt to rid itself of these foreign invaders through mechanisms commonly known as "Montezuma's revenge," "tourist two-step," Delhi belly," or "Turistas," any name you give it, it's still diarrhea.

When the latter occurs, it's a natural response to take an anti-diarrheal, Lomotil® or Immodium AD® for example—*not* a good strategic move in most cases. Diarrhea, especially watery diarrhea, can be helpful for the colon that has been invaded by bacteria to which it possesses no defenses. Our gut's reaction is to rid itself immediately of the invading bacteria so as to not allow it to take up residence and gain territory in the colon. This cleansing

process rids itself of any germ that is not battened down or having resided long enough to adhere to the intestinal surface. As long as the distress is caused by a new unrecognizable bacteria and the change of flora in the colon, your "gut wisdom" will handle the invaders just like it has in the past—let mother nature do it's job through specific "attack" orders from your "second brain."

All things considered, it should come as no surprise that we possess a "second brain" deep within our body, after all, scientists do not make or invent principles, they discover them. In the words of Dr. Gershon, "The bowel just is not the kind of organ that makes the pulse race. No poet would ever write an ode to the intestine. To be frank, the popular consensus is that the colon is a repulsive piece of anatomy. Its shape is nauseating, its content disgusting, and it smells bad. The bowel is a primitive, slimy, snakelike thing. Its body lies coiled within the belly and it slithers when it moves. In brief, the gut is despicable and reptilian, not at all like the brain, from which wise thoughts emerge. Clearly, the gut is an organ only a scientist would love. I am such a scientist."

The research brought to the forefront by Dr. Gershon has given this lowly, overly abused, and misunderstood organ an entirely new respect; after all, we now not only have another brain, we understand that our invisible illnesses are not quite as invisible—after all how could they be, they have their own computer operating systems?

Identifying Your Invisible Metabolic Blueprint

Introduction
THE CLINICAL VALIDITY OF HAIR TISSUE MINERAL ANALYSIS (TMA) —A PSYCHO-PHYSIOLOGICAL VIEWPOINT
by Richard Malter, Ph.D.
Licensed Clinical Psychologist
Licensed Nutrition Counselor

Background

Hair tissue mineral analysis (TMA) is a relatively new laboratory test. Its importance stems from the fact that the nutrient minerals that are measured in a TMA are vital to the healthy functioning of the entire mind/body system. There also is a close nutritional relationship between the use of TMA and these nutrient minerals because *they can't be produced by the human body.* They have to be ingested through food or supplements.

From time to time in medical and health care literature, 'studies" are published, or editorial comments are written, attempting to discredit the *reliability* of TMA, of which there are few limited studies in sample size. These studies and literature have basic flaws in their methodology and data analysis that lead the authors to erroneous conclusions about the reliability of TMA thus confounding the issues of reliability and validity. I recently addressed the issue of TMA reliability in an article in the *Journal of Orthomolecular Medicine*; it showed, in fact, the accuracy and reliability of TMA is very high and compares favorably with other laboratory tests making reliability of TMA easy to establish.

Establishing the clinical *validity* of TMA is more complex and involved. The purpose of this chapter is to discuss the clinical validity of TMA. Regardless of one's personal or professional views about hair tissue mineral analysis (TMA), the nature of this laboratory test, and the conceptual systems used to interpret the TMA data, can be highly useful in understanding many of the crucial issues in present day health care. In this context, the issue of validity of TMA is highly relevant.

The biochemical and psycho-physiological phenomena that TMA mineral data reflect are inherently complex, highly interactive and dynamic. The nature of the psycho-physiological phenomena reflected in a TMA cannot be properly understood within the prevailing medical model—essentially a simple dichotomous disease model. Under this disease model, either the individual is healthy or he/she has a diagnosable medical condition.

In many important aspects, this widely used disease model is quite limited. This model *does not* lend itself well to dealing with those physical and psychological conditions that are often experienced as uncomfortable and life-altering, but are not clinically severe enough to be diagnosed as a disease. However, these types of conditions often mark the early stages of a medical and/or psychological disorder. The vast majority of people fall into an intermediate range on what I call the "health/energy continuum"—the range between optimal health and having a disease that can be diagnosed by the conventional medical system. They lack optimal health and energy, but are not severe enough to fall outside of the "normal"

ranges of blood and urinalysis norms.

When we view a TMA profile as an energy profile, it provides a great deal of information regarding a person's energy levels and fluctuations. The complex TMA interpretation system relies on mineral patterns as well as ratios between pairs of minerals. The synergistic and antagonistic relationships of minerals are very important aspects of the psycho-physiological system.

A crucial point to keep in mind regarding TMA data and their interpretation is that the test results are non-specific in the same way the stress response is a general and non-specific response. The psychophysiology of the stress response provides a broad conceptual framework for meaningfully interpreting TMA data. From a psychological perspective on the mind/body relationship, there is a very good match between the psycho-physiological phenomena of the stress response and TMA data. When a health care practitioner, or integrative physician applies this conceptual framework to TMA data, the mineral patterns become much more meaningful in regard to a person's stress response and the effects of stress all the way down to a cell and tissue level. This perspective can be clinically useful, leading to the selection of a combination of supplements and diet that provides the body with optimal nutritional support for energy production and the resiliency for coping with stress.

CLINICAL VALIDITY

The question of validity is certainly a crucial question in regard to TMA, but it is also crucial in regard to any other tests applied to clinical concerns, whether they

are physical or psychological. If we were to raise the question of the clinical validity of blood tests such as those used for the determination of hypothyroidism, it might shake the foundation of some aspects of standard medical practice. I have encountered many depressed individuals in my psychology practice who describe a set of symptoms that Dr. Broda Barnes, author and researcher of hypothyroidism, would consider as indicators of a slow thyroid. However, the blood tests of many of these individuals were determined to be "normal" according to the arbitrary "standard" conventional tests.

TMA sheds some very interesting and important light on this common health concern today, namely symptoms associated with hypothyroidism. Many of the individuals with whom I work in psychotherapy have several of the symptoms on their health history checklist including cold hands and feet, low blood pressure, hypoglycemia, cool body temperature, dry skin, etc. (SEE SYMPTOM CHECKLIST ON PAGE 99 FOR COPPER TOXIC SYMPTOMS) Most of these clients are women who suspect that they have a slow thyroid. Typically, their doctors tell them that their blood tests for thyroid function are within the "normal" range. Therefore, doctors conclude that they do not have a thyroid problem; yet they often experience hypothyroid related symptoms.

When we look at the TMA profiles of these individuals, invariably, they show a high calcium and low potassium level. The Ca/K ratio is considered by Trace Elements Lab to be an index of thyroid expression. An elevated TMA Ca/K ratio is an indication of reduced thyroid function. This TMA pattern invari-

ably correlates well with the hypothyroid symptoms reported by the individual. When these individuals are given thyroid and nutritional support, they usually respond very well. This suggests that the TMA thyroid ratio (Ca/K) is far more clinically valid than the more commonly used serum thyroid indicators. In this context, one can raise some serious questions about the clinical validity of serum thyroid indicators. Many of my clients have found that their doctors simply dismiss their hypothyroid symptoms because, after all, the serum thyroid indicators can't be wrong. In many such cases, the problems and symptoms that are experienced by a person occur in clusters that are strongly correlated with that person's TMA.

IDEAL TMA NORMS

In my view, the appropriate test of the ideal TMA norms used by such labs as TEI is whether there is strong clinical validity for the TMA lab results for a particular individual. Do the observed measured data fit the psychological and physiological symptoms and reactions of that individual? Do these data adequately help to account for the psycho-physiological phenomena that are experienced by the person? A crucial question is this: are these approximations (TMA ideal levels) sufficiently close to the clinical psycho-physiological conditions, i.e. the person's cluster of symptoms? Are we clinically better off with these TMA ideal levels than guessing without these TMA laboratory data? In almost all cases, the TMA data are far better than guessing. We already have far too many cases of "clinical" guesswork in standard medical and psychiatric practice. For the

health and well being of thousands of people, we need to do a much better job of addressing the issue of clinical validity of our various laboratory tests and clinical assessments. These should include blood and urinalysis tests as well as TMA.

I continually see the clinical value of TMA results in accounting for many health conditions that baffle most conventional medical doctors and seriously inflate the cost of health care. Since TMA data reflect the mind/body connection by means of the stress response, a psychological component needs to be included in any meaningful interpretation of these types of data. In fact, TMA data often show a clear connection between psychological and physical problems. In the vast majority of cases that conventional medical doctors attempt to diagnose and treat, the psychological stress component is rarely, if ever, addressed. In many cases, TMA data suggest that, when the psychological stress factor is not adequately addressed, the mind is often capable of "over-riding" the effects of vitamins, minerals, hormones, drugs, and medications. Until we look at TMA data longitudinally in individual cases, it is easy to underestimate the power of the mind in regulating psycho-physiological phenomena.

BLOOD AND TISSUE MINERAL ANALYSIS (TMA)

Blood analysis, especially in modern medicine, is commonly assumed to be the best indicator of a person's health condition. In many cases, blood analysis reveals important information about an individual's health status. Yet, in many other cases, blood does not reveal anything significant even though the

patient reports multiple health concerns and symptoms. When it comes to understanding energy producing capacity in its relationship to health status, blood analysis often has several limitations. One is that blood is a *transport medium*. That is, it transports glucose and oxygen to cells and tissues in which energy is produced. Blood also transports carbon dioxide and other waste products from cells and tissues to be eliminated from the body. These, of course, are vital functions of blood.

Blood remains *outside* of cells and tissues in the healthy body. In terms of energy production, it is *inside* of cells and tissues that the body's *energy is produced*. More specifically, energy is produced within the mitochondria that are outside the cell. Minerals involved in cellular energy production may appear to be normal in the blood.

Blood is *homeostatic*. That is, blood has the capacity to balance itself in essential minerals at the expense of *tissue reserves*. For example, cells and tissues may be losing essential minerals such as potassium and magnesium while the blood retains what appear to be normal levels of these essential minerals. A person may be experiencing *signs* and *symptoms* of potassium and/or magnesium deficiency, but the blood analysis may be perfectly "within normal range." Therefore, a blood analysis may be a *late* indicator of health problems— either physical and/or psychological.

TISSUE MINERAL ANALYSIS (TMA): SYNCHRONIZING YOUR 'SPARK PLUGS'

The body's tissues contain the cells in which energy is produced. Energy production is dependent to a

large extent on essential nutrient minerals such as magnesium, copper, and phosphorus. These minerals are also related to other minerals such as calcium, sodium, zinc, manganese, and iron. They are all part of a *complex system* of minerals, which regulates the body's stress response, immune system, and energy production. They are sometimes referred to as the 'sparkplugs" of the body because of their critical function in energy production.

The balance between these essential nutrient minerals is more easily disrupted in the cells and tissues than it is in the blood. Deficiencies and excesses of minerals are more readily observed in a *Tissue Mineral Analysis* (TMA) than in a blood analysis or urinalysis. Therefore, a TMA is often an *earlier* indicator of a *trend* towards health problems (physically or psychologically) than is a blood or urine analysis. In regard to many of the essential nutrient minerals that are measured in a TMA, many of these minerals perform multiple functions in the mind/body system. When there are deficiencies or imbalances involving these minerals, clusters of physical and/or psychological symptoms may manifest because of the disproportionate levels associated with these minerals.

SYMPTOM CLUSTERS

Quite often, people experience a health problem as one of several problems which occur in *clusters*. These clusters of health problems frequently have both physical and psychological symptoms occurring together. For example, it is not uncommon to find that depression occurs with anxiety and panic attacks,

with cold hands and feet, dry skin, constipation, and a short attention span with memory problems. Such a symptom cluster is commonly associated with an excess of copper in the body's tissues.

Another perspective for viewing this particular cluster of symptoms is to consider that excess copper is the common underlying problem associated with this particular cluster of health problems. Since excess copper is the underlying problem, then dealing with the excess copper often leads to an improvement in some or all of the problems in the cluster. There is a great deal that is known about the neuroendocrine effects of excess copper. These changes in metabolic rate are associated with copper's effect on thyroid function. There is also a great deal that is known about nutritional interventions that will help to reduce the level of excess copper in the body's cells and tissues. The primary nutrients, which help to accomplish this, are vitamin C, zinc, and vitamin B6. As excess copper is eliminated from cell and tissue storage, there is usually a temporary reduction in metabolic rate. After excess copper is eliminated, there is usually an increase in metabolic rate.

Symptoms Associated With Excess Copper:

PMS	Fatigue & Exhaustion	Allergies
Brain Fog	Headaches, Migraines	Mood Swings
Supersensitive, weepy	Cold Hands, and/or feet	Depression
Dry Skin	Chocolate cravings	Paranoia
Feeling of loss of control	Despair, suicidal feelings	Arthritis
Calcium spurs	Constipation	Racing heart
Non-tolerance to vitamins	Lack of concentration/memory	Cysts
Short attention span	Muscle Cramps	Hypothyroid
Obsessive thoughts	Low blood pressure	Mind races
Insomnia	Panic attacks, high anxiety	Hypoglycemia
Anorexia, Bulimia	Mononucleosis	"Spaciness"

The following Health History Checklist is a compilation of common symptoms of copper excess which are typically found in different clusters depending on the individual's developmental and health history.

METABOLIC TYPES: OXIDATION

Excess Copper—Clusters of health problems can sometimes have two or more causes occurring together. Many of the problems associated with an excess of tissue copper are also associated with the condition of *Candida Albicans*, yeast infection. These same problems in the cluster may also be associated with *hypothyroidism*. Excess tissue copper and hypothyroidism frequently are found together. When they do occur together, the person's overall metabolic rate tends to be slower than normal. This condition is referred to as *Slow Oxidation*.

Copper Deficient—A *deficiency* of copper tends to be associated with *hyperthyroidism*. Hyperthyroidism and copper deficiency tend to be associated with a faster rate of metabolism. This condition is referred to as *Fast Oxidation*.

The concept of *Oxidation Type* with an emphasis on distinguishing between *Fast* and *Slow Oxidation* was extensively used by Dr. George Watson, a psychologist at the University of Southern California. Dr. Watson's work with oxidation types was summarized in his book *Nutrition and Your Mind*. He found that *Fast* and *Slow* Oxidizers need *different* nutritional programs to improve the psychological and physical health condition of each oxidation type. This was an important discovery for applied clinical

nutrition because it reflects a major *paradigm shift* for assessing and treating nutritional factors related to psychological and physical health problems.

Fast Oxidation and *Slow Oxidation* patterns are easily observed in most TMA profiles of nutrient minerals. *Fast Oxidation* is reflected by lower than ideal levels of the minerals calcium (Ca) and magnesium (Mg) along with elevated levels of sodium (Na) and potassium (K). *Fast Oxidation* also is reflected by a *lower* than ideal *ratio* of calcium to phosphorus (Ca/P).

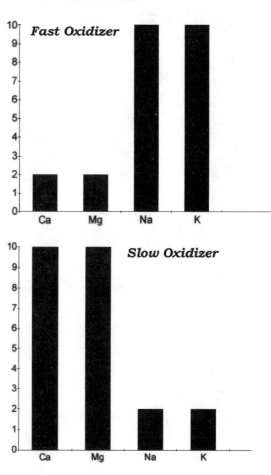

The following graph illustrates the described imbalances.

In contrast, the following graph reflects *Slow Oxidation* by higher than ideal levels of calcium and magnesium along with low levels of sodium and potassium. *Slow Oxidation* is also reflected by an *elevated ratio* of calcium to phosphorus (Ca/P).

STRESS: IT'S MANY FACES

The pioneering research, which led to our present understanding of the psychological and physical characteristics of the stress response, was carried out and described by Dr. Hans Selye. He identified

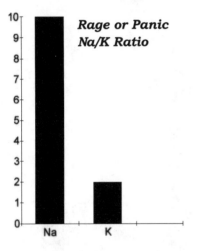

three stages associated with the stress response. The first stage, the **Alarm**, is also more commonly known as the "fight or flight" response. In this stage, the adrenal glands become activated and raise tissue sodium levels. The primary emotions with which this stage is associated are *Anger* and *Fear*.

The effect of the adrenal glands in the "fight or flight" response is reflected in a TMA by an *increase* of sodium (Na) over potassium (K). As stress increases, the adrenal glands secrete a hormone called aldosterone, that causes retention of sodium in relation to potassium. The more intense the stress, the more reactive the adrenal glands become, resulting in an increase in sodium in the body's tissues. On an emotional level, anger and fear intensify. If, for some reason, the sodium level in the tissues becomes extremely high in relation to potassium, then the intensity of the emotional response shifts to *rage, panic,* or *terror.* This TMA pattern reflects intense adrenal gland activity.

Some of the physical reactions of the *Alarm* stage are an increase in blood pressure, increase in heart rate, tensing of muscles, and inflammation of soft and connective tissues.

Dr. Selye described the second stage of the stress response as the **Resistance** stage. This is reflected in a TMA by an increase in potassium to balance the elevated sodium level of the *Alarm* stage.

With the removal of the source of stress, the emotional and physical characteristics of the *Alarm* stage diminish and return to normal. The intensity of the anger and/or anxiety diminish; the person becomes much calmer, swelling and inflammation diminish and adrenal gland activity decreases and becomes more normalized.

Dr. Selye called the third stage of stress the *Exhaustion* stage. This stage occurs when the source of stress is prolonged and unrelenting. The adrenal gland hormone called aldosterone primarily regulates sodium retention in the body's tissues. As the adrenal glands become depleted from exposure to prolonged stress, sodium retention in the body's tissues diminishes. The adrenal glands become depleted when they do not have *time* and *sufficient nutritional* support to recharge themselves. This phenomenon is seen in a low sodium to potassium *ratio* in a TMA. This is called an *inversion* of the Na/K ratio. When the Na/K ratio drops below 2.0 (ideal is 2.4), the inverted ratio reflects a trend towards the *exhaustion* stage of stress.

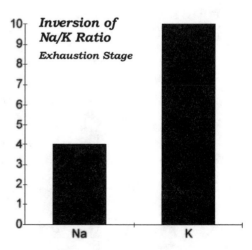

When the *exhaustion* stage of stress becomes more chronic, then the absolute level of sodium in a TMA drops significantly below the ideal sodium level of 24mg.This is very commonly seen in the typical *Slow Oxidizer* TMA pattern which shows low sodium and potassium levels.

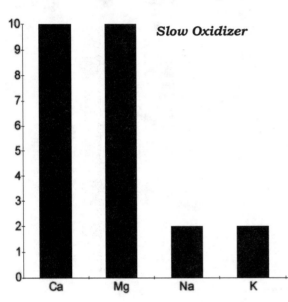

Slow Oxidizer

The Na/K *inversion* pattern of the *Exhaustion* stage is more commonly found in the *Fast Oxidizer* pattern. However, it is sometimes observed in the mineral patterns of some Slow Oxidizers who have very *low* tissue copper levels. These *Slow Oxidizers* usually are individuals who were once *Fast Oxidizers* who have gone into an adrenal "burn-out," as occurs in Prescription Drug Withdrawal Syndrome.

A BALANCED OXIDIZER: THE IDEAL

The *Balanced Oxidizer* is an *ideal* pattern showing normal or ideal levels of essential nutrient minerals, especially calcium, magnesium, sodium, potassium,

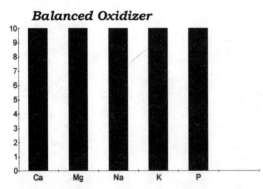

Balanced Oxidizer

and phosphorus. When these five minerals are at their normal or ideal levels concurrently, then they also are in ideal balance with each other. This balance would be reflected in ideal TMA rations.

CHRONIC FATIGUE:
THE "INVISIBLE" CONNECTION

Today, one of the most common health problems has to do with chronic fatigue, exhaustion, and low energy levels. Even though it is so common among current health concerns, it is one of the least understood problems in healthcare today. Perhaps the reason why chronic fatigue and exhaustion are so poorly understood is that these conditions involve intense energy loss rather than a clear-cut disease. However, modern medicine rarely focuses on a person's capacity to produce energy at a cellular level. Most physicians tend to look for a bacterium or virus, which they believe "causes" a disease including chronic fatigue syndrome. In this context, a paradigm shift focusing at energy production and loss in a different way may be more helpful. This is where the "health/energy continuum" can be applied rather than the "health/disease dichotomy."

The purpose of including the following information is to provide this paradigm shift by explaining TMA in greater detail. It introduces a new perspective for assessing the body's energy production and how it is related to health and disease on a physical and psychological level. This information will also help to explain why chronic fatigue and exhaustion are such widespread problems today, especially among young people—children, adolescents, young adults and, of course, those exposed to toxic metals and overuse of prescription drugs. Also discussed are psychological and behavioral problems—Attention Deficit Disorder, Hyperactivity, Depression, Anxiety and Panic Attacks, Aggression and Violence, and Alcoholism—

from a perspective of stress and nutrition. Some of the psychological effects of toxic metals such as lead, mercury, aluminum, and copper are discussed.

COPPER, CHRONIC FATIGUE AND "BRAIN-FOG"

There is increasing evidence that significant environmental changes in biochemical factors are contributing to a wide range of psychological problems in children, adolescents, and adults. Copper is a mineral essential for health providing many vital functions. It can, however, build-up excessive levels in the tissues and drain energy, just as dangerous heavy metals like mercury or lead.

Copper is included as an important component of many enzymes in the body, and is involved in everything from energy production to pigment formation in hair and skin. It's essential for building collagen, the matrix necessary for strong bones, joints, and connective tissue; for forming hemoglobin and red blood cells; and for synthesizing neurotransmitters that send messages throughout the nervous system and brain. Copper also plays important roles in reproduction and pregnancy and in the proper function of the thyroid and adrenals, which are key energy-producing glands in the body.

Excess copper (toxicity) has been shown to manifest in conditions such as: ADD, hyperactivity, distractibility, memory problems, learning disabilities, depression, anxiety and panic disorder, bipolar disorder, obsessive-compulsive disorder, anorexia, violent aggression, depersonalization disorders and suicidal tendencies. To grasp the magnitude of the nutritional/biochemical problems we are facing

today requires a shift in perspective and a new paradigm. The old paradigms and medical/psychological models have become obsolete and are much too limited in perspective.

During the past 20 years, data from hair tissue mineral analyses (TMA) of children, adolescents, and adults (especially women) point to copper excess (or in extreme cases, copper toxicity) as a major factor associated with many of these psychological problems.

Copper excess also is frequently seen in adult women, possibly because of the high correlation between copper and estrogen—estrogen being a strong contributing factor in many cases of copper excess.

Environmental Factor

There are a number of environmental factors that further exacerbate the problem of copper excess. For the past forty to five-five years, the use of copper pipes in household plumbing has contributed substantially to ingestion of increased amounts of coppers, especially in the presence of "softened" water. Also, zinc deficient diets may lead to copper excess because zinc antagonizes copper. When zinc is not present in sufficient amounts, excess copper tends to build-up. This is also commonly seen in cases of intense and prolonged stress that induces a significant zinc loss from cell and tissue storage. Food processing and the deficiency of zinc in our soils are contributing directly or indirectly to the risk of copper excess.

Clinically, there are some important dynamic aspects to the identification of copper excess as a possible contributing factor to medical/psychological

problems. In some individuals, the first hair tissue mineral analysis may clearly show a high copper level regardless of what is seen in the rest of the mineral profile. In other individuals, what appears to be a normal *level* of copper may actually be a very high level in *relationship* to zinc; that is, the zinc/copper *ratio* is significantly below normal. These are the two principle ways in which copper excess may manifest itself in the first hair mineral analysis.

In some cases, copper excess may be latent and not seen so clearly at first. This is because the high amounts of copper may be stored and locked in tissues so the hair sample is not picking up the excess amounts. This may be due to the presence of other heavy metals that mask copper identification. Lead, cadmium, mercury, and/or aluminum may show more readily in the first hair analysis. However, after the individual goes on a nutritional program, the excess copper may be released from tissue storage and will be clearly seen in a subsequent hair mineral analysis.

Liver and Copper Homeostasis

The liver plays a vital role in maintaining copper homeostasis (a stable state of equilibrium between the different but interdependent elements) in the body, although many of the precise details of liver function are still not known. Generally speaking, when copper is ingested or is absorbed through the lungs or skin, the liver takes up copper and attaches it to copper-binding proteins allowing the mineral to be safely transported through the bloodstream to perform its various functions.

Excess copper that is not needed by the body is normally eliminated primarily via bile, which flushes from the gallbladder through the liver into the stool. Any reduction in bile function, liver function, or gallbladder function limits the body's ability to excrete copper, causing a buildup first in the liver, then in other organs such as the brain, heart, kidneys, and adrenal glands.

Excessive Copper: The Biochemistry/ Psychodiagnostics Connection

According to Dr. Richard Malter, "there have been significant dynamic changes occurring in the environment since the end of WWII, that have had a profound impact on the psychological functioning of many individuals. Among the most notable of these dynamic changes are (1) the increase in toxic metal pollution, (2) the introduction of female contraceptive devices such as the 'pill' and copper IUD, (3) copper water pipes, (4) water softeners, (5) psychotropic and other medications, and (6) calcium supplementation for women related to 'preventing' osteoporosis."

The psychological conditions with which these dynamic environmental and biochemical changes are associated include: depression, anxiety and panic attacks, phobias, aggressive and violent behavior, ADD and ADHD, and obsessive-compulsive disorder.

Large numbers of people are much more toxic from heavy metals, other contaminants, and the long-term effects of drugs and medications than were their parents, grandparents, and great-grandparents.

Estrogen Replacement Therapy

This case illustrates the relationship between estrogen, copper excess, and slow oxidation. A 49 year-old post-menopausal female was placed on estrogen one and-a-half years prior to the hair analysis described herein. She reported being active and energetic prior to the start of the estrogen therapy. She now reports that she feels chronically fatigued and exhausted, and has a problem with easily gaining weight. She reports that her mind has been "racing" during the past few months.

The TMA analysis chart showed this woman had a very high copper level (14.0) with a very low zinc level (4.0). The resulting zinc/copper ratio of .27 is indicative of an extreme degree of copper excess (ideal Zn/Cu ratio = 8.0). In addition, she is an extremely slow oxidizer with a tissue calcium level of 900! The normal TMA calcium level is 40 mg. The high copper results in a lowering of potassium and a very significant increase in tissue calcium. A high calcium/potassium ratio is one of the characteristic ratios of a "slow oxidizer."

The psychological effect of a very slow oxidation with a very high copper level is that the person's mind is hyperactive, while the person's body feels chronically exhausted and fatigued—"the mind is writing checks the body can't cash." The person has all sorts of ideas racing through the mind, but is too tired to act on any one of them. Such an individual easily becomes confused and frustrated. The low energy level of many depressed individuals is associated with very slow oxidation.

Excess Copper and The Thyroid Gland

As excess copper builds up in an individual's tissues, more energy production is required in order to eliminate the accumulated excess tissue copper. However, since one of the effects of the excess copper buildup is the slowing of thyroid gland activity—the body's capacity to produce energy is diminished. Therefore, as a person becomes more and more copper toxic, the body's capacity to produce the energy necessary to eliminate the excess copper is diminished and the copper will continue to accumulate, primarily in the brain and liver.

Excess Copper: Estrogen Production, Pregnancy, Learning & Behavioral Problems

In a female who has copper excess, her estrogen production will contribute to larger and larger accumulations of excess copper. This trend will be exacerbated if she uses the birth control "pill" (more estrogen) or a copper IUD. During pregnancy, with all of its accompanying stresses, some of the stored copper will be eliminated from tissue storage into the blood stream and some of it will find its way into the placenta and into the fetus.

This process of copper transfer from the mother to the fetus normally occurs in pregnancy, but in the case of a teen girl or a woman who starts her pregnancy with a copper excess, the amount of copper which may be transferred to the fetus is likely to be much greater than normal. Since copper antagonizes zinc, the baby may also experience a significant zinc deficiency—resulting in a lower than ideal ratio of zinc/copper. Since much excess copper is

stored in the liver, high bilirubin counts may contribute to jaundice at birth—immune system weakness, allergies and recurring infections are commonly found in the health history of such children.

A female child born to a mother who has a copper excess will begin life with a higher copper level than her mother began life. Throughout her developing years, such a female child is likely to accumulate more and more copper in her tissues, especially during pre-adolescence and adolescence when her own estrogen production increases. She is likely to give birth to children who will absorb higher amounts of copper than she absorbed *in utero*. In each succeeding generation, this cycle is likely to repeat itself resulting in more and more children born with significant copper excesses. This process of transmitting more and more copper *in utero* from one generation to the next allows for increasing amounts of excess copper to build-up and accumulate to toxic levels. Each future generation is likely to produce an epidemic of psychological and physical problems (learning and behavioral) associated with excess tissue copper. This is primarily due to the fact excess copper tends to be stored in the *brain* and in the *liver*.

Such a trend has very serious implications for families, schools, and society in general. Aggressive and violent behavior also will tend to increase with the build-up of excess tissue copper levels manifesting as addictive cravings, addictive behavior, depression and panic disorders.

Elimination of Excess Copper

The elimination of excess copper often occurs with significant discomfort. Many of the signs and symptoms of the premenstrual syndrome are also experienced with the elimination or "dumping" of excess stored copper. Teen girls and women who experience PMS reactions have some familiarity with what "copper dumping" feels like—resembling flu-like symptoms.

The elimination or "dumping" of excess copper requires an increase in the *metabolic rate*, which will be associated with an increase in cellular energy production. Any process or activity that will increase the metabolic rate and cellular energy production may trigger a copper "dump" from cellular storage: aerobic exercise, stimulant drugs, an increase in a person's stress level leading to an increased metabolic rate, certain vitamins and minerals with stimulating effects.

When copper "dumping" or elimination occurs without the person being aware of what is happening, this process can be very frightening and disturbing. Depending on the person's major symptom reactions, the individual may think he or she is having a heart attack, going crazy, experiencing thoughts of suicide, depression, uncontrollable anger and rage, anxiety and panic attacks, sleep disturbances, a "racing" mind and difficulty with concentration and memory. Overall, copper "dumping" is frequently experienced as a *roller coaster* ride with both highs and lows.

When a person is aware of the phenomenon of excess tissue copper and the possibility of copper "dumping," there is usually less fear when it occurs.

Even through copper "dumping" is uncomfortable, when understood, most individuals are able to cope with it. This is especially true if the person is taking nutritional supplements, under the direction of a naturopath or nutritionally aware physician, to minimize the effects. Copper "dumping" usually occurs in cycles manifesting as the above described *roller coaster* ride. As more and more excess stored

Case Illustration #1:

This case illustrates the importance of determining the person's metabolic type as well as clinically significant mineral ratios.

A 50 year-old woman who was leading a physically active life and developing a highly successful business had experienced an extremely stressful year. In her personal life, her father died rather unexpectedly and she was going through the stress of divorce after many years of marriage.

She began to experience uncontrollable diarrhea, weight loss, was exhausted all the time and it was hard for her to concentrate. Even though she was taking excellent nutritional supplements, she was unable to positively affect these very uncomfortable and disturbing problems.

This woman agreed to do a TMA in order to see if there was something in her mineral pattern that might shed light on these problems and facilitate a healthy resolution. The results showed that she is a very slow oxidizer with a high copper level and an extremely low zinc level. This resulted in an extremely low zinc/copper ratio. It is a well-known fact that stress depletes magnesium and zinc. In this woman's case, her TMA revealed that a severe zinc loss had occurred, producing a very low zinc/copper ratio. These TMA levels suggested that a severe Candida yeast infection flared up producing the problems and symptoms she was experiencing.

The woman was greatly relieved to get her TMA results that (1) explained and accounted for her problems and symptoms and (2) provided a set of guidelines to add the appropriate supplements and dietary changes to deal with the Candida flare up. A zinc, manganese, and vitamin C supplement was a primary addition to her supplement program, along with capryllic acid. Within two weeks, the worst of her problems was completely resolved. She steadily felt better and better in response to this supplementation routine.

copper is eliminated, the effects are an increase in energy and a greater sense of well-being.

The identification and elimination of excess stored tissue copper is one of the most challenging health problems we face today. We have gone through several decades of excess copper build-up primarily as a result of the widespread use of the birth control pill and exposure to copper from water pipes. Trace Mineral Analysis (TMA) is the most effective laboratory tool we have for identifying the underlying mineral patterns associated with excess tissue copper. TMA also provides a guideline for selecting vitamins and minerals to provide the individual with nutritional support for eliminating the excess tissue copper, while optimizing energy production at a cellular level.

Case Illustration #2:

Another case is that of a 52 year-old woman whose symptoms included inability to sleep, depression, severe anxiety, brain fog, and extreme fatigue.

Her TMA pattern indicated that she was a fast metabolizer *with a major characteristic of a slow pattern, namely, an extremely* low potassium level. *With such a low potassium level in a fast metabolic type, she still had an* above normal sodium level *that produced an extremely high sodium/potassium ratio of 37.1 (ideal ratio = 2.4). This extremely high sodium/potassium ratio strongly suggests this woman has been experiencing an extremely intense stress reaction for an extended period of time. This can explain the intensity of her anxiety reactions, inability to sleep, brain fog and headaches. The extremely low potassium is a very common characteristic of people who experience depression. The intense stress of a high TMA sodium/potassium ratio also can induce psychological reactions having to do with feelings of guilt, worthlessness, doom, and an overwhelming feeling of insecurity.*

Case Illustration #3:

This case is that of a 36 year-old male who presented with headaches, coughs, digestive problems, loss of smell, chronic sinus infections, and hives.

His TMA showed a slight slow metabolic type *mineral pattern with an extremely* low sodium/potassium ratio of *.80 (ideal ratio = 2.4) —the opposite sodium/ potassium ratio described in the previous case. This "inverted" sodium/potassium ratio strongly suggests that the adrenal glands are exhausted and the immune system is compromised—leaving the person highly susceptible to chronic infections.*

His TMA also revealed an elevation of mercury (.09). Eight months later, a second TMA showed that he was still in a slight slow metabolic pattern, *but the* sodium and potassium levels increased substantially—*sodium rose from 4 mg/% to 59 mg/% and potassium rose from 5 mg/% to 56 mg/%. The sodium/potassium ratio also increased from .80 to 1.05. These changes indicated that, with nutritional support, this man's adrenal glands were stronger and more reactive.*

More than a 3-fold increase in his mercury level also accompanied these results, from .09 to .30. Since the hair is also an excretory pathway, an increase in a toxic metal from one TMA to the next usually indicates that the toxic metal is being released and eliminated from cellular storage where the concentration of toxic metal is decreasing. As this is occurring, the hair is picking up the released toxic metal and temporarily shows an increase in a TMA as the toxic metal is being eliminated and excreted.

Health-Care, Not Symptom-Care, Naturally

YOU CAN'T LEAVE HOME WITHOUT IT!

Breathing, the first thing you do upon entering this earth is so automatic it's taken for granted. The rhythm of our breathing varies in great degrees depending upon the minute-by-minute function of not only our activities but also our feelings. Have you *really* communicated with your breathing?—most of us have not. The next time you feel angry, excited, surprised, relaxed, rushed or ill, notice the breathing patterns. Most people are so unaware that they're *barely* breathing, that it appears ridiculous to suggest the way you breathe might have to do with healing and wellness—it does!

The body requires oxygen in order to exchange "good" air for "bad" air. Deep breathing helps to normalize the pH in your body and support metabolic function. According to Dr. Linda Berry, deep breathing quickly takes you out of a sympathetic nervous system alarm state and reduces the stress in the moment. The bottom line is that deep breathing (adding oxygen) is required for all healthy bodily functions. The brain dies after being deprived of oxygen for just one to two minutes. The body cannot repair without sufficient oxygen to fuel the cells. Dr. Berry describes the importance of deep breathing as it especially pertains to chemical toxicity and lung cancer.

The apex, or top part, of the lungs that sits above your collarbone is the most common site of lung cancer. Some lung cancers begin here, perhaps because people usually breathe shal-

low breaths that don't expand this area. Since air is not exchanged there, it becomes a collection spot for particulate matter (such as pollution) from the air. Think of a closet or drawer that you don't go into often but is exposed to air from the outside world: it stays shut and still collects dust. The same thing can happen with your upper lungs.

Deep Breathing: Nature's Health Aide

In order to train yourself in conscious breathing, try the following exercise:

▶ *Set aside 3 minutes* *each day where you can be quiet, comfortable and uninterrupted—this can be anywhere.*

▶ *Practice watching your breathing going in and out—it's your best friend.*

▶ *Observe the flow in and out of your nostrils, your chest and abdomen—especially observe your belly.*

▶ *Listen to your body—pay attention to the movement of the muscles and the associated feelings.*

▶ *If you feel tense and tight, visualize breathing oxygen into that area.*

▶ *Practice conscious awareness—if your mind starts to wander to happy or stressful thoughts, pay attention to how your breathing changes.*

▶ *Consciousness breathing means just that, JUST BREATHING. Don't attempt to control or change it, just observe and proceed as you have been.*

▶ *DO NOT think about your breathing, just breathe—it will get easier after performing this exercise a few days.*

▶ *Be AWARE and feel—don't alter, analyze or judge.*

Conditions such as *hyperventilating* occur when people experience a stressful situation and, as a subconscious coping mechanism, breathe faster and faster and more shallowly. They do not get enough oxygen and they're blowing off too much carbon dioxide—literally "blowing-off" steam. When this occurs, the person feels lightheaded and like someone or something is sitting on their chest, then these symptoms manifest as a "panic attack"—symptoms can become so acute the victim is convinced he/she is having a heart attack. The situation does not usually become life threatening because if

you don't get enough oxygen you'll black out; which is the body's way of saying "you can't handle this situation, so I will." The body goes into "auto-pilot" when you black out and the breathing returns to normal because you're no longer experiencing the symptoms that caused the manifestation. This example is an all too common scenario because most of us have never been taught to breathe correctly, or the consequences of inadequate breathing.

According to Jon Kabat-Zinn, Ph.D., focusing on breath in your belly is calming. "Just as the surface of the ocean tends to be choppy when the wind is blowing, the mind, too, tends to be reactive and agitated when the outside environment is not calm and peaceful. In the case of the ocean, if you go down ten or twenty feet, there is only a gently swelling; there is calm even when the surface is agitated." Therefore, when we focus on our breathing down in the belly, we are tuning into a region of the body that is below the agitation of our thinking mind and is intrinsically calmer. This is a valuable way of re-establishing inner calmness and balance in the face of emotional upset or when your mind is so overwhelmed you experience "emotional overload." This exercise is invaluable in situations where gut or digestive disorders are *not* the main cause of distress. As described in the chapter 'The Gut Has a Mind of Its Own—Literally,' the gut reactions of stress can cause an escalating pattern of symptoms because the "little brain" in the gut literally reacts to external stimuli, thus the old saying "gut feelings."

The "belly" type of breathing mentioned above is called diaphragmatic breathing. This type of

breathing is accomplished by focusing on your belly, which is naturally slower and deeper than chest breathing, which is rapid and shallow.

As infants, we instinctively practice diaphragmatic breathing, babies aren't trying to relax their bellies—they're already relaxed. As we get older we start breathing shallower and get into patterns of strictly chest breathing.

THE EMOTIONAL PART OF BREATHING

With every movement, thought and emotion we breathe. If any of these behaviors are restricted, so will be our breath. The unfortunate reality is that this restriction accumulates as built-up tension and becomes a learned pattern. Because breathing is so unconscious, we are not aware of the gradual decline of oxygen. Over time, the pattern of tension and learned restriction becomes the norm, literally "choking off" our entire vitality.

Added to our own self-imposed pattern of restriction, we pick up the messages from our culture about not breathing. Everything from models to athletes shows us how we look better if we assume a certain posture that incorporates a restriction of our breath. We are told to hold our chest out, suck our stomach in and pull our shoulders back, all telling our bodies not to breathe fully.

Self-imposed, or modeled from others, the effect is the same; as our breath shuts down, so does every aspect of our existence. We begin restricting our breath to an early demise.

If the breath is able to travel in a natural manner, we are able to use it to catalyze our life with the life

force energy; this energy rejuvenates our entire being. Ancient civilizations have known for centuries the value of breathing, as is expressed in practices of Tai Chi, Yoga or Chi Gong. It is as if the spinning of the wheel of a natural breath acts as a generator producing energy. This energy can heal and can create peace, harmony and health, naturally.

According to ancient wisdom, and practiced by certified Rolfer and Me'tis-Medicine Way practitioner, Owen Marcus, observing yourself and where you restrict your breath will give you an insight as to where you restrict yourself in your life. Do you hold back on the in hale—do you have problems receiving? Or do you restrict your exhale—do you have challenges letting-go? The secret to changing our patterns is being aware of them in the moment we're in them. The mindfulness of how we hold our breath will be what will set us free to breath freely. As the breath is our first act of life, so is the breath the first act of a stress response. When we are not inhaling and exhaling fully, we are not allowing stress to run through and out of our body. When we bring awareness to our breath, we bring awareness to our full experience, negative and positive. Our breath is a teacher; listen and it will tell you when we are holding-on to patterns with our bodies, not allowing the natural flow of transformation. It also teaches us that we are not fully expressing our emotions, not allowing life to be in co-creation with our creator, and not being open to receiving help or insights. The mindful breath wakes us up to the unawareness that has existed.

One example of being in the flow comes from how our breath is the bridge between our conscious and

unconscious, or voluntary and involuntary nervous systems. We can control or restrict our body by limiting our breath or we can co-create and enjoy our body by using our breath to enhance our experience. In a stressful situation, the normal experience is to hold our breath as if holding will lessen the pain and discomfort. Here, in some conscious way, we determine that we do not want to fully experience a situ-

Breathing Exercise

This exercise is especially helpful in assisting you in getting to sleep after a day of stress, and or, pain.

Get in a comfortable, quiet, position on your back lying down. Turn-off all phones, computers, beepers etc.—"turn-off from the external world." The goal is to not focus on anything except your breath. Listen to your breath, in and out, and experience your body. If your mind wanders, just continue to direct it back to your breathing. Do this prior to sleep for at least 20 minutes every night. At first you may only succeed with 3-5 minutes and slowly work up until it's your natural "sleep aid." The more you do it, the easier it becomes, many clients report it's a habit forming sleep aid—a healthy habit worth pursuing!

Take a natural breath, one that starts at the floor of the pelvis, rises up the abdomen to the diaphragm and the top of the chest, and then feel the "wave" that releases back down to the abdomen. If this breath is to be fully natural, all aspects of your trunk should move—the front, back and sides. The sensation is one of experiencing a wave or ripple through a pond, traveling in a complete and restricted manner.

When this natural wave of breath occurs, we are capable of experiencing one of those "peak experiences" or "in the flow" moments that you hear athletes speak of when describing their "magical" moments; when everything "clicks-in" to create a sense of being in another time and space. In this space one moment can, and usually does, feel like many and an hour can feel like a moment. It is here that our entire being can experience it's optimum state, often simultaneously; our mind will be receiving new insights, our spirit a state of peace and oneness, our emotions flowing and joyful, our physical body devoid of stress—just pleasure in being one with our life-force.

This exercise is truly amazing if performed properly, try it, what have you got to loose?—except maybe some stress, sleepless nights and pain?

ation; as we limit or restrict our breath, we stop an involuntary process from running its natural cycle—experiencing the moment.

Another example is using your breath to do the opposite, releasing old stress that has been stored in our body and mind. We do this by increasing awareness of our breath and its cycle through the body. Here we are using the breath's natural connection to our involuntary nervous system as an instrument for change. Over time, this practice will not only release current and old tension, but will train the body in a healthier and more natural pattern of breathing.

Breathing is much more than breathing air in and out. The breath is the key to experiencing a full life. We can choose to use the breath to enslave us in old limiting patterns or we can choose our breath to be the catalyst for health freedom—our breath can set us free, naturally.

MASKS: MORE THAN JUST A PRETTY FACE

In addition to learning how and why deep breathing is essential to health and wellness, we must also be informed in methods of protecting ourselves from toxic air we breathe.

A combination of food and environmental sensitivities alters a life-style like no one can imagine, unless actually experienced. Any environment beyond our control becomes a huge risk factor until the immune system detoxifies and repairs. People facing these challenges can, and usually do, get very discouraged. A new set of symptoms can emerge weekly, daily, even hourly.

A stroll in a shopping mall, attending worship services, commercial flying, a visit to the doctor's office, a trip to the hairdresser, something as routine as having your car serviced or fueled, or having a repair-person come to your home, is no longer predictable.

I was so discouraged when I first developed chemical sensitivities. I purchased, and attempted to wear, several styles of filtering masks—all bulky, uncomfortable, difficult to breathe through, and unsightly. Finally, a dear friend and board member of the Environmental Health Network, Barb Wilkie, recommended I try a mask made by "I Can Breathe™." I contacted the designer and manufacturer, Adrien Bledstein, and shared my frustration and that of my clients. Adrien, also chemically sensitive, had created masks with a disposable charcoal filter out of the same necessity—truly a case of "finding a need and filling it"—with charcoal that is. Just creating a mask with disposable filters wasn't enough for this innovative genius; she made them in a lightweight style that is worn like a surgical mask around the front of the face and "looped" around the ears. She then proceeded to make them in lightweight flesh colored lace, white and denim colored honeycomb fabric, a variety of colors out of polar fleece for winter, organic natural cotton, and silk. She even custom made me one in black lace to be worn in the evening for a special event that I was determined not to miss, and....there's still more—she includes a satin mini rose with each mask for the ladies. She will also custom make a mask out of the customer's own material, which she did for me on a couple of occasions.

These masks allowed me to travel, shop and resume quality of life until my health no longer necessitated wearing them in all public places. I still, however, wear them every time I fly and during times I know the air would challenge my immune system. I use it when I go outdoors during the farmers' field burning season or when I know pesticides or fertilizers have been recently applied. I never go anywhere without my mask and plenty of replacement filters. People actually stop me in airports and public places to ask me where to purchase one. They are so small and lightweight they fit in the palm of your hand like a folded handkerchief. The demand for these masks is so high that we now stock them in our health center. I now also have non-chemically sensitive clients and their colleagues purchasing them for their flights and trips abroad—as protection from the barrage of germs in an airplane cabin with chemicals, pesticides,

FLASHBACK

I have found with some of my clients that once their chemical sensitivities lessen, they become over-confident and expose themselves to toxic substances that can again compromise their immune system.

I had a client who worked very hard at getting well naturally, spent a great deal of money on supplementation, therapy and organic food, suffered through all the pain, fear and helplessness (emotionally and physically) of chemical sensitivities, recovered after 2 long years, and then proceeded to return to the beauty salon to have her hair colored and permed. Granted, she no longer had gray hair, it was springy with curl. However, within 2 weeks of her salon experience, her chemical sensitivities returned along with the chronic fatigue, swollen glands, headaches and rashes. She again had to stay in her "safe" environments and restrict her quality of life until her immune system recovered from the toxic chemicals of the permanent wave and hair coloring. Her health has now returned to wellness, but only after another 9 months of detoxification. I can assure you, she now treasures her gray hair, "service stripes" as much as I do, naturally.

germicides, and re-circulated air—a perfect "toxic soup" blend as a souvenir of your trip. After the terrorist attacks of September 11, 2001 and the events that followed, many people in the U.S. decided to not go anywhere without one. They chose to be proactive rather than just re-active.

NON-DRUG SOLUTIONS FOR INJURIES, PAIN AND INFLAMMATION

"M & Ns"

It is estimated that 26 million people, in the U.S. alone, suffer from inflammatory disorders including, fibromyalgia, myofascial pain syndrome, or both. In saying that, it is my goal to offer natural options to prescription drugs.

Pain and Inflammation, without an actual injury such as a fracture, strain or sprain, is our bodies way of attempting to deal with toxic overload. Many illnesses, and nearly all injuries, result in inflammatory reactions to a certain degree. However, in the absence of an injury, pain and inflammation are symptoms with some common denominators: leaky gut syndrome, toxic colon, over/burdened liver and lymph system, and the resulting immune system dysfunction. This is evident in related conditions such as fibromyalgia, chronic fatigue, Myofascial pain syndrome, lupus, arthritis, psoriasis, and scleroderma to mention a few.

As the immune system becomes hyperactive and malfunctions, its over-reaction produces antibodies that attack even harmless substances in the blood. This causes formation of irritating circulating immune complexes (CICs), that are so misshapen and foreign to

the body, they themselves are attached by the immune system. In other words, healthy tissues, in the same neighborhood are impacted, causing further exacerbation of the immune reaction or response. This process causes the immune system to attack both its own cells and tissues; the result, chronic pain and inflammation. CICs are made up of proteins such as damaged antibodies, antigens and diseased tissues. When CICs accumulate in the joints, for instance, they act as irritants, causing inflammation. Most conventional treatments address symptoms of inflammation with anti-inflammatory medications, and do not address the underlying systemic cause. These medications reduce pain and inflammation but leave in their path dangerous side effects that do *nothing* to start the healing process. I'm a prime example after a life threatening fall and the resulting immune system disorders from the prescription drugs—discussed in detail in my book *I was Poisoned by my body: The Odyssey of a Doctor Who Reversed Fibromyalgia, Leaky Gut Syndrome, and Multiple Chemical Sensitivity, Naturally.*

There is a natural option to drugs with their barrage of side effects—many times worse than the original symptoms.

The solution lies in systemic oral enzymes; they stimulate healthy production of messenger immune cells (cytokines). They reduce inflammation and speed up immunity by producing a cleansing effect and helping to break up CICs at the center of the body's immune/inflammation reaction. The treatment of a disturbed or compromised immune system, however, requires patience and time—you didn't get this way over-night.

The effects of systemic oral enzyme therapy on the immune system and treatment of autoimmune diseases, especially rheumatoid factors, are profound, and may involve intense therapy for weeks or months. One must keep in mind that we're resolving causes, not suppressing or masking the symptoms. Systemic enzyme therapy markedly reduces the body's inflammation level, enabling the person to once again resume normal activity and restore quality of life. If you're in acute pain, your nutritionally aware physician or healthcare professional can assist you in incorporating prescription drugs (for immediate relief) with enzyme therapy (for long-term healing), naturally.

At the time of my accident, I was not aware of the anti-inflammatory properties of systemic oral enzymes—or I would *not* have consented to drug therapy. After reviewing hundreds of pages on systemic oral enzymes and using several dozen brands, there is only one that eliminated my chronic muscle pain and inflammation, Wobenzym®N, manufactured in Germany by the Mucos Pharma GmbH & Co. Wobenzym®N is the world's most researched enzyme formula, with over 50 clinical studies supporting its use.

The proteolytic enzymes in Wobenzym®N help to break up and destroy the bad proteins of CICs, clearing the way for the body's natural repair process. Studies show that Wobenzym®N helps to reduce the stiffness and swelling of inflamed joints, increases mobility, and slows down further damage. In Germany, it remains a best-selling product, preferred by millions of Europeans over drug therapy

and taken daily to maintain good health. I continue to use this product as needed, and continue to see the astounding benefits for both my clients and me.

Sadly, health-care providers may not know about systemic oral enzymes. In our conventional medical system, attention is only given to those products studied and studied over again in the U.S. Most European studies are not totally validated as a basis for clinical opinion in the U.S. The U.S. medical institutions tend to *not* teach nutrition; it merely teaches the bare basics about the use of vitamin and mineral therapies.

Most American medical journals have, until recently, avoided articles on nutrition, feeling they should be published elsewhere (in other countries or health-food-store-type publications). It appears a great majority of doctors seem uncomfortable recommending a food or natural substance in place of drugs. This position has finally began to change, thanks to physicians who understand and incorporate integrated medicine—combining the best of traditional medical wisdom and conventional medical science.

Our economy is now global, as are our resources for products and services. Multi-national clinical trials are now becoming abundant. The information on medicine and complimentary therapies is now as close as your computer. European research is as good, and in many cases better, than research done in America.

It is my personal and professional experience that systemic oral enzymes offer the first mainstream long-term treatment option for inflammatory

disorders, with proven healing and safety. This is particularly true when compared to corticosteroids and non-sterodial anti-inflammatory drugs (NSAIDs) with their side effects, of which I'm a prime example.

The results with Wobenzym®N are the same as when I took the NSAIDs. At times of acute pain I took 10 tablets, 3 times a day on an empty stomach. As the pain and inflammation subsided, I reduced the dose to 5 tablets, 3 times a day. Eventually, as my body healed, I reduced the dose to 3 tablets, 3 times a day. Now, I only use them as needed. Wobenzym®N are small round tablets, easy to swallow and resemble the famous candy that "melts in your mouth, not in your hand®," except Wobenzym®N does not contain any coloring. My clients call them their "M and Ns: medicinal, nutraceutical 'candy'."

ADDITIONAL BENEFITS OF WOBENZYM®N— SYSTEMIC ORAL ENZYMES

- **Supports healthy blood flow**—Systemic Enzymes help to break down the CICs and other dead (necrotic) matter that accumulate in the blood and blood vessels. The body also uses enzymes to regulate the amount of fibrin in the blood, breaking down excess fibrin when the blood becomes too thick. With age, many people do not have enough of these enzymes; Wobenzym®N supports the body's natural blood-thinning process.

- **Mobilizes the immune system**—Systemic Enzymes clean the Fc receptors used by white blood cells to carry away invading pathogens. Systemic enzymes also activate the body's sec-

ond line of defense; the macrophages that remove damaged cells. When damaged cells are not removed, they interfere with the body's normal repair processes.

- **Speeds Injury Recovery**—After an injury, the body uses large amount of enzymes to facilitate repair. Even young, healthy individuals may experience a shortage of enzymes after injuring a muscle or ligament. This shortage delays the repair process needlessly. Wobenzym®N efficiently enhances the body's ability to recover from sprains and strains.

- **Supports the cleansing** of tissues and promotes better circulation.

- **Stimulates** the formation of new healthy tissue.

- **Increases flexibility of red blood cells**—improving their ability to pass through the capillaries.

- **Activates white blood cells (macrophages)**—the bodies' natural killer cells. This activation allows the immune system to deal with inflammation by cleansing itself of cellular debris and quickly neutralizing errant cancer cells.

- **Degrades protein molecules** that penetrate from the blood capillaries into the tissues, subsequently causing edema (fluid retention) and exacerbating the inflammatory process.

As we get older, we frequently need more enzymes. This is why we don't recover as quickly from injuries or illnesses as we did when we were younger. Our joints no longer repair themselves properly, leading to diseases like osteoarthritis. Our blood begins to thicken, causing disorders of the heart and vascular system.

The body performs millions of chemical reactions each second. Most of these reactions need enzymes; the same way a fire needs oxygen to continue burning. Therefore, in order for the body's healing actions to be supported, systemic oral enzymes are a necessary part of any routine for healing and sustaining wellness.

Wobenzym®N has the ability to also help you live longer and healthier. According to Garry Gordon, M.D., "If we can harmonize and re-balance patients' inflammatory pathways, particularly levels of C-reactive protein, we can help them to reduce their risk of heart attacks and stroke. Today, we finally have a safe anti-inflammatory tool: systemic oral enzymes. In my own practice, I emphasize the use of Wobenzym®N over aspirin and have had great results in keeping my patients alive and free from heart attacks and stroke, without the concomitant risk of ulcers and hemorrhagic stroke."

FYI:

- *Take systemic enzymes on an empty stomach, 30-45 minutes before or after a meal.*
- *Wobenzym®N can be taken concurrently with any nutritional supplement or medication except for the Warfarin® based blood thinners such as Coumadin™.*
- *For daily health maintenance, take three tablets two times a day.*
- *For acute injuries, pain and inflammation, take 10 tablets three times a day.*
- *Before engaging in physically demanding tasks and sports, take systemic enzymes as a preventive measure.*
- *If you're already using NSAIDs such as ibuprofen, gradually adjust the dosage over several weeks, according to the recommendations of your health care professional.*
- *Enzymes are not painkillers. They are slower acting than drugs such as aspirin or ibuprofen. You should use Wobenzym®N for several weeks, preferably a minimum consistent dose for 90 days before rendering a verdict in the case regarding their effectiveness.*

NEWTRITIONAL TOOL KIT™

The Wobenzym®N-Painful Joints Newtritional Tool Kit™ brings together the massively proven German Wobenzym®N systemic oral enzyme formula with glucosamine, chondroitin sulfate, vitamin D3, calcium, turmeric, and white willow. The formula is designed both for the more common forms of osteoarthritis and more difficult-to-treat rheumatoid types of arthritis. These ingredients come conveniently packaged with 3 Wobenzym®N tablets and 2 Painful Joints® capsules. This kit is exceptionally beneficial for anyone with actual joint pain. However, those suffering the disorders affecting strictly soft and connective tissue, as in fibromyalgia and allergic arthritis, may need to supplement with additional Wobenzym®N, as defined in the preceeding page as "FYI."

The Painful Joints® formula capsules are also available alone, therefore allowing each user to purchase the products that best suit their specific needs—single or in combination.

ULTRA MuscleEze®

When pain occurs in the soft and connective tissues, as in any of the myalgias, nutritional support is needed for synthesis of the myelin sheath and to maintain nerve cell function.

Ultra MuscleEze® made by BioGenesis® is a mineral amino acid chelate and vitamin beverage that includes malic acid, L-carnitine, and selenium for optimizing energy support. It can be mixed into food, water or juice. It contains the following ingredients to support reduction of pain and inflammation:

Magnesium—a co-factor in over 300 enzymatic reactions in human physiology. It supports neuromuscular activity, including energy production through carbohydrate metabolism.

Malic Acid—an important ingredient in production of energy within the mitochondria (energy factory of cells). It facilitates the delivery of lactic acid into the Krebs Cycle (a process creating ATP energy from glucose, also called the citric acid cycle), which helps clear lactic acid and prevents its build up.

Selenium—participates as a co-factor in glutathione peroxidase, an important antioxidant enzyme that supports the antioxidant effects of Vitamin E.

Glutamine—restores nitrogen balance, and promotes protein synthesis and muscle growth. It is the primary source of energy for cells lining the gastrointestinal tract.

Potassium—participates in transmembrane ionic shifts, contributing to neuronal transmission and muscle cell depolarization. The ion is essential to normal cardiac impulse generation and conduction.

Calcium—plays an important role in contraction within muscle cells, generation of transmembrane action potentials in cardiac pacemaker and conducting fibers, and transmission of impulses by nerve fibers.

Vitamin E—provides a primarily physiologic function to prevent free radical oxidation damage. This activity protects normal cellular structure and function.

Symbiotic (meaning in harmony) nutrients—
Molybdenum, L-carnitine, Taurine, Vitamin B_6,
Vitamin B_{12} and Folic acid.

The normal dose for this powder is 1 heaping tea-
spoon (approx. 5 grams) in water/juice or added to
any food. It should be taken twice daily for maximum benefit. One serving contains 500mg of protein.

"LIVE" FOODS REPAIR AND EXTEND LIFE: PHYTOSTEROLS/ STEROLINS

Tragically, modern food processing techniques remove two vital components from most foods, sterols and sterolins.

FYI:

‣ *Your health care professional may suggest you start with 1 teaspoon and slowly work up to 2 teaspoons twice a day. For those with multiple chemical sensitivities and leaky gut, it's best to start with 1/2 tsp. to avoid a negative reaction until tolerance level is established.*

‣ *Taking a powdered drink enables better absorption and less stress on the digestive system.*

‣ *This powder can be mixed with any of the medical foods, mineral replacements or organic protein powder.*

Unless you eat 75 percent to 90 percent of your food
uncooked, you are lacking sterols. Plant (phyto)
sterols and sterolins are plant "fats" present in all
fruits and vegetables. They are considered biologically active molecules isolated from plants called
"phytochemicals" that have been *clinically proven to
significantly modulate the effects of the immune
system.* Following ingestion, sterols are found in the
tissues of healthy people. The sterolins (glucosides)
are components that "activate" the sterols. Both are
needed and work together to enhance one's immune
function. Without sterols/sterolins in our diet, the
immune system may become too stressed to pro-

duce enough invader-fighting T-cells or may over-produce cells responsible for autoimmune responses. Some of the richest sources of sterols/sterolins are found in seeds. This is truly an example of the ancient saying "food is your best medicine."

The ideal method of getting the sterols we need is to eat food uncooked. This, however, does not fit our modern lifestyle or digestive systems. The healing power of raw foods comes from intact sterols and sterolins along with essential enzymes, vitamins and minerals. Victims of the "invisible illnesses" have compromised digestive systems that will not allow for eating as much raw food as would be required to get maximum benefit.

Modern food processing techniques remove sterols/sterolins from most foods. Preparation techniques such as freezing (which releases glucoside destroying enzymes), and boiling wipe out these beneficial substances. Sterols/sterolins dissipate quickly after harvesting, therefore, our foods today have little sterolin (slucoside) content left in them by the time we eat them. Just as importantly, foods in their natural state containing high amount of sterols/sterolins are hard to digest, even with perfectly functioning digestive systems. Therefore, we need supplementation in a highly absorbable form to get the true benefit of these remarkable plant lipids.

Sterols/Sterolins as Immune Enhancers:

Scientists have long been searching for a drug that could effectively balance the T-cells, strengthening the immune system against disease, yet controlling

the autoimmune reaction. The answer, as always, has been provided by nature—sterols and sterolins. There function is to *bolster an under active immune system and turn off an overactive immune system*, naturally. Taking both sterols and sterolins helps to balance the cells of the immune system so they can function optimally—either speeded up or slowed down.

By enhancing only the function of the TH-1 cells, and not the TH-2 helper cells, PhytoSterols/Sterolins may provide you with that crucial balance.

As reported in *Nutrition News*, the plant fatty acids/lipids, sterols/sterolins, have proven to be useful in the treatment of autoimmune diseases including lupus, multiple sclerosis, HIV, tuberculosis, multiple chemical sensitivities and hepatitis C, to mention a few.

Scientists are convinced these substances modulate and enhance T-cell function, and since T-cells are white blood cells produced by the thymus gland, they are a vital component of the body's complex immune system. They also specialize in fighting viruses and certain bacteria living inside the cells.

Autoimmune Responses:
You "DO" Have a Weapon in This War

Our body's immune system is like a production line in a factory; every step in the process is dependent on every other step—you, and you alone, ultimately control the switch. You can turn it off by eating "empty" food, or you can eat the foods tolerated at your present level of health, and supplement with

PhytoSterols/Sterolins to turn the switch "on" to achieve optimum health.

Illnesses, viruses and infections create an imbalance by suppressing our TH-1 cells. The TH-1 cells control the TH-2 (Type 2 helper) cell's release of chemicals (IL4, IL6 and IL10) that enhance the activity of B-cells. B-cells produce antibodies that literally attack invaders outside the cell walls. Therefore, a drastic reduction of the TH-1 immune chemicals (lymphokines) will allow the TH-2 cells to over over-produce their chemicals that will, in turn, create too many B-cells or antibodies. Too many antibodies cause an autoimmune reaction. Uncontrolled over-activity of B-cells is responsible for debilitating or chronic autoimmune disorders like Rheumatoid Arthritis, Lupus, Multiple Sclerosis (MS), Myasthenia Gravis (MG) and many others too numerous to name. Many allergies and asthma are also attributed to autoimmune responses.

Studies show that the pro-inflammatory IL6 and TNF-a chemical produced by the TH-2 cells are "switched off" when

FYI:

▶ *The State University at Buffalo New York reported that PhytoSterols/Sterolins might actually block the development of tumors in the colon, breast and prostate glands by altering cell membrane transfer in tumor growth.*

▶ *PhytoSterols/Sterolins have been shown effective in blocking the abnormal production of inflammatory proteins, thereby inhibiting inflammatory disorders by decreasing blood levels of Cortisol.*

▶ *Luc Montagnier, the discoverer of HIV, now advocates the use of PhytoSterols/Sterolins in conjunction with antiviral treatments.*

▶ *The State University of Buffalo at New York also found that PhytoSterols/Sterolins help block excess animal cholesterol absorption.*

▶ *The Journal of Complementary Medicine published an article regarding studies showing the benefits of PhytoSterols/Sterolins in immune dysfunctions such as chronic fatigue, MS, fibromyalgia, BPH, TB, psoriasis and some tumors.*

the cells are cultured in the PhytoSterols/Sterolins. Scientists monitoring the tests of Phytosterols/ Sterolins believe the plant fats have the ability to actually "turn off" the factors that initiate the inflammatory process.

Natural Sources of PhytoSterols/Sterolins:
These natural substances are available in a certified organic and/or chemical free whole food grain and seed complex, known as RevivAll™ by Garden of Life™. All ingredients are 100% pre-digested (by lacto-fermentation). Pre-digestion makes nutrients up to five times more bio-available to the body, increasing their effectiveness. In addition, no chemical extraction is ever used. This "Bio-Activated" blend contains pre-digested Brown Rice, Wheat Flakes, Rolled Oats, Maize Meal, Soy Beans, Pearl Barley, Sesame Seeds, Sunflower Seeds, Linseed and Buckwheat—and, all ingredients are *non-GMO* and *Gluten-free*. These bio-activated PhytoSterols and Sterolins in the original whole food form are available in capsules of 500 mg.

This type of supplementation has been invaluable to clients who are hyper-reactive to most foods and face the challenge of malnutrition and/or malabsorption due to digestive disorders and chemical sensitivity syndrome.

THERAPEUTIC BODY WORK

Introduction
by Virginia Taft, P.T., MFR® Therapist
"Getting In-touch With Your Body"

A Therapist's Advice For The Patient

A critical part of the healing process is getting in-touch with your body, and that means being-touched as well. The healing touch of an experienced practitioner of manual massage therapy is an invaluable tool for assisting the release of toxins from the body. Therapeutic bodywork can decrease pain, improve sleep, improve range of motion and flexibility, as well as provide relaxation and stress reduction.

Many techniques can be grouped under "manual therapy;" therefore, it is sometimes difficult to determine the type of treatment that would be of most benefit for your individual health. One important point to remember is that different people need different therapies at different times. It is often overwhelming to search for and choose the "right" technique, especially if you have not have any experience with therapeutic body-work. So where do you start? You start by consulting with a naturopath, integrative medical doctor or a physician that understands complimentary bodywork. Your health care provider will suggest the type of therapies to facilitate your wellness.

As a physical therapist and specialist in Myofascial Release® therapy, my first recommendation would be a preventive one. Before you are ill or injured, or after you've recovered from the illnesses described in this book, find and use bodywork

practitioners on a regular basis. Most of us would consider it foolish to drive our cars non-stop without maintenance. However, we do this constantly with our bodies. We wait until there is a crisis before we pay attention; by that time, our bodies may not just call to us, they may be screaming! This is why it is critical to listen to your body. You might just be feeling a little sluggish, stressed or "off" and need a "tune-up," that's the time to schedule an appointment with a therapist. When a crisis does occur, you have a better understanding of what you need and have developed relationships with practitioners who you trust to help you. True, lasting healing is not just about a quick fix for reduction/elimination of symptoms, it's a journey that consists of ups and downs and consistent maintenance.

An experienced practitioner of the healing arts has a whole variety of techniques that can be used to address your specific needs. For instance, in most massage techniques, pressure can vary from light to heavy; don't be afraid to ask for what you want, however, heavier or deeper is not always better. If you feel your body needs more pressure, a longer treatment in a specific area or a lighter touch—ASK. Your therapist may then see that he/she may be able to massage a little deeper into the tissue or a restricted movement. As the therapist responds to your feedback, you may be able to allow for deeper work. If you come up to the edge of pain, you may feel "therapeutic pain" which may be temporary discomfort, tingling, burning or aching—give it a couple of minutes, it will generally release soon so you

can move through it. If it feels "right" to you, continue—but don't allow yourself to feel forced into deeper therapy against your will. This type of bodywork therapy is not "no-pain no-gain." Pain is the body's warning mechanism, if your body says "NO" respect that message. Forcing through pain may delay your progress, or even cause re-injury.

After a massage therapy you may experience light-headedness, drowsiness, aching or flu-like symptoms from the release of toxins in the body. To assist the body's release of toxins, it is imperative you drink plenty of water (not soft drinks, coffee, tea or even fruit juice). It is also important to continue to move and stretch-out any tight areas, rather than letting yourself fall back into old patterns of poor posture and movement.

In my 20 plus years of physical therapy, I found Myofascial Release® to be specifically beneficial, especially for patients of the invisible illnesses described herein.

Myofascial Release®:
The Body's Connective Force

Myofacial Release® therapy (MFR)® is comprised of two words, "Myo" referring to muscle and "Fascia" the tough connective tissue surrounding the body structure. The fascia spreads throughout the body in a three-dimensional web, traveling head to toe uninterrupted and acts as a "shock absorber" for the body.

Myofascial Release® therapy (MFR)® is a hands-on, gentle, highly effective form of treatment to release restrictions, improve mobility, decrease pain and assist patients in resuming function and quality of life.

MFR® compliments other medical and complementary treatments to allow for a truly wholistic approach.

MFR® technique provides sustained pressure into the myofascial restrictions of the fascial system (or connective tissue). Fascia is very densely woven, covering and interpenetrating every muscle, bone, nerve, artery and vein as well as all of our internal organs including the heart, lungs, brain and spinal cord.

The most interesting aspect of the fascial system is that it is not just a system of separate coverings. It is actually one structure that exists from head to foot without interruption. In this way you begin to see that each part of the entire body is connected to every other part by the fascia, like the yarn in a sweater (See diagram on page 145).

Fascia also plays an important role in the support of our bodies, since it surrounds and attaches to all structures. These structures would not be able to provide the stability without the constant pull of the fascial system. In fact, our bones can be thought of as tent poles, which cannot support the structure without the constant support of the guide wires (fascia) to keep an adequate amount of tension to allow the tent (body) to remain upright with proper equilibrium.

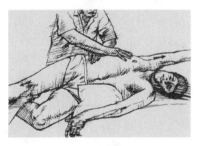

*MFR Therapy
Techniques*

In a normal healthy state, the fascia is relaxed and wavy in configuration. It has the ability to stretch and move without restriction. When we experience physical trauma or inflammation, how-

ever, the fascia loses it pliability. It becomes tight, restricted and a source of tension to the rest of the body. Trauma, such as a fall, whiplash, surgery or just habitual poor posture over time has a cumulative effect. The changes they cause in the fascial system influence the skeletal framework of our posture. The fascia can exert excessive pressure producing pain or restriction of motion. It affects our flexibility and is a determining factor in our ability to withstand stress and strain.

The use of MFR® allows us to look at each patient as a unique individual. Myofascial Release® promotes independence through education in proper body mechanics and movement, through the enhancement of strength, flexibility, and postural and movement awareness.

When the fascia tightens following injury, repetitive motion, stress, inflammation, poor posture or scarring, it pulls, often on already sensitive structures. The fascia tightens over time, and if left untreated, is often the underlying cause of chronic, invisible pain as in fibromyalgia. The pain is not always where the restriction is; pulling of a distant part can put a drag on the entire body. As an example, imagine sewing up a hole in a sweater. The tightened hole may pull at the hem, neck and sleeve of the garment. Likewise, in your body, hand pain may result from tightness in the neck and shoulders, leg pain from misalignment of the pelvis, or low back pain from restriction or scarring of internal organs.

Trauma, posture or inflammation can create a binding down of fascia, resulting in abnormal pressure on nerves, muscles, blood vessels,

osseous bone structures and/or organs. Since many of the standard test such as x-rays, myelograms, CAT scans, electromyography, etc., do not show the fascial restrictions, it is entirely probable that an extremely high percentage of people suffering with pain and/or lack of motion may be having fascial problems, however, most go undiagnosed by conventional methods.

Fascia is likened to the threads of a sweater

MFR®: Its History

Myofascial Release® therapy was founded by internationally recognized physical therapist John F. Barnes, more than thirty-five years ago. He developed this innovative and effective whole-body approach for the evaluation and treatment of pain and dysfunction. He and his instructors have trained over 20,000 therapists and physicians in MFR®, in his therapy and education centers located in Sedona, Arizona and Paoli, Pennsylvania.

Conventional therapists, tired of working in "assembly line" atmospheres focusing on quick symptomatic treatment, and who are over-loaded with burdensome paperwork are joining facilities and private practices that focus on Myofascial Release®.

Barnes believes that health professions have ignored the importance of an entire physiological system, the fascial system—profoundly influencing all other structures and body systems. This glaring omission has severely affected the effectiveness and lasting quality of conventional efforts. Including MFR® into the current evaluatory and treatment regimes allows therapists and physicians to provide a more comprehensive approach

Fascia and how it can affect over-all structure alignment

for the patient that is safe, cost-effective and consistently effective.

According to Barnes, fascial restrictions can exert tremendous tensile forces (stress, tension) on the neuromuscular-skeletal and other pain sensitive structures. This enormous pressure (more than 2,000 pounds per square inch) can create the very symptoms that we have so long been trying to eliminate. The knowledge of MFR® frees us from only trying to relieve symptoms—it gives us the tools needed to find and eradicate the cause and effect (symptoms) relationship. It provides a permanent resolution of the patient's complex problems, applying the true principle of health-care verses symptom-care.

FYI—Important facts concerning fascia

- *It supports and stabilizes, thus enhancing the postural balance of the body.*
- *It is vitally involved in all aspects of motion and acts as a shock absorber.*
- *It aids in circulatory economy, especially in venous and lymphatic fluids.*
- *Fascial change will often precede chronic tissue congestion.*
- *Chronic passive congestion creates the formation of fibrous tissue, which then proceed to increase hydrogen ion concentration of articular periarticular structures.*
- *Fascia is a major area of inflammatory processes.*
- *Fluid and infectious processes often travel along fascial planes.*
- *The central nervous system is surrounded by fascial tissue (dura mater) which attaches to the inside of the cranium, the foramen magnum and at the second sacral segment. Dysfunction in these tissues can have profound and wide-spread neurological effects.*
- *Every muscle of the body is surrounded by a smooth fascial sheath.*
- *Every muscular fascicule is surrounded by fascia.*
- *Every fibril is surrounded by fascia.*
- *Every micro-fibril down to the cellular level is surrounded by fascia that can exert pressures of over 2,000 lbs. per square inch—no wonder our muscles feel like we're carrying the weight of the world on our shoulders!*
- *The fascia ultimately determines the length and function of its muscular components.*

Diet and Nutrition

NIGHTSHADE FOODS AND THEIR
CONNECTION TO PAIN AND INFLAMMATION

Most of my clients have never heard the term "nightshades," much less make the connection to a food group that contributes to pain and inflammation. Nightshades are a botanical group known as *Solanaceae*, they make up over ninety-two varieties and over two thousand species.

> **The nightshade group includes:**
>
> Tomatoes Potatoes
> Eggplant Tobacco
> Paprika Pimento
> Peppers of all kinds (red, green, yellow, chili, paprika, cayenne, hot/sweet)
>
> Black and white pepper, of the seasoning variety, is NOT a nightshade.

The connection of nightshades and arthritis type disorders was brought to the forefront largely by the efforts of Dr. Norman F. Childers, former Professor of Horticulture at Rutgers University. Dr. Childers knew first hand the pain of severe joint pain and stiffness. He discovered that after consuming a meal containing any tomatoes, he experienced severe pain. As his interest in the inflammatory responses to nightshades grew, he observed livestock kneeling in pain from inflamed joints. The livestock had consumed weeds containing a substance called *solanine*. *Solanine* is a chemical known as alkaloid, which can be highly toxic.

Since I live in Idaho, known worldwide for its potatoes, it has been extremely difficult to eliminate potatoes from my diet. Even as a child, potatoes (especially mashed with gravy) were always my "comfort food." However, what many of us potato

lovers didn't know is that potatoes, especially those stored improperly or aged, have been known to cause toxic symptoms severe enough to require hospitalization. These symptoms range from gastrointestinal inflammation, nausea, diarrhea, and dizziness to migraines. It is believed that the reason for the toxicity in potatoes is the solanine that is present in and around the green patches and the eyes that have sprouted.

I have many clients with both gastrointestinal and inflammatory disorders that resist eliminating nightshades, even for an initial trial period of 90 days. Those that do, however, return to report the amazing improvement in symptoms of fibromyalgia, chronic fatigue, headaches, arthritis, gout, carpal tunnel and scleroderma, to name a few.

Another consideration is to refrain from taking any homeopathic remedies that contain Belladonna (known as the deadly nightshade). Belladonna is widely

FLASHBACK

I was recently on a business trip and enjoyed a meal in a five-star restaurant. I ordered broiled salmon, salad and steamed vegetables of broccoli, zucchini and carrots. I informed the chef of my dietary restrictions and he assured me he understood about my sensitivity to nightshades, preservatives and wheat/gluten. When my meal was delivered he had placed red and green peppers on my fish for esthetic effects. He had been very kind in listening to my culinary requests, so I decided I was healthy enough to just place aside the peppers and eat the remainder of my meal. The following morning, I could barely get out of my bed at the hotel. I was stiff and my arms and legs ached as if I had been beaten. I then remembered the peppers perched on my fish. I can't emphasize enough that the nightshades cannot even touch your food, in any way, if you are to free yourself of symptoms and continue to enjoy wellness after you've eliminated nightshades from your diet.

Many of my clients have learned the hard way, as I did. Even using the same cooking utensil to stir or serve a nightshade cannot be used for someone who is sensitive to their effects, which includes most victims of the "invisible illnesses."

used in homeopathy with positive results for various conditions. However, anyone sensitive to the nightshades, should refrain from any remedy containing this substance.

In recommending any type of elimination diet, there is always resistance—echoing that it's too difficult to find adequate substitutions. When people have tried every other means to eliminate the pain and stiffness that deteriorates their quality of life, to no avail, they finally agree to eliminate the nightshade family of foods. The most challenging aspect of the diet is to take time to read labels. Many of the nightshades are actually "hidden" in a wide variety of prepared foods. Therefore, if you don't take the time to scrutinize every label before buying or eating its contents, you will not achieve the benefits.

It is recommended to use this elimination diet for a *minimum* of 90 days; however, best results are achieved in 6 months. After the diet has been followed to a tee, resume eating foods in the nightshade family and observe how you feel. It has been suggested by people who comment "I cannot do without tomatoes or potatoes," that they may be just as addicted to this specific group of foods as those addicted to tobacco. Someday scientists may actually find and validate evidence that nightshades are an addicting substance.

The nightshade plants are not limited to those we eat or smoke. Ornamental plants are also in the family: petunia, chalice vine, day jasmine, and the Angel's and Devil's trumpet. Other plants have long provided medicinal drugs such as belladonna, atropine and scopolamine (used widely as an ingre-

dient in sleeping pills). **Patient beware:** If you're taking sleeping pills containing these substances, you may get a good nights sleep but wake up stiff and in pain and not relate it to the nightshade.

The specific origin of the word "Nightshade," is not clear. The English apparently called this member of the *Solanum* genus, "Nightshades" because of their "evil and loving" narcotic nature of the

FYI:

1 In L.H. Bailey's Encyclopedia of Horticulture, *it is said, "Potatoes when exposed to the direct rays of the sun and "greened," the deleterious substance (solanine) is so greatly increased that the water in which they are boiled is frequently used to destroy vermin on domestic animals. In any case, the water in which potatoes with peel are cooked should not be used in the preparation of other foods such as gravies."*

2 *Cholinesterase is an enzyme in the body originating from the brain that is responsible for flexibility of movement in the muscles.* Solanine, *present in nightshades, is a powerful inhibitor of cholinesterase, in other words, its presence can interfere with muscle movement—the cause of stiffness experienced after consuming the nightshades. All people are not sensitive to Nightshades in the same degree, hence, some people develop inflammatory disorders, others do not.*

3 *Livestock have died in North America and Europe after ingesting potato vines, sprouts, peeling, and greened spoiled potatoes.*

4 *According to A.A. Hansen, a researcher, human fatalities are also documented.*

5 *Arthritis among people in Peru is an increasingly common disease, as is the average life span of 25-30 years. Peruvians mostly grow potatoes instead of grain because of their climate.*

6 *Potatoes are used in the production of alcohol (including vodka), synthetic rubber, starch in sizing textiles and paper.*

7 *Potato flour or starch is used to give body to breads, doughnuts, biscuits, candies, cookies and soups. It is widely used in baby foods, possibly setting the stage for inflammatory disorders.*

8 *Paprika, widely found in many items in grocery shelves and sprinkled on foods, comes from a non-pungent pepper mostly grown in Hungary, which has a higher rate of cancer than surrounding countries.*

night. Also the Latin word, "*solamen*" means quieting with sedative qualities. It is also written that the ancient Romans were said to prepare potions from the deadly nightshades and offer them to their enemies—they pulled the shade over their enemy's life for a long night! They died!

The United States alone spends an estimated $50 billion a year in medical expenses, loss wages

9 *The tomato was originally known as "The Love Apple," and grown at first only as an ornamental. It was considered poisonous and disease producing, and still is in some European communities. The vines and suckers are extremely poisonous to livestock as well.*

10 *According to Early American Horticulture, the tomato was known as the "Cancer Apple." Literature shows that the drug, Tomatine in the tomato has toxicity similar to Solanine in the potato.*

11 *The garden pepper includes many varieties in the* Capsicum *family and includes Tabasco pepper, cherry, red cluster, bell, sweet, green, pimento, chili, long and red peppers. The garden pepper should not be confused with black pepper used as a condiment, which is the small berry of a tropical vine. Black or white pepper does not seem to aggravate arthritis and inflammatory disorders.*

12 *Eggplant,* Solanum Melongena, *was also only grown as an ornamental in early years. It was called the "Mad Apple" in Mediterranean culture because it could cause insanity if eaten daily for a month. Consumption of this food aggravates inflammation and pain, the same as the other nightshades.*

13 *Many cultures consume tomatillo,* Physalis ixocarpa, *and are unaware that it is part of the nightshades, the symptoms are the same as with it's nightshade cousins.*

14 *Research also warns about consuming the garden huckleberry,* Solanum nigrum, *native to my home in northern Idaho.*

15 *Always be suspicious of labels reading "spices," "vegetable starch," "natural flavoring," or "seasoned salt." Most of these contain potato starch or tomato in some form. If the ingredients are not specifically listed individually, don't use it. Many sufferers have diligently adhered to their no nightshade diet, only to experience the same symptoms from "hidden" ingredients.*

16 *Avoid condiments such as ketchup, Worcestershire Sauce® and most steak, poultry and fish sauces—instead make them homemade so you can control the ingredients.*

and worker-compensation benefits as a result of chronic pain. According to John J. Bonica, President of the International Association for the Study of Pain, "chronic back pain alone, the most common problem, disable over seven million people annually and is responsible for nearly 19 million visits to doctors each year," at a cost of over 10 billion dollars, according to an estimate by the National Institutes of Health in the 1980's. More than 20 years later, the numbers continue to rise at alarming rates, exceeding 20 billion annual dollars attributed to pain related doctors visits. It appears our dietary lifestyle choices, which include the nightshades, are a large contributing factor.

> **FLASHBACK**
>
> *I knew giving up potatoes was going to be a hardy sacrifice. In searching for alternatives, I found using parsnips just as satisfying. I peel them, boil them, mash them, slice them and sauté them with onions like hash-brown potatoes. I include them in oven roasting and even make fried mashed parsnip patties from leftovers. The taste is sweeter but pleasant, and most importantly, does not cause the pain and inflammation that last for days and even weeks from consuming nightshades.*

GLUTEN: "GLUE" FOR YOUR "GUT"

Most people have heard the term gluten intolerance, however, few people actually understand the problems associated with this disorder. Gluten is a mixture of proteins that are present in some cereal grains, but mostly in wheat. Some people are gluten intolerant from birth; others develop it from disorders associated with the digestive system, mainly the small intestine. When gluten intolerance becomes acute, the condition is clinically known as celiac's disease, non-tropical sprue, or gluten-sensi-

tive enteropathy. Gluten is a thick, syrup like substance that allows the binding in bread dough—it is what makes bread bounce. A specific type of gluten protein, Gliadin, is found in rye flour and in

FLASHBACK

I became gluten intolerant, as do many of my clients, after developing leaky gut. The symptoms were acute constipation, cramps, bloating, weight loss, malabsorption, muscle weakness and extreme fatigue. Generally, relief is experienced after as soon as 2 weeks, when a gluten-free diet is strictly adhered to. In my clinical experience, I found that about half of the individuals could again resume diets containing gluten, after complete healing of the leaky gut. However, the remainder, like myself, lose their tolerance for gluten altogether.

It was challenging, to say the least, to learn to cook all over again without gluten. The most difficult was eating out because of all the prepared food and seasonings that contain "hidden" gluten, not to mention the nightshades. With all the new flours available today, cooking doesn't have to be difficult, just viewed with a different perspective – after all, you can still make your favorite gravy, except with rice flour instead of white wheat flour.

The only substitute I haven't been able to master is piecrusts with rice flour—but then, no one ever said I was a good baker, just a gourmet cook. A dear friend and client Jean Mace, who is an excellent baker, mastered the rice flour piecrust and now delivers one to my office about once a month—a luxury my health can now afford, thanks to my overall detoxifying and healing routine, Naturally.

Gluten-Containing Flours:

Barley	Buckwheat	Oat	Spelt	Rye	Triticale
Millet	Quinoa (contains small amounts of gluten)				

Wheat (semolina, durum, white, kamut, couscous, bulgur, whole wheat)

Gluten-Free Flours:

Rice	Corn	Garbanzo (chick pea)	Arrowroot	
Kudzu	Amaranth	Potato	Soybean	Bean

NOTE: Be sure and read labels carefully; the label may say "Wheat-free" and actually contain other ingredients with gluten. It must be "Wheat-free" and "Gluten-free."

blends of flour called triticale.

Many individuals develop gluten intolerance *after* developing a digestive disorder like leaky gut, ulcerative colitis, Crohn's disease, irritable bowel, and various immune system disorders. Nutritional deficiencies occur as a result of a damaged intestinal tract, leading to malabsorption. Consequently, because of the vitamin and nutrient deficiencies that occur, many individuals develop iron-deficiency anemia and extreme fatigue—many suffering for years before receiving a correct diagnosis. Irritable bowel syndrome and inflammatory bowel disease may actually be a side effect of gluten intolerance.

There are also those who, *because of gluten intolerance*, develop a variety of skin disorders

FYI: My Favorite Pie

In my constant search for "clean" foods, I was contacted by a company called Natural Feast®. *Because of the company's dedication to specialty foods for special needs, they are now manufacturing a line of pies and other "clean" food items (muffins, cakes, etc.) that are safe for most sensitive individuals. These great tasting pies meet the needs of the following special dietary groups, as well as the demanding tastes of all health conscious gourmets.*

▶ *Allergic or intolerant to certain grains—this group includes celiacs and others who are unable to tolerate the gluten in wheat, oats, barley and rye, and must avoid all foods which include these ingredients or their derivatives.*

▶ *Diabetics and Candida Patients—people who must monitor their refined sugar and carbohydrate intake to prevent symptoms.*

▶ *Hypoglycemics—those who, like diabetics, must avoid high levels of sugar.*

▶ *Vegetarians and others—who prefer all natural, gourmet quality foods with no dairy or animal fats.*

▶ *Kosher—these products are certified for this group of individuals*

▶ *Multiple Chemical Sensitivity Patients—these products are easily tolerated because they are free of artificial additives, preservatives and coloring.*

(psoriasis, eczema, dermatitis). If you have been diagnosed and medicated for these disorders, be sure appropriate testing is performed to rule out an invisible cause such as gluten intolerance. With a correct diagnosis of the root cause, you can then proceed to embark on a plan for healing, Naturally.

THE BODY'S ELECTRICAL SYSTEM: "A WHEY OF LIFE"

Minerals are the body's electrical transmitters. They serve as electrical signals to every cell. Brain signals are transmitted through body fluids. Intestinal disorders, particularly leaky gut and diarrhea, cause a deficiency of minerals. Since minerals are stored primarily in the body's bone and muscle tissue, the absorbed

FYI: My Favorite Pie continued

▶ *Fibromyalgia/Arthritis/Inflammatory Disorder Patients—* *these products are suitable for this group of individuals because they contain NO nightshades which have been shown to accelerate the inflammatory process.*

▶ *Compromised Intestinal Tract and Digestive Disorder Patients—* *these products do not contain the grains, refined sugars and diary that can compromise gut integrity.*

Natural Feast® pies are an exceptionally delicious dessert, naturally.

▶ *No Hydrogenated Oils*

▶ *No Corn*

▶ *No Dairy*

▶ *No Refined Sugars*

▶ *No Wheat or Gluten*

▶ *No Additives or Preservatives*

▶ *Nightshade Free*

▶ *GMO Free*

▶ *No Cholesterol in Most Pies*

▶ *Reduced or Low Fat*

The pies are available in the following flavors: Chocolate Mousse, Blueberry, Cherry, Apple, Boston Crème, Key Lime, Pumpkin, Walnut Torte, Raspberry, Peach. There is also a walnut torte cake.

For a distributor near you, contact Natural Feast® Corp. at www.naturalfeast.com or call (508) 785-3322 eastern time.

mineral must be carried by the blood to the cells and then absorbed by the cell membrane to be utilized.

Individuals with inflammatory and circulatory disorders especially experience muscle spasms, tingling, numbness and "brain-fog." These symptoms can be caused by a deficiency of minerals. However, the supplementation must be easily absorbed in order to be effective.

A supplement that is superior in "re-connecting" the body's electrical system is organic mineral whey powder. This powder is a mineral-rich, golden brown, dry natural food dehydrated from organic goat milk whey. The nutritional analysis of whey confirms it to be high in natural amino acids and minerals, and contains some vitamins. The soluble protein lactoglobulins in whey are identical to serum globulin in human blood and contain antibodies that strengthen the immune system. The amino acids in whey are rated higher in bio-availability than those in eggs, soy, rice, wheat and beef, according to the World Health Organization.

In those individuals where any type of cleansing, especially colon cleansing, is part of their healing regimen, mineral supplementation is vital. When cleansing takes place, not only are toxins eliminated, but also minerals and electrolytes. These electrolytes make up the electrically charged ions that help regulate water balance, acid-alkaline balance, osmotic pressure, nerve impulse conduction, and muscle contraction.

A product that contains the mineral combinations found in whole foods, is high in sodium, potassium and calcium and has an alkaline reac-

tion is Capra Mineral Whey® made by Mt. Capra Cheese Company™. The powder is grainy but very sweet and tasty, much like a combination taste of Ovaltine™ and Graham Crackers™. It contains a jam-packed array of minerals and electrolytes in each serving—in potassium alone it packs a walloping 884 mg. per two tablespoons. Mineral whey is not only essential in restoring the body's electrical balance, but in maintaining it, naturally.

INTESTINAL ECOLOGY: CREATING A BALANCE

Understanding *Candida*: An Important Weapon in the Battle for Health

Candida is a form of Dysbiosis, meaning that the beneficial bacteria in our bodies are out of balance. Dysbiosis was named by Dr. Eli Metchnikoff in the early 1900's. He won the Nobel Prize in 1908 for his work on *lactobacilli* (beneficial bacteria) and their role in immunity. Metchnikoff was a colleague of Louis Pasteur and succeeded him as the director of the Pasteur Institute in Paris. The origin of the term "Dysbiosis" originated from the word "symbiosis," meaning to live together in mutual harmony. Dysbiosis was derived from the original term by the prefix "dys," meaning *not*—example, "dys" is dysfunction, meaning to *not* function as opposed to functioning.

When our bodies have a balanced intestinal ecology, they are armed with beneficial bacteria to combat the overgrowth of yeast, fungi, parasites, and health-depleting bacteria. When dysbiosis occurs, these organisms continue to multiply and eventually manifest in most of the invisible illnesses described in this book.

Candida is a normally occurring fungus living in the mucous membranes, especially in the digestive tract and vagina. It can also be found in the sinuses, ear canals, and genitourinary tract. The body in symbiosis can handle normal amount of this fungus, but when it becomes over-growth, it contributes to the decline of digestive health that leads to many other serious invisible illnesses. Anything weakening the immune system encourages the growth of *Candida*. When the yeast outnumbers the beneficial bacteria, the condition is known as "candidiasis."

Causes of *Candida*: A Fungus That Can Kill You, or Make You so Sick You Wish You Were Dead!

There are many causes allowing *Candida* yeast to grow out of control. Our western civilization is accustomed to a diet of fast and convenient foods rich in sugar, carbohydrates, yeast, and preservatives—another major cause is the over-use of antibiotics.

It's been widely reported that antibiotics change the balance of intestinal micro-flora. Antibiotics kill both beneficial and harmful bacteria throughout our body, especially in our digestive system. This altered state creates the perfect condition for bacteria, parasites, viruses, and yeasts that are resistant to antibiotics. In a healthy intestinal tract, these harmful bacteria may be present in small numbers without any adverse reactions or symptoms. However, once the overgrowth occurs, they produce waste material that becomes poisonous chemicals to the cells and the body they live in.

Candida (yeast) is nothing new to the medical profession. As stated previously by Dr. Ralph Golan, and bears repeating, "At one extreme, it can cause skin rashes or vaginal infections (Mucocutaneous Candidiasis). At the other extreme, in individuals whose immune systems are severely compromised, yeast can invade the entire bloodstream (Candidemia) and cause death." Your *Candida* may not have reached life-threatening proportions, but nonetheless present a major roadblock to health.

With *Candida*, not un-like some of the other invisible illnesses of fibromyalgia, chronic fatigue, depression, brain fog, and multiple chemical sensitivities, a very different opinion is finally emerging—that yeast is not an invisible entity but an opportunistic fungus causing a changed state of the organisms, a disturbance of the natural equilibrium or harmony of the body systems.

Yeast Infections: Feed The Craving, Starve The Body

It's important to understand that *Candida* (aka: Yeast, *Candida* Albicans and Systemic Candidiasis) is an *invisible invader of health* whose symptoms manifest as diverse variables from person to person. It is a fungus that manifests "underground" cravings in its victims in order to survive and provides its host (you) with toxic by-products that, given the right systemic conditions, can literally kill you.

The following definitions are provided to assist you in understanding the disease we know as *Candida*:

CANDIDA—A genus of yeast-like fungi that develop a pseudomycelium and reproduce by a

process called "budding." This fungi is the primary etiologic agent for many diseases called "mycotic" (a disease caused by microorganisms, specifically yeasts and fungi).

CANDIDA ALBICANS—A small, oval shaped, budding fungus, the primary etiologic organism of moniliasis (Candidiasis). Formerly known as "monilia albicans."

Candida knows no boundaries. It is a disease that can transform a healthy, energetic, *obviously* healthy individual, into an individual with chronic symptoms that can only be defined as the prototypical lifestyle disease; in some individuals its symptoms are only minor annoyances; in others it can be *life-threatening. Candida* shatters the immune system and is affected by toxins as well as varied allergens in the actual *Candida* organism. This action allows dozens, if not hundreds, of environmental influences to batter the body and slowly lead us to a path of self-destruction. The spread of *Candida* spares few, if any, organ systems. Few conventional physicians recognize the widespread catastrophes associated with one little organism—one that has heretofore been considered to be only a nuisance in a few people, mostly women.

Symptoms of Candida

General

Cravings for high carbohydrate foods: pasta, dairy, popcorn, crackers, breads and grains
Cravings for sweets, natural or refined sugars: Candy, pastries, sweetened drinks, fruit

Loss of appetite, chronic fatigue, hair loss, chronic weight gain or loss, lack of coordination or dizziness, insomnia or lethargy. Symptoms are usually worse on damp days or when exposed to damp moldy areas, such as basements.

Emotional Symptoms

Nervousness, anxiety, depression, confusion and/or poor concentration and memory. Chronic mood swings, headaches, hypoglycemic-like symptoms and feelings of your brain not communicating with your body, another example of "your mind writing checks your body can't cash." These symptoms persist even though conventional medical tests are not conclusive.

Cardiovascular Symptoms

Cold hands and feet, muscle cramping in legs, wheezing/coughing leading to a diagnosis of adult on-set asthma. Heaviness in chest or mitral valve prolapse, chronic chest pains similar to experiencing a heart attack, sometimes accompanied by symptoms of tachycardia.

Muscle/Joint Symptoms

Tingling, numbness or paralysis of the extremities, poor coordination and muscle weakness. Aches and pains in soft and connective tissues, generally associated with fibromyalgia and chronic fatigue syndromes. Stiffness, swelling and associated arthritic symptoms.

Urinary Symptoms

Frequent bladder/ kidney infections, frequent urinating and burning.

Eyes/Ears/Nose/Throat Symptoms

Blurred vision, vision spots, reoccurring eye or ear infections, pain or fluid in ears, heightened sensitivity to noise, periodontal inflammation and infections, white patches in mouth and tongue, chronic halitosis, chronic nasal congestion, postnasal drip and sinus infections.

Skin Symptoms

Chronic acne, itching, scaly skin, psoriasis, athlete's foot, toenail or fingernail fungus.

Multiple Chemical Sensitivities

Rashes, hives, itching, swelling and redness, allergies to food, water or environmental allergens—in extreme cases, anaphylactic shock.

Gastrointestinal Symptoms

Chronic bloating, gas, cramping, usually accompanied by chronic constipation or diarrhea.

Symptoms Specific to Women

Vaginal or rectal discharge of thick mucous and/or white "yeasty" substance usually accompanied by itching or burning. PMS or menstrual cycle abnormalities, endometriosis, or loss of sexual desire.

Symptoms Specific to Men

Loss or decreased sexual desire, prostate problems, or loss of libido.

Symptoms Usually Specific to Children

Thrush, chronic diaper rash, chronic colic, reoccurring ear infections, hyperactivity, learning challenges, attention deficit disorders, chronic nasal congestion and post nasal drip, cravings for carbohydrates and sweets.

Candida: Fighting Your Fungus, Nutritionally

In eliminating and managing *Candida*, and the invisible illnesses that manifest as a result of a toxic and weakened immune system, effectiveness depends primarily on diet, diet, diet. The old saying "you are what you eat" is more relevant than ever in cases of *Candida*, albeit not the entire cause or solution. In order to understand how your diet is contributing, if not initially causing, your infection, we need to consider the foods that contribute to yeast overgrowth.

Just as with diabetics, carbohydrates must be limited in order to control or eliminate yeast. The pancreas converts carbohydrates to sugar, therefore, a diet with abundant pasta, breads and potatoes will contribute to yeast overgrowth with nearly the same intensity as eating refined sugars and fruits.

Proven Dietary Recommendations
I Share With My Clients

Eat plenty of leafy green vegetables and avoid or limit the ones high in carbohydrates. The following list provides a brief overview of the dietary sugges-

tions used in my clinical practice. The listing shows the amount of carbohydrates contained.

3% or less—These can be consumed on an *"unlimited"* basis. All leafy greens and vegetables high in protein, such as avocados. Also, asparagus, broccoli, cabbage, cauliflower, celery, Swiss chard, cucumber, radish, spinach, watercress, onion, garlic, chives and seeds.

6% or more—String beans, beets, Brussel sprouts, collards, eggplant, leeks, parsley, red pepper, pumpkin, kale, turnips, rutabagas, kohlrabi, these should be limited and counted in your daily allowed intake, but not avoided.

15% or more—Artichoke, parsnip, green peas, squash, carrot

20% or more—Dried beans, lima beans, corn, white potato, sweet potato, yam

Fruit and dairy products should be avoided, or at least limited to one serving a day equal to $1/2$ cup.

All **animal proteins** can be consumed in *"unlimited"* quantities, within moderation—chicken, turkey, fish, beef, and wild game. *Note:* In some individuals all animal products should be avoided at least for the initial *Candida*-killing period, check with your health care provider for guidance.

All **sugars** should be avoided including, honey, molasses, maple syrup, fructose etc.

The following **quick-acting carbohydrates** count as one serving in the indicated quantities:
- $1/2$ cup White Rice or Pasta
- 1 cup Brown Rice
- 1 cup Milk (Rice, Soy, Almond)
- $1/2$ cup Cold or Hot Cereal
- $1/2$ cup Fruit Juice
- 1 slice whole grain or rice bread

In individuals with **extreme sensitivity** to **molds** and **yeast**, the following should be strictly avoided:

- Breads, pastries and other baked goods containing yeast
- All cheeses, especially moldy cheeses such as Roquefort, Stilton and Blue Cheese
- All condiments containing vinegar
- All products containing malt, including cereals and candy
- Dried and candied fruits of any type
- Leftovers—they create mold quickly
- Edible fungi—all types of mushrooms, morels and truffles
- Processed and smoked meats and cheeses
- Melons—especially cantaloupe (you can actually smell the mold)
- Nuts—they generally contain mold
- All alcohol
- Sprouts—they contain mold

When a victim of *Candida* manages his/her diet for 90 days, limiting their servings of all foods not on the unlimited list to 3 servings a day (in the referenced quantities), there is an impressive reversal of symptoms and overall improvement of health. Generally a serving is equal to $1/2$ cup.

When these guidelines are strictly adhered to for 90 days, along with a professionally guided cleansing therapy routine for the colon, the body will suffocate or starve the yeast fungus. In some cases, there is an initial worsening of symptoms and cravings as the yeast die off (Herxheimer reaction), as the associated toxins circulate through the body. The yeast fungus eats first, and your body gets

their leftovers, including toxic by-products of their digestion and the actual die-off.

While localized yeast symptoms can appear in the form of a vaginal infection or common allergies, yeast organisms can also change from a simple yeast to an invasive fungus. The result is a condition called "polysystemic chronic Candidiasis," meaning yeast or fungal toxins affecting the entire system. One of the most powerful toxins emitted by yeast is acetaldehyde, similar to formaldehyde (**embalming fluid**)! With a systemic yeast infection, the body is literally being embalmed while still alive, is it any wonder we experience brain fog, fatigue, lack of coordination, anxiety or depression (to mention a few)?

Mold: The Champion Magician— Now You See It, Now You Don't

Just because you don't have visible evidence of mold growing, doesn't mean it's not there. The best breeding ground for mold is your refrigerator—yes, I said refrigerator. These molds are not a homegrown crop of penicillin to make your own antibiotic, they're dangerous. They can magically transform a once nutritious food into a toxic poison.

Precautions: Visibly Moldy Food

• Remove any area of mold from food with at least an inch all around the moldy area. This will reduce the risk of invisible mold growing from the infected spot.

 This can *only* be done safely on *firm* foods such as: cheese, hard salami, carrots, cabbage

etc. The food should be immediately re-wrapped as air tight as possible, and consumed before more mold appears (usually within 2-3 days).

Soft vegetables, fruits, and food such as, but not limited to: tomatoes, cucumbers, lettuce, berries, melons, avocados, butter, jellies, jams, yogurt, and sauces etc., should be discarded immediately at the sign of mold.

Foods such as, bacon (turkey or pork), sausage, hot dogs, luncheon meats, chicken, ham, and essentially any meat, should be discarded immediately.

- *NEVER* smell a food that is moldy, especially if you have allergies and/or Candida. Mold sores are airborne and can cause severe allergic reactions, some immediate, some delayed—as in the case of muscle pain and fatigue.
- Discard any bread with visible mold. If one slice is moldy, it's a good bet invisible mold has already threatened the entire loaf.
- Discard any nuts, seeds, and nut butters (like peanut or almond butter) at the first sign of mold.
- Discard any grains at first sign of mold

Precautions: Staying One "Trick" Ahead of The Mold

- Drinking-water Bottles—Always wash in hot soapy water, preferably in a dishwasher. Many of us take our own drinking water wherever we go. It is important to remember that *invisible* mold and bacteria forms in the bottle once it's opened—what started out as a healthy measure

can turn into an un-healthy threat. Once your bottle is empty, *do not* refill the bottle until it is properly cleansed.

- Always clean your refrigerator in the area where a food has been identified as moldy. Check the surrounding foods and wipe any containers or food to inhibit the invisible mold and prevent it from multiplying. White distilled vinegar is a safe product to use (full strength) to clean the area. Another product, which I find superior, is Organic Choice™. It's a fragrance-free all purpose cleaner that removes and inhibits mold growth. This non-toxic product is widely used in commercial kitchens because of its ability to not only clean, but also degrease and protect. I have personally used and recommended Organic Choice™ for cleaning mold infested commercial and residential buildings and for general cleaning to inhibit mold in damp areas. If a surface can be safely cleaned with a water-based product, Organic Choice™ is the only product you'll need. Since experiencing chemical sensitivities, I use it for everything.

- In the winter, clean the inside of your vehicle to protect against the dampness from rain and snow and the potential of mold forming in the carpet and upholstery.

- Another area that is commonly overlooked for mold and bacteria is the refrigerator drip pan. This pan is a virtual breeding ground for illnesses, make sure you clean it weekly and dry it thoroughly before replacing.

• Herbs, spices and seasonings form mold very quickly, especially if used over the stove while cooking. When using a spice or seasoning to add to foods cooking, place the amount needed in a small container then add desired amount, never open the container above the hot food—the moisture/steam from the food is a perfect breeding ground for invisible mold. Buy small quantities, and always clean spice containers before adding any new stock. Make sure you don't store them in a damp area.

Candida: It's History

Candida is a common fungus that lives in the colon, but can live in many other organs and body systems. At the turn of the century it was a rare disease. It was reported a few times in terminal patients in hospitals and in other patients with obviously failing immune systems, but otherwise unknown. The rates of Candidiasis and other diseases such as cancer have grown explosively during this century, while deaths from infectious diseases have dropped off the scale.

Women's yeast infections and other candidiasis manifestations are now so common that almost everyone has some knowledge of the problem. These infections have become routine, but troublesome and difficult to cure in conventional mainstream medicine. Conventional medicine has had *almost no* success treating this disorder, because they prescribe drugs for symptom-care without any regard to life-style modifications. As with other diseases, this disease, along with most chronic disorders

associated with aging, viral diseases, cancer and autoimmune disorders, *does not* fit the modern medical paradigm.

Allopathy, or modern conventional medicine, is based on the theory that disease is caused when the body is invaded by a foreign entity, as in a "them" or "us" mentality. When the "them" is defined, the treatment applied is a specific poison directed to that entity to destroy it, or to remove the trouble causing entity from the body, a sort of internal ethnic cleansing. This is the basis of almost all-modern pharmacology. As long as this dominant model exists, and all diseases must be treated within those confines of allopathic theory, there is no real hope that conventional physicians can cure Candidiasis. Cures will not come to those unwilling to look at underlying causes to ensure true health-care verses treatments for symptom-care. It is not that the allopathic approach is wrong; internal ethnic cleansing works very well with some diseases, not others; *Candida* is one of these others. Naturopaths and Integrative physicians using other paradigms of viewing and treating Candidiasis have had total success in restoring their patients to health.

It is a matter of proper perspective; a measure of having this model of balance with nature built into ones thinking. As an example, what does your doctor do when prescribing antibiotics? Does he/she also give you a prescription or recommendation to replace normal intestinal flora when the course of antibiotics is finished? If they don't, they *are not* considering the necessary balance of nature in your body.

The surest way to check a physician's understanding of this disorder is to ask how they are going to treat it, assuming they acknowledge *Candida* could be the basis of your varied symptomatology. If they d r a g-o u t their prescription pad to give you a potion to kill the yeast, you know they do not understand the disease. When this happens, you may have met the type of physician defined by Descartes over two hundred years ago, "A physician is a person that treats a patient until they die, their money is all gone, or they are cured by nature." A doctor that *does not* understand the physiology of Candidiasis is likely to be of very little use to you, and may do more harm than good.

Candida is always present in the body, particularly the colon, where a colony can always be found. Diphtheria and other fatal disease organisms that conventional treatments work so well to correct are not meant to be there, *Candida* is! Having a massive colony of fungus growing in profusion in the colon, or any other location, *is not* normal. A healthy amount of *Candida* is meant to be in balance with the body's other flora. In understanding why this overgrowth of *Candida* happens, we can see how to approach curing it—until we gain this understanding, all treatments are no more than wild guesses. Where the underlying premise is wrong, these guesses are doomed to the total failure we have seen in modern medicines handling of this disease. The normal anatomy, physiology and balance of life are where this disease has its origin—balance is the key word. In our bodies we have billions of our own cells; we also have billions of rambling microbes and

"uninvited" guests—some are crucial to life, others, if given the chance, can kill or make us so sick we wish we were dead.

Candida: Immune System Command Center

The walls of the colon are lined with extensive immune monitoring cells. These cells report back to the control systems of the immune system all the bioactivities in the colon, but do not try to police them as they would if they were within the tissues of the body. The presence of *Candida* in the colon *does not* mean it will be tolerated in other locations. The problem arises when an overgrowth of *Candida* in the colon reaches a level where the reporting cells send the message that they are being overwhelmed. At this point, rather than fighting back, the immune system tends to say—hey, there are too many of you, I'll turn off the response to this particular bio-entity. At this point the body develops the disease of candidiasis. It is not the result of Candida Albicans being present in the colon; it is the result of TOO MUCH *Candida* Albicans in the colon.

The body has set up a system in which the immune system controls its responses based on the activities within and without the body. The skin and external organs are loaded with immune tissue and maintain an active and hostile response to all invaders that enter the body through these un-authorized channels. In addition, there are internal immune stations that respond to internal situations. The colon is *major* among these monitoring stations. It is very rich with sensing membranes that check all the protein in the colon and report these

back to the immune system command centers. This is a very special point of interpretation. The colon is the end of the production line for general discharge of the body's by-products and indigestible waste.

The anatomy of this area is very clear, as is the design of the immune tissue. Many colon therapists, naturopaths and integrative physicians, such as myself after developing life threatening leaky gut syndrome, subsequent anaphylactic shock and multiple chemical sensitivities, have observed the relationship of this to immune response. Most of us in clinical practice and recipients of colon therapy, have observed activation, and de-activation of immune responses following colonic irrigations. These observations and personal experiences have firmly validated the methodology of the importance of the colon as a key to health and a major role in reversing the invisible illnesses.

Candida: The Importance of Colon Health

In treating *Candida*, colon health is imperative, thus a case where it is much easier and less costly to detoxify the colon than spending the money to diagnose it, assuming your physician believes in the relevance of colon health to the immune system.

Ridding yourself of *Candida*, and the associated invisible illnesses, comes down to a simple routine of diet modification, nutritional supplementation and colon cleansing. It is imperative you locate a colon hydro-therapist that will coordinate your care with your health care professional. *Do not* attempt to embark on a colon cleansing routine without the help of a health care professional. Your naturopath

or nutritionally aware physician will recommend a colon fiber product that is formulated specifically with your situation and food tolerances in mind. Your practitioner will guide you to specific dietary changes, colon cleansing techniques, and the introduction of beneficial bacteria, or *Candida* antibody therapy, to rid yourself of the fungus that destroys health, wealth and dreams.

Nature's Most Digestible Protein

Many individuals with invisible illnesses have challenges tolerating animal protein, generally due to damaged or compromised liver function. In my personal and professional experience Goatein™,

FLASHBACK

At the onset of my leaky gut and chemical sensitivities, there was no way I could tolerate animal protein—the liver was already damaged, swollen beyond my right breast, and created constant pain. I was losing so much muscle tone without animal protein, that even though I was improving overall, I was losing physical strength. Even after being introduced to Goatein™ I was extremely cautious and hesitant to sample any quantity whatsoever, for fear of yet another anaphylactic reaction or increased liver pain. I finally agreed to start with one half teaspoon in rice milk, once a day. When this dose did not cause any type of allergic reaction, I slowly increased the dose to the recommended one-tablespoon. Goatein™ became the basis for all my liquid meal supplements, at times adding a bit of fresh fruit or mineral whey to supplement a meal.

Within thirty days my muscle tone improved, as did my energy level and strength. Today, I still make my own "protein cocktail" whenever I travel, or when I know I won't be able to safely consume the foods I can tolerate. I have been on long international flights and pre-packaged several "cocktails." When I'm ready to eat I mix them in water and they maintain my energy and normal blood sugar levels.

an organic protein product has been tolerated by more individuals than any other protein supplement. Because it does *not contain any* fat, it does not add burden to an already compromised liver or gallbladder.

Goatein™ provides organic protein, the essential building blocks of life. Protein is 90 percent of the dry weight of blood, 80 percent of muscles, and 70 percent of the skin. Proteins provide the building blocks for connective tissue and are the primary constituents of enzymes, hormones and antibodies. In short, protein is the basic stuff of muscles, skin, bones, hair, heart, teeth, blood, brains, skin and the zillion biochemical activities going on in our bodies every minute. When we fail to consume adequate amounts of protein, the blood and tissues can become either too acidic or too alkaline. Lack of dietary protein can retard growth in children, and in adults can be a contributing factor in chronic fatigue, depression, slow wound healing, and decreased resistance to infection.

Goatein™ is an exceptional natural food supplement, especially for those afflicted with compromised immune system disorders that cannot tolerate other animal proteins.

Why Goatein™ Over Other Protein Supplements?

Goatein™ is *Pure*. It is the highest quality protein powder available. It is produced from goat's milk that contains *NO* antibiotics or female growth hormones. Most commercially available dairy protein powders are produced from animals given antibi-

otics and/or BrST that can transfer to the user unacceptable amounts of female hormones. Many vegetable protein powders are made from non-organic or GMO sources and may contain residues of chemicals.

Animal Protein vs Vegetable Protein

Animal protein is the only source of *complete* protein available. Animal sources of protein (such as Goatein™) have many advantages over vegetarian sources (such as soy) because vegetarian sources are typically low in one or more of the essential amino acids, even when overall protein content is high. There is now some controversy regarding the safety of soy. Soy protein is thought by some researchers to be high in mineral-blocking phytates and thyroid-depressing phytoestrogens. Soy also contains potent enzyme inhibitors that may even depress growth.

Absorption of Goat Protein vs Cow Protein

Goat's milk contains smaller molecules that are closer in size and composition to human milk, making it naturally easier to digest. Goat's milk protein is also substantially less allergenic than cow's milk protein in susceptible individuals. Additionally, Goatein™ is partially *pre-digested* through a lactic acid fermentation process to make it even more bio-available while virtually eliminating its lactose content.

Research has shown that proteins from milk that has been pre-digested by lacto-fermentation are absorbed more efficiently as compared to those

of non-fermented milk. During the fermentation process, many digestive enzymes are created that aid in the assimilation of food nutrients. According to William Campbell Douglass, M.D., protein contained in cultured (lacto-fermented) dairy products is the very highest quality available for human consumption.

A Word About Protein Processing

Most milk protein powders are made from cow's milk, and even though they claim to be "minimally processed," they may use several invasive processing steps that include heating at high temperatures. These methods denature many important amino acids and destroy enzymes and beneficial bacteria. Research suggests that processing whey with heat and acid (i.e. ion-exchange) results in the loss of several key amino acids including Cysteine, Threonine, Serine, and Lysine. Because Goatein™ is processed without the use of acid or excessive heat, the amino acids, enzymes and beneficial bacteria remain in their natural form.

Gloating About Goatein™

Goatein™ is:

- the only protein powder available that contains 14 super strains of probiotics designed to be resistant to heat, cold, chlorine, fluorine, stomach acid and extremes of pH.
- made by fermentation with lactic acid bacteria that creates biologically active lactic acid that plays a major role in energy production and fat burning.

- lacto-fermented, a process credited by the healthiest and longest living people for their longevity.
- a cultured (lacto-fermented) dairy product, a process credited by some as capable of lowering cholesterol and protecting against bone loss.
- abundant in natural occurring digestive enzymes including protease, amylase, lipase and lactase.
- often tolerated by people who cannot drink cow's milk
- produced from goats that are not fed pesticides, herbicides, growth hormones or antibiotics

Goatein™ also contains lactic acid, essential for proper pH balance of the gastrointestinal tract and bodily tissue.

Your Personal Surveillance System: With an Armed Immune System, You Win the BATTLE and the WAR on Disease

EXACTLY WHAT IS THE IMMUNE SYSTEM?

It's those intelligent, highly trained biological defenders that are inherently trained to identify, attack and destroy disease-causing enemies. It also has a built in cellular memory system that rarely forgets an enemy, even if somewhat disguised to evade detection. Lets say you are immunized against a specific disease like tuberculosis. The introduction of the tuberculosis germ into the body is not recognized by the immune system; therefore, its surveillance system identifies it as an invader (antigen). Antigens are foreign substances that trigger the body's army with a call to "war," with specific orders to "destroy" by producing substances called antibodies—meaning against foreign or unrecognizable bodies. The antibodies produced by the body are specific only to that antigen. Therefore, if exposed to tuberculosis, the body will immediately recognize it as an enemy, builds its resistance army of invaders and destroys it.

If the immune system is destroyed or weakened by, lets say, drugs, excessive stress or chemotherapy, it looses its ability to fully protect us against invading enemies. Likewise, if our army gets paranoid and over-zealous during their surveillance maneuvers, they can target healthy cells for destruction—thus the birth of auto-immune diseases like rheumatoid arthritis, lupus, fibromyalgia and scleroderma, to mention a few.

There is also another form of destruction by our immune cell "army" besides total destruction—it's called phagocytosis, a

process by which the invader is eaten or digested, a kind of metabolic cannibalism. This occurs when the body's surveillance cells, which are called phagocytes and include granulocytes and macrophages, signal the immune system response team to destroy as many invaders as possible, viruses, bacteria and dead cells. This type of cell does not have receptors like other immune cells, therefore, communication is somewhat subject to interpretation and invaders are "disposed" of but not completely annihilated. These cells do not need to directly communicate to get their orders, they are natural killer cells (NK cells) and are "programmed" to make decisions on the "spot," on their own; they do not contain a "memory" like antibody cells. They have to eliminate the intruder by releasing toxic enzymes that destroy. These NK cells also have the unique ability to stop viruses from replicating by releasing a substance called interferon, a kind of "metabolic nerve gas."

The highly sophisticated immune system contains various weapons of mass destruction that, when used against an invading enemy of disease cells, can save a life—when used against its own population of healthy cells, destroys life.

The good news is—I'm going to share with you ways to send in reinforcement troops, naturally.

BOOSTING THE IMMUNE SYSTEM: "GO OUT AND GRAZE"

In this age of high toxic exposures, affecting our liver, lungs, and metabolic functions, it is literally a matter of "life or death," directly proportionate to the ability of our immune system to protect us.

Contaminants are everywhere, in our air, food, water and even medications—prescription and over-the-counter. We cannot totally avoid exposures in today's world, however, most forms of illness can be reversed, if the body is given what it needs to detoxify and repair. Taking care of your immune system is full coverage insurance from disease; the dividend lies in the arsenal of defenses that makes health your true wealth.

Nations spend trillions of dollars each year preparing their defense systems against unfriendly foreign invaders. Just as important is building our body's defense system. It is my professional goal to provide consumers, patients, and health care providers, the logic of self-healing and self-cleansing as it relates to reversing disease, even the most feared, cancer.

The most powerful drugs alone cannot totally destroy diseased cells; the body must replace the diseased cells with healthy ones. The immune system is the life-giving system; in addition all that's needed is the individual will to experience wellness.

Water and protein are the most plentiful nutrients in the body, and more than 50 percent of dry body weight is protein. According to Dr. G.H. Earp Thomas, a soil and plant scientist, Dr. Thomas found that Wheatgrass contains vital nutrients, which he felt could serve as regenerative and protective factors in human health. His findings concluded that fresh wheatgrass juice was theoretically capable of sustaining human life for weeks and even months at a time. Research written by Dr. Charles Schnabel, estimated that fifteen pounds of wheatgrass was equal in protein and overall nutri-

tional value to three hundred and fifty pounds of ordinary garden vegetables.

At the Oregon Institute of Science and Medicine, Dr. Arthur Robinson conducted a research project in which wheatgrass and live foods fed to mice, was responsible for the decreased incidence and severity of cancer lesions by 75 percent in squamos cell carcinoma.

Wheatgrass Juice: "A Clean Sweep" For Your Blood
Test your Green I.Q.

- *What has a wider range of metabolic activity than animals and humans?*
- *What is capable of more efficient neutralization and detoxification of many pollutants?*
- *What can deactivate carcinogenic (cancer-causing) and mutagenic (capable of altering genes or DNA, and affecting future generations) effects of 3,4 benzpyrene, found in smoked fish and meats that are charcoal-broiled?*
- *What contains so much chlorophyll that it protects us from carcinogens better than any other food or medicine?*
- *What has been scientifically shown to have anti-neolastic ability (the ability to fight tumors) without the use of toxic drugs?*
- *What can cleanse the blood and digest toxins in our cells?*
- *What food has a dilating effect on the blood vessels—making the vessels larger to increase blood flow?*
- *What has the ability to nourish the cells and remove cellular waste?*
- *What food can naturally treat anemia in a form that is easily converted by the body into healthy red blood cells?*
- *What food contains the three vital ingredients (choline, magnesium, potassium) to repair and maintain liver health*
- *What food contains a compound called* indole, *an enzyme capable of deactivating carcinogens in the liver?*

The answer to **all** *the above questions is* **Wheatgrass Juice.**

No, wheatgrass juice is not a miracle cure, however it can most definitely pave the way to wellness, naturally.

According to famed nutritionist Ann Wigmore, "Wheatgrass juice is perhaps the most powerful and safest healing aid there is. Not because it can attack and destroy bacteria or malignant cells, like some drugs, but because it has the ability to strengthen the whole body by bolstering its immune system." This ability is attributed to a unique combination of nutritional and chemical values.

It is well known that the body's ability to fight illness, including cancer, is determined by the strength of the immune system. Ms. Wigmore believed that, in contrast to modern drugs to correct one symptom or another without effectively strengthening the overall state of health, wheatgrass juice provides the necessary ingredients to strengthen the body's defenses to allow for healing, naturally. Hippocrates, the father of medicine, stated, "The body heals itself; the physician is only nature's assistant." Wheatgrass juice is the body's healing weapon by providing concentrated ammunition to build up the arsenal of defenses—against bacteria, viruses and yes, even cancer.

WHEATGRASS: A SWEET SUPPLEMENT

Until recently, those choosing to take full advantage of the benefits of wheatgrass had only one choice, to juice fresh wheatgrass. Now there is a convenient option, Sweet Wheat®, grown and manufactured by Sweet Wheat Inc®.

Sweet Wheat® tastes like fresh wheatgrass juice, without the hassles of juicing. It contains *no* fillers, sweeteners or binders and no irradiation is ever used. It reconstitutes immediately in liquid.

Sweet Wheat® is grown in a controlled greenhouse environment, using a specially blended organic soil, pure artesian well water and only natural sunlight. Besides the full compliment of phytonutrients, antioxidants, chlorophyll, vitamins, minerals, amino acids, active enzymes, well-bal-

Benefits of Wheatgrass:

- Destroys harmful germs and microbes
- Effective antioxidant for cell strength & preservation
- Stimulant for transport of oxygen to cells
- Neutralizes the toxic effects of fluorine
- Immune booster
- Blood cleanser
- Detoxifies and Regenerates the liver
- Chlorophyll contents protects from carcinogens
- Chemically neutralizes pollutants
- Neutralizes toxicity of nitrogen compounds found in automobile exhaust
- High in enzymes and amino acids
- Anti-mutagenic & anti-neoplastic effect (ability to fight tumors)
- Neutralizes toxins in our cells
- Contains exogenous enzymes (powerful detoxifiers)
- Contains amino acid chains (polypeptides)
- Contains bioflavonoids (compounds related to vitamins that help cleanse blood and tissues)
- Neutralizes toxic substances like: mercury, strontium, nicotine, polyvinyl chloride by changing them into insoluble salts for easy elimination.
- Contains liquid oxygen
- Stimulates digestion
- Has a dilating effect on blood vessels (making them larger thus improving blood flow)
- Beneficial in treating anemia
- A source of B_{12}, folic acid, iron, copper, potassium and protein readily converted by the body into healthy red blood cells and bio-available because it's eaten raw and cooking makes them non-absorbable or destroys them
- Contains choline which helps prevent fat deposits in the liver
- Contains magnesium which draws out excess fat from the liver the same way magnesium sulfate (Epsom salts) draws pus from an infection.
- Contains potassium which acts as a stimulant and is also beneficial to muscle integrity and prevention of spasms
- Acts as a natural body deodorizer effective against bad breath, perspiration odor, menstrual odors, and foul-smelling urine and stools
- Effective in destroying anaerobic bacteria
- Wheatgrass is a nutritionally complete food

Your Personal Surveillance
System: With an Armed
Immune System,
You Win the
BATTLE and the
WAR on Disease

185

anced protein-carbohydrate and calcium-magnesium ratios, it contains 47% protein, 26% minerals, and 23% carbohydrates.

Sweet Wheat®'s true freeze-drying is the gold standard of preservation techniques; preserving the integrity of the nutrients. It is 100% certified organic and kosher. This is pure juice, the juice, and nothing but the juice, naturally. It contains NO additives and is NON-GMO.

How does Sweet Wheat® compare to fresh juice?

Powder—One teaspoon of Sweet Wheat® powder is equivalent to $1^1/2$ pounds of raw organic vegetables, and it instantly dissolves in water or juice.

Capsules—Two capsules of Sweet Wheat® is equivalent to one teaspoon of powder.

Since Sweet Wheat® is so highly concentrated, it is best to check with your health care professional before deciding the daily quantity of intake. Because wheatgrass in general contains such high amounts of naturally occurring chlorophyll, it is important to understand that your body will be quickly detoxified. Therefore, those with compromised immune systems, liver and digestive system need to consume plenty of pure, plain water to assist the body in flushing out the toxins being released. Chlorophyll also binds with carcinogenic toxins in the digestive tract, blocking them from absorption into the body. Therefore, if you experience abdominal cramping or abnormally loose stools, reduce the quantity of juice until a tolerated level is found. The most important aspect of detoxifying is listening to your body; if in question, reduce the intake temporarily until

enough toxins are flushed out and natural balance can be re-established.

The following is a summary of the study conduced at my health and research center in northern Idaho. It consists of the responses of my clients when fresh juicing was recommended as part of their wellness program, keeping in mind that most of my clients consult with me because of chronic illness and immune system disorders.

- 29% followed through, purchased a juicer, either grew the grass or purchased it. These clients had the same commitment to achieving health as I did; no matter what effort it took. These clients followed the entire program for health and healing and have regained their quality of life.

- 25% couldn't be bothered with fresh juicing and wouldn't allow themselves to even imagine drinking grass juice. These clients were obviously not serious about wellness, or wanted a "magic" pill that would be less effort, with little or no inconvenience to their already restricted quality of life.

- 33% were either too ill to juice, too ill to leave the house to purchase the grass and grow it themselves, or because of acute sensitivities to mold, couldn't tolerate the mold that forms on the soil of the wheatgrass nursery flat or growing container.

- 9% couldn't afford to purchase the juicing equipment
- 4% had tried fresh juice from a health food store or juice bar and experienced accelerated symptoms because they were not under the care of a health professional and did not know how much to take, how often or what to expect. Therefore, they were afraid to try it again.

A friend introduced one of my clients that had benefited greatly from fresh juicing to a wheatgrass powder. She tried the powder form and felt she benefited the same as with the fresh juice, without the time commitment and hassle. She shared the information with me, which I researched thoroughly.

I had to be completely convinced that anything other than fresh wheatgrass would be as tasty and nutritionally beneficial. Since "seeing is believing" I proceeded to have a blood test called live cell microsophy. This laboratory test actually allows the patient to view the blood, along with the technician, to see the health and integrity of the cells. I've had this test performed for over 10 years, as fully described in my book *I was Poisoned by my body*. I first had the test performed before starting any type of wheatgrass therapy. I then used fresh wheatgrass for ninety days and was re-tested. The results were amazing—the integrity of my red blood cells was impressive! I then proceeded to use only SweetWheat® for ninety days. I was again re-tested and the cell integrity was the same as when I used fresh juice. The integrity of the red blood cells had improved, they were "free-floating" with increased speed (oxygen) and the cellular membrane was

healthy. I have had my blood tested every three months since developing leaky gut, fibromyalgia, chronic fatigue and multiple chemical sensitivities; therefore, I was a prime example for monitoring the progress of my entire therapy program for health and healing.

I can personally attest to the health benefits of "mother natures" condensed "solar energy" in those little blades of wheatgrass, naturally.

The Emotional Part of Healing: You Are What You Believe

INTRODUCTION

by Owen Marcus, MA

Owen's clinical practice has focused, for over 20 years, on discovering the underlying patterns that keep his clients from healing. He is co-founder of the Scottsdale Institute for Health and Medicine, and developer of a wholistic approach for teaching mindfulness stress reduction programs. Owen now lives in Sandpoint, Idaho and maintains Rolfing and Me'tis Medicine-Way Lightwork practices in Idaho and Arizona.

In traditional ways people spoke of life being comprised of four aspects: emotional, physical, mental and spiritual. When one of these aspects was out of balance, all other aspects would eventually manifest as physical symptoms. The converse is true, as more aspects are engaged in the healing, the deeper and quicker the healing.

Stress is one excellent illustration of how the four aspects are interrelated. We all have a psychophysical process that assures our survival, the stress response. If we are functioning at our normal resting level the parasympathetic nervous system is dominant. This is often referred to as the relaxation response, but that is not entirely accurate. We are designed to exist in this parasympathetic state all the time, not just when we are relaxed.

We leave this "idle" to rev our engine of survival when a stressor challenges our relaxed state. It may be hiking in the mountains and noticing a mountain lion that is stalking you.

Without thinking, every resource you have will be activated. You will do what ever you need to survive. You will run through the brush, jump over huge rocks and take chances to get away. Once you get away, the fight-or-flight response of the sympathetic nervous system leaves, to be replaced by a recovery stage. It is here that you realize that you cut yourself in several places, sprained you ankle and bruised your head on a branch.

When we are surviving, that is all we are doing. When we shift our state from survival to recovery then into the parasympathetic state, we allow all the resources that were used to save ourselves to heal ourselves. We are hard wired to survive first, heal second. The problem occurs when we have lived decades in states of survival. We habituate to existing in a state of stress. So even though we believe we are relaxed, our body is still physiologically operating at some state of survival. Over years of this continued state, our bodies wear down; where the wear first shows will vary in individuals; some might develop back symptoms, others heart disease and others chemical sensitivity, fibromyalgia, psoriasis, or chronic fatigue.

Addressing the external causes is critical to healing; removing the internal toxics is essential. Yet, for complete recovery far beyond symptom alleviation, shifting the body to a state of parasympathetic-relaxation is required. If the body is still fighting a perceived threat, it will continue to allocate resources to battle that threat; thus bankrupting our reserves. Acquiring the full support of all the body's resources to heal only occurs when

there is not a threat; in other words, when you keep depositing into your emotional account rather than withdrawing more than you deposit.

The importance of having the availability of all our resources is simple, but the creation of such a state may not be as simple. Over the years of psychological and physiological conditioning, our body and mind literally gets stuck in the survival state just as an accelerator of an automobile can stick. We singularly and collectively are unaware of the scope of how fixated to stress we are; we become unconsciously addicted to stress. Our mind-set is that we always need to be "on". We are told consciously and unconsciously not to stop, but to push harder. When we are young this is exciting; as we age we begin to pay the price of this accelerated life style that continually depletes our reserves.

To achieve our full healing potential, we need to un-learn the conditioning of stress. There are no drugs that can do this for us. There are many wholistic or ancient approaches that can be very effective at reversing what may seem like the aging process.

On a somatic level, releasing the stress that is unmistakably stored in the soft tissue of the body can produce amazing benefits. Emotionally learning to express the emotions as they are felt, not storing them as stress or tension, produces such profound shifts that some "incurable" conditions can actually reverse themselves. *If there is a core concept to all of this, it is to experience the stress for what it is, when it occurs. Then take measures to either eliminate the stress or change your attitude about the stress.*

HOW CAN WE REVERSE THE CYCLE
OF STRESS AND ILLNESS?

Understanding that whatever the problem, it did not develop over night and in a vacuum. Once we realize the inter-relationship between all aspects, we become open to a broader range of solutions. In our modern culture we first want to name the disease or disorder, then fix it as if it is a broken part. After that does not work, we're open to exploring broader causes and treatments.

As medicine becomes more cognizant of how the body is not a machine, integrative physicians are admitting we are influenced by many variables. Several of the therapies that are derived from this new awareness unfortunately can be limited in their effectiveness. It is when we examine the more labor intensive, less hi-tech therapies that we often see more significant long-range recoveries.

In homeopathy they speak of a "constitutional" approach where the patient's whole being and all of her aspects and symptoms are considered. This constitutional focus exists in other disciplines such as bodywork. One example is Rolfing, a process of releasing stress from the body's connective tissue while re-aligning it, without manipulation. From a series of Rolfing sessions, old patterns, including the stress response patterns, are un-learned. As the body lets go of what does not serve it, the body often naturally learns more appropriate patterns.

A new form of constitutional work is evolving with the integration of the four realms of our existence: emotional, physical, mental and spiritual.

Me'tis Medicine-Way Lightwork utilizes many of the approaches of traditional practices to catalyze a shift for someone out of an old pattern into one of health. Practitioners of this Lightwork assist their clients energetically and emotionally to release old restrictions while teaching them how to hold their new experience of power and relaxation. The distinction in this approach is that often nature is used to aid the person in her healing. As we disassociate from our bodies, we disassociate from the natural world. By learning to experience the natural world of therapeutic light-work bodywork, people can begin to heal old patterns. As these old patterns of emotional-physical stress dissolve away the body is not fighting to survive, it begins to relax to experience all the pleasures of life. These techniques, as part of an integrative healing plan, assist in facilitating the healing process, naturally.

ROAD-BLOCK TO WELLNESS: A SELDOM DISCUSSED ADDICTIVE DISORDER

Many people challenged with chronic illnesses develop an airborne addictive disorder known as "negative thinking." *At this juncture, don't put this book down and think "I was okay up to this point, but now she's going to preach to me about my saneness—my mind is just fine (except for a little occasional brain-fog) it's my body that's sick."* If that thought just entered your consciousness, you just proved the methodology of this discussion—You are what you think, and it can manifest into a bad habit, which, over time, degenerates into an addiction that adds to your total toxic load. If you reacted

negatively to my opening comment, you've already planted the negative seed in your subconscious and if you're not open to finishing this chapter, you've just added another drop to your over-filled toxic cup, which hinders your recovery.

Addictions are generally accepted because the victim believes that a known entity is better than the unknown. A drunk stays drunk because every time he tried to stop he had terrible unsuspected withdrawal symptoms— hence, he'd rather stay drunk and know what to expect.

Another example is that of a patient with chemical sensitivity, reacting to most everything in their diet and environment. They possess the desire to get well, however, they are not consciously aware that all the negative thoughts they allow to take up residence and multiply in their mind, are contributing to their dis-ease. They can become addicted to the sheer intensity of their illness, even though it entails a great deal of discomfort and fear.

Another example of a roadblock to health is allowing other people's negative comments to manifest as a negative thought pattern in our lives. Many of us with the invisible illnesses are simply overburdened with just surviving; not at all equipped to

> ## FLASHBACK
> *I have encountered clients that have reacted to specific foods several months or years prior. They embarked on various programs for detoxification and desensitizing, and still refuse to try the suggested food again, being convinced they'll react the same as last time. I personally understand the fear of trying something that caused an allergic reaction, in my case anaphylaxis. However, after weeks of detoxifying, following a strict organic diet of tolerated foods, and making life-style changes to support my recovery, I can again tolerate most foods that caused terrifying reactions months before.*

deal with negative comments from others, especially those close to us. Prior to my accident and subsequent illness, I was fortunate enough to travel extensively. My family, extended family, and friends know very pointedly my desire to continue traveling. However, when I developed MCSS/EI, various expressed comments went something like this, "it's too bad you'll *never* be able to tolerate traveling again," "you'll never be able to travel, look at all the precautions you'd have to have in lodging, food and transportation," "it will be *impossible* to travel by yourself, what if you have a reaction?" All the above comments were made in an attempt to "comfort" someone who was now not able to resume their normal quality of life. However, in the process, these comments can perpetuate a negative comment into an escalating pattern of negative consciousness, one that can become a subconscious addiction if not detected early. Like any addiction, negative thinking must be treated with a personal commitment to life, patience, discipline, a will to get better, forgiveness, and the knowledge that recovery is not just possible, but inevitable—assuming you refuse to give any energy to negative thoughts or persons.

Conventional medicine, for the most part, accepts the concept of "mind over matter," however; the idea that a consciousness of negative thoughts is an addictive disorder is still quite controversial— yet, Doctors and researchers taking a close look at a negative thinking pattern agree it fits the criteria of addiction in the medical sense.

For the sake of discussion, lets go back to my example of traveling. Since situations don't just

happen without thoughts, we are literally a result of a lifetime of both our positive and negative thinking patterns. I have always "known" and "believed" traveling is an integral part of *my* life, enabling me to fulfill my goal of teaching, sharing experience and expertise, and learning through diverse cultural and professional differences. Had I allowed those well-meaning individuals, who expressed negative comments about not regaining my ability to travel to "plant" the seed of negativity and doubt, I would have never attempted to travel (much less alone) and lecture again. The expressed fear would have the perfect opportunity to "set-in" every time I entertained the thoughts of traveling—in other words, I'd fertilize those negative statements.

Instead, I took baby steps in resuming travel, not without some of the normal apprehension—but with enough faith and enthusiasm to fuel my determination. The first trip out of the country, I arranged for a business associate to accompany me. The second trip, I traveled myself and took the necessary precautions, such as wearing my "I can breathe" mask while flying and educating the chef at the hotel restaurant about my dietary needs. Everyone I encountered was happy to accommodate my requests and the trip was a success. When I was asked, upon my return how I "endured" the trip, the individuals addicted to a negative consciousness commented, "oh, I could never ask for those type of special accommodations, I'd be too embarrassed. I couldn't possibly ask the chef to take precautions in preparing my food, request that the hotel not spray room fresheners or use harsh chemicals for cleaning like bleach, wear a mask while

flying and have to carry my own food for the flight and layover time in the airports." This is a pointed example of individuals who are addicted to negative thoughts, therefore, everything "different" becomes a problem rather than an opportunity. I enlighten dozens of individuals on my journeys and have hopefully made a positive contribution for the awareness of life-altering invisible illnesses.

DE-NIAL IS NOT A RIVER IN EGYPT: IT'S A STATE OF MIND

Another obstacle to wellness is denial of situations that add to our toxic load, I know, I've been there!

I made major modifications to my home and office to reduce my toxic load after acquiring MCSS/EI, even though I was in total denial about the negative effects of my natural gas cook stove. After all, I am a gourmet cook, and I had acquired an extraordinary gourmet stove. I had made so many changes in order to facilitate my healing, that this last one was one I denied until I no longer could. All other rooms in my home were now reaction free, but every time I entered the kitchen and started to cook, my face got welted, red and I was gasping for fresh air. I felt as if someone had suddenly shut-off my supply of oxygen. When I left the room for 10-15 minutes, the symptoms disappeared. This was the ultimate state of denial— wanting so desperately to "hold-on" to something that resembled my previous "normal" life, and all the while, hindering my entire healing process.

I finally sold the gas stove and purchased a used electric range; it was used because I couldn't toler-

ate the "off-gassing" of a new range. I didn't' like electric cooking before, and my verdict hasn't changed, but it's a choice I made to facilitate my healing. Not long ago, I was visiting my youngest son in Seattle, Washington and his lovely home has a gas stove. I, of course, couldn't visit without cooking dinner for he and his friends (it's part of how us Mom's show love). I'm pleased to report I cooked a meal for 8 with no reactions, but I'm no longer in a state of denial. I know, from experiences with my clients, that if I revert to cooking everyday with gas, it would again start filling my toxic cup— and that price is too high to pay for even a stubborn, doctor who happens to be a gourmet cook.

ANGER IS ONE LETTER SHORT OF DANGER

We've all heard about the negative health effects of anger. Redford Williams, M.D., director of Behavioral Research at Duke University Medical Center, has most recently reported that approximately 20 percent of the general population has levels of hostility high enough to be dangerous to health. Another 20 percent has very low levels, and the rest of us falls somewhere in between.

Anger not only raises blood pressure, it is literally a toxin to your body. The Chinese have known, for more than five thousand years, what we are just now learning—circulation and its relationship to the energy of the body. They describe their techniques as pathways or meridians, a way for energy to be felt or influenced. Theoretically, negative emotions (anger, guilt, fear, worry, impatience) put a "crimp" in the circulation of this energy; just as

crimping a garden hose causes pressure and restriction. Eventually in the body, the pressure builds up to a point where it causes pain, first psychologically, and if not allowed to flow, physically.

In individuals with MCSS/EI, the anger stress connection can perpetuate the same devastating reaction as an allergic response to food or environmental toxins. This occurs because of what is called "stimulation-related" changes. When we're under emotional stress, the involuntary part of our nervous system, called the *autonomic nervous system*, kicks into gear. This system consists of two systems, the *parasympathetic* and the *sympathetic*.

When we're experiencing abnormal stresses, nerve fibers from the sympathetic nervous system in the adrenals produce a rapid response to potential threats. In turn, the inner part of the adrenal gland, the medulla, manufactures and releases, among other substances, *epinephrine* (adrenaline). This substance is responsible for the hyper-activity we associate with the fight-or-flight response. It is this rapid release of adrenaline that can trigger an allergic reaction in an MCSS/EI victim. When long-term stresses are experienced, they cause an acceleration of adrenal secretions, otherwise known as

Parasympathetic Nervous System:
- *Induces glandular secretion*
- *Increases muscle tone of internal organs*
- *Increases stimulation of the heart muscle*
- *Slows down body reactions to stress*

Sympathetic Nervous System:
- *Depresses glandular secretion*
- *Causes contraction of blood vessels*
- *Decreases contractibility of smooth muscle tissue*
- *Produces heightened sense of arousal for the body and mind as a response to stress stimuli*

adrenal "burn-out"—a case of prolonged anger or stress turning to danger.

The cortex of the adrenal gland is the site of *cortisone* production. Chronic elevation of cortisone will dramatically reduce the stomach's resistance to its own acid, leading to gastritis, ulcers and a host of gastrointestinal symptoms. Cortisone also triggers the retention of sodium, resulting in elevated blood pressure; it also protects us from short-term allergic reactions by calming the immune response. Therefore, long-term anger and stress, lead to chronically elevated cortisone levels, suppressing the immune system and making it "fertile" ground for other diseases.

The liver also responds to anger and stresses by gearing up for a long-term endurance challenge. It increases its stores of the complex sugar glycogen, and manufactures and ships out *more* cholesterol, which, under normal conditions, provides for long-term energy needs. Most people with the invisible illnesses have high levels of blood serum cholesterol, is it any wonder? My cholesterol level was 309 after my accident, and it did not return to my normal range until the chemical sensitivities were under control and I resumed a "normal" lifestyle.

Anger also causes a stress reaction that releases stored toxic materials in fat cells—sending them into the bloodstream. As an example, carcinogens such as benzene and mercury, known to be hazardous at low levels, are stored in fat cells and become a "toxic soup," causing reactions that have no *apparent* culprit. Since fat is very mobile within the body and is ill equipped to metabolize and

excrete these synthetic compounds, they tend to circulate from one fat cell to another—is it any wonder we "hurt all over" and have fibromyalgic soft and connective tissue "lumps" and soreness?

In closing, lets not forget the brain, the equipment that processes all these emotions and responses. We create beliefs, emotions and attitudes that are translated into our emotional responses. All these responses are interconnected and therefore create physical effects aided by the part of the brain called the *hypothalamus*. This part of the brain is a walnut-sized body under the cerebrum, essentially where our reality occurs. The next time someone thinks you're "nuts" because your symptoms are "invisible," just respond, "yes, I guess I am and it's in my cerebrum," watch their attitude change very quickly.

Another substance that bears mentioning is *melatonin*. It is produced by the *pineal gland*, located in the brain and is responsible for the production of *melatonin*; a substance responsible for what is called the circadian cycles (sleep-wake cycles, production of sex hormones, growth hormones and liver enzymes). Armed with this information, it should be easier to understand why victims of the invisible illnesses have such varied symptomatology, sleep disturbances, liver disorders, and hormonal imbalances.

According to author Norman Cousins, the negative emotions—anger, frustration, confusion, and suppressed sorrow, all have ripple effects that resound though the entire body, shattering our biochemistry and our lives.

Reducing Your Toxic Load: Environmental Controls

WHAT THE NOSE KNOWS, THE BODY FEELS

The Workplace

Common office products and items are cause for concern. Things like household cleaners used on windows, furniture made of wood compositions, new carpeting, wood/fabric partitions, computer monitors, floor waxes and carpet cleaning products leave harmful residue in the air. Likewise, bathroom and carpet air fresheners, bathroom cleaners, permanent markers used with flip charts, correction fluid and photocopier toner cartridges.

Author's Note:—*For obvious reasons of space and not repeating the invaluable recommendations previously made by individuals who have generously written about information regarding safe products and precautions to create a safe home and office environment, I suggest you read the following books. These books will provide specific details of toxic ingredients contained in commonly used products and safe alternatives. This list is by no means complete; it is meant to serve as a quick-reference guide.*

▶ Home Safe Home—*Debra Lynn Dadd (Jeremy P. Tarcher/Putnam)*
 ISBN 0-87477-859-x
▶ The Nontoxic Home & Office—*Debra Lynn Dadd (Jeremy P. Tarcher)*
 ISBN 0-87477-676-7
▶ Healthy Living in a Toxic World—*Cynthia E. Fincher (Pinon Press)*
 ISBN 0-89109-978-6
▶ The Safe Shoppers Bible—*David Steinman & Samuel S. Epstein, M.D.*
 (Macmillan) ISBN 0-02-082085-2
▶ 1001 chemicals in everyday products—*Grace Ross Lewis (Wiley-Inter Science Publication, John Wiley & Sons) ISBN 0-471-29212-5*
▶ Better Basics for the Home—*Annie Berthold-Bond (Three Rivers Press)*
 ISBN 0-609-80325-5

In order to reduce or eliminate toxic effects in ordinary products, buy odorless, water-based markers and make sure that any office products with a strong scent or smell of chemicals is tightly sealed and stored away in an area not sharing the same air as it's human occupants. Purchase cleaning products without fragrance, or those specifically labeled "safe" for chemically sensitive. The only general, all purpose cleaner and degreaser I use and recommend for commercial and residential purposes is Organic Choice™. Besides its cleaning/degreasing abilities described in earlier chapters, it is a substance that cleans, protects and shines wood surfaces and any item that can be safely cleaned with a water-based cleaner.

Mold: Invisible Invaders

Mold is not just a problem in the workplace, however, it appears to be an area that is not taken seriously and gets less attention and maintenance.

- Molds cannot grow when the humidity is maintained between 30 and 50 percent
- Effects from mold exposure can be worse in winter, when cold weather dries out the nasal membranes—allowing mold spores to more readily make their way to the brain
- Not all mold is visible—always dry and treat areas where water damage has occurred
- Be sure to provide fresh air circulation in attics, basements and suspended ceilings
- Mold hides behind layers of wallpaper, paint and wallboard—if a room smells musty, it most likely contains a source of invisible mold

- Mold spores become airborne, if treating mold, be sure to have adequate ventilation and wear protective respiratory gear

The Home

"Air Poisoners"

All of the advertisements strive to make us feel that we *do not* have a really "nice" or "clean" home unless "air fresheners" are supplied in all bathrooms, kitchens, and generally around the house to assure we, and our guests, are persuaded that ours is not just a clean home, but one with requisite elegant touches. There are chiefly two types of air poisoners—the spray type, with their non-recyclable aerosol cans or plastic packages, adding to unnecessary solid waste, and the wick type that send out continuous "fumes" of fragrance.

These products do not, in fact, do anything to improve the quality of the air. Instead, they add a number of pollutants, some designed to deaden your sense of smell, others serving as propellants, and others adding various toxic perfume to "drown out" whatever undesirable smells.

A prominent constituent of many of these products is formaldehyde—it can destroy your sense of smell and is one of the worst offenders for respiratory irritation, not to mention a neurotoxin and, according to the EPA, a causative factor in cancer.

"Candle Light Nightmare"

Chemical toxicity comes in many seemingly innocent disguises. One such toxic substance, not readily known by the general public, is the candlewick. In

1973, the EPA Administrator urged a mandatory ban on all candles with lead-containing wicks. As a result, a voluntary ban was approved and then not complied with or even monitored. An EPA study in 1974 determined "Burning only two candles three hours each day on a regular basis in the home could increase exposure to airborne lead by a factor of 5 or more. This exposure to lead from candles could equal or exceed the exposure to airborne lead associated with the busiest freeways in America." [This statement was made at the time leaded gasoline was still fairly commonplace] "Inhabitants of homes in which lead wick candles are burned could be exposed to substantial incremental quantities of lead which, if continued on a regular basis would pose a significantly high risk to health, especially among children." The EPA determined that burning candles with lead-containing wicks exceeded the current EPA air quality standard by over 10 times— yet, to date candles containing lead in their wicks are still being manufactured and sold!

Is a little "atmosphere" worth the price of exposure? Imagine an individual who already has a compromised immune system and is a victim of chemical sensitivity. Maybe you should consider what many have already—buy those nice mock candles, the ones operated by tiny batteries. They're safer for your health and do not pose a fire threat.

The above dealt with dangers of lead in candles, now lets consider the same dangers from the resulting smoke and fragrances in candles. For more information on the health risks of fragrances, see the section on Fragrances.

Neighborhood Health Notice!

- Have you been enjoying a walk in the neighborhood and found you've suddenly fallen or felt like you could?

- Do you get a numb feeling in your face, or tingling around your mouth and the doctors can't find the reason?

- Do you get a sudden onset of dizziness or headache?

If you answered "yes" to any of the above, you could be experiencing symptoms of Central Nervous System Disorder from fabric softeners, clothes dryer exhaust and treated fabrics.

It has been discovered that fabric softeners are some of the most toxic products made for daily household use. They contain chemicals like chloroform, benzyl acetate, pentane and Alpha Terpineol, known to cause cancer and/or damage to lungs, brain and nerves. These chemicals are even more dangerous when heated in clothes dryers. The toxic fumes go into neighborhood air and everyone for blocks around is forced to breathe them.

These chemicals especially affect infants, children, seniors and people who have allergies, respiratory disorders and multiple chemical sensitivities. Damage can be permanent, causing lifelong illness. Infants often react with rashes, frequent crying and/or diarrhea. Disinfectants can have the same effects. Experts suggest a possible connection between Sudden Infant Death ("crib death") and the use of these products for washing baby clothes, crib sheets and blankets. As if fabric softeners aren't toxic enough, most contain added fragrances.

To soften fabrics and reduce static cling, add a cup of plain baking soda to each wash and half a cup to the rinse. To kill germs, a hot water wash and the high heat of the clothes dryer are safer than disinfectants and fragrances. When possible, use the good old standby, hang things out in the sun, naturally.

To educate yourself about the toxic effects of these and other products, refer to the work by Julia Kendall available on the Environmental Health Network website at: www.ehnca.org. This website is a wealth of information for anyone affected by chemical sensitivities and those choosing to learn about this syndrome.

REDUCING YOUR TOXIC LOAD: PERSONAL CARE

Fragrances: A Historical View

Using scents originated in the era when bathing was a once-or-twice-a-year event and perfumes masked the body's natural odors. In this era of personal hygiene and deodorants, the original reason for perfumes is gone—it's now an antiquated custom, as is the notion one must wear fragrances in order to be "attractive" or "desirable."

Did you know fragrance formulas are considered "trade secrets"—meaning the industry does *not* have to reveal to you, or anyone else, the materials in the fragrance part of the product?

They do, however, have to inform you that these products contain phthalates such as diethyl phthalate and dibutyl phthalate, which are suspected of being hormone disrupters. The recent Center for Disease Control (CDC) report on chemi-

cals found there was high exposure to these two materials in women of childbearing ages.

They do *not* have to inform you of synthetic musk compounds, which are present in your blood, fat tissue, and breast milk—if you're a nursing mother. They also do not have to inform you that these materials are found in waterways and aquatic wildlife, at levels high or higher than pesticides.

The following information is taken from Betty Bridges, R.N. and creator of the *Fragranced Products Information Network* (www.ameliaww.com/fpin/fpin.htm)

Fragrance sensitivity is far from an isolated event. Perfumes and fragrances are known triggers for asthma, rhinitis, sinusitis, allergies, migraine headaches, and an array of symptoms for those that suffer from chemical sensitivities. When you consider these populations combined, the impact on health and the economy are significant.

The *Fragranced Products Information Network* is a grass roots effort to educate on the chemicals used and the health effects of fragranced products. The sites' goal is strictly educational.

This site attempts to compile available information in an easily accessible site. Information from a variety of reliable sources is available. There is information from industry, government, medical and activists sources. Providing information from a variety of sources allows the reader to have an overall view of the fragrance issue—it's determent to health, especially those with compromised immune systems.

Unfortunately, fewer and fewer people are able to enjoy the luxury of true *fresh air* anymore. All those years of adding chemicals and pollutants to

our environment are taking a toll and increasing numbers of people who now suffer from allergies, breathing disorders, migraines, chemical sensitivities and environmental illness.

A Fragrance by Any Name is Still a Fragrance

Many people suffer from exposure to scents and aromas from simple items almost everyone uses but seldom thinks about:

•perfumes	•flowers	•lotions
•shampoo	•hair conditioners	•soaps
•detergent	•fabric softener	•hair spray/gels
•after shave	•deodorants	•antiperspirants
•potpourri	•suntan lotion	•lipstick/lip balm
•incense	•body powder	•candles
•air fresheners	•furniture cleaners	•baby products

If you're wondering how a *fresh* smelling product can pose such a serious problem, it's simply a matter of science—example: those fresh flowers you just purchased at your local grocery store for your dining room table may have been sprayed with a fragrance, making them more marketable. That floral scent is a result of experimenting with more than 4,000 chemicals and synthetic compounds—it doesn't take a rocket scientist to figure out this is not Mother Nature's creation. Any *one* of these synthetics can cause adverse reactions in someone's health, let alone someone with a compromised immune system. When these compounds are loose in the air, they can contribute to not only asthma and serious health problems, but also to acute allergic reactions for those with chemical sensitivities, some life threatening.

INVISIBLE illnesses

Fragrances: A Pain in The Neck
And Other Places

Individual reactions to certain scents range from mild discomfort to severe physical distress. Some people are so sensitive they can be affected by scents worn by people walking through a hallway, sitting in a nearby office space, at the end of the pew in church or in the restaurant several tables away. The problem lies in the fact that the "wearer" does not detect the fragrance in the same intensity— example: a smoker does not detect the odor of smoke and the potential health effect it has on others because they have become desensitized.

Did You Know?

▶ Nine out of 10 breaths drawn in are likely drawn indoors

▶ 15-25% of our population has some breathing problems such as hay fever or asthma and is adversely affected by strong odors included in perfume, after shave, hair spray and body lotions.

▶ There was a 38% increase in prescriptions for airway medications from 1985 to 1990

▶ 5% of chemicals used in fragrances are petroleum-based synthetic compounds

▶ There are about 4,000 individual fragrance compounds—several hundred may be used in creating a single scent

▶ Environmental discomforts and illnesses are increasing at alarming rates

▶ 17-22% suffer from fragrance related migraines

▶ Reactions from scented products result in sick time, lost productivity, increased insurance costs and hostility from employers and employees who do not understand the health threats of fragrances

▶ Sensitive individuals cannot simply avoid fragrances, they share air in which they have NO control, other than through education and sensitivity

Common symptoms resulting from exposure to chemical compounds used in many scents include, but are not limited to:

- sinus congestion/pressure/mental confusion
- dizziness/lightheadedness/nausea
- eye swelling and redness
- generalized anxiety
- palpitations
- tingling of extremities
- profuse sweating
- eczema
- sudden fatigue
- crying for no reason
- irritability
- "brain-fog"
- chest pressure, unable to breathe deeply
- seizures
- runny nose
- swollen lymph nodes
- laryngitis
- spiked blood pressure
- muscle and chest pains
- headaches/migraines
- tremors
- wheezing
- unexplained rashes
- poor concentration
- loss of short-term memory
- blurred vision

Scents and Sensitivity: Understanding and Helping Others

Before *you* apply any scented product, consider the health and well being of those around you. Think twice before you use that spicy new air freshener, deodorant soap

FYI:

I was recently on a long flight out of the country. As luck would have it, I was seated next to a lady wearing a very strong, obviously recently applied, scent. The moment I was seated, even though wearing my "I can breathe™" mask, my chest immediately started to feel tight and my face started to get red blotches. I called the flight attendant and explained I was wearing the mask because of chemical sensitivities and I could not sit next to the lady to my right. She did not even hesitate, she asked the lady if she would like to be relocated or should she relocate me. The passenger replied she did not want to move, so the attendant placed me in another seat. Later, the attendant commented to me, in private, that she gets terrible headaches when she's exposed to passengers with strong fragrances and that she was taking early retirement because she could no longer tolerate being in an airplane cabin with re-circulated air containing fragrances, chemicals and pesticides.

or scented body lotion—these sensitivities are serious health threats to millions. Remember, it's physiological *not* psychological—reactions to fragrances and chemicals are neurotoxins. If you are not affected, be thankful and sensitive to those who are, after all, someday you may be walking down the same path if you continue to wear those fragrances.

A Perspective
ALA and AMA: Fragrances DO Trigger Asthma!
by Barbara Wilkie, President
Environmental Health Network (EHN)
of California, 501c non-profit agency

It came to me without fanfare. It came quietly into my computer. Not over my radio, nor the television, certainly not with appropriate apologies from the infamous television report of "Junk Science." Nor did I read of this through the popular press.

Just one day, there it was, quietly sitting on a web page of the American Lung Association (ALA), waiting to be discovered: "Common Asthma Triggers..Avoid perfume and perfumed cosmetics..."[emphasis, mine]. The last time I checked there was no mention of fragrances as asthmatic triggers.

Feeling a wave of encouragement, I decided to check web pages under the American Medical Association (AMA) and discover—"Discuss ways to reduce exposures to the following: Other irritants (e.g., perfumes, cleaning agents, sprays)."

Vindicated! All of us! Oh to be sure, "discuss ways to reduce exposures" could mean another fifty years of pondering by the AMA, but with these published statements, we can move forward—move

forward to preventing and acknowledging the danger and resulting medical conditions (of which multiple chemical sensitivities is one).

This is the validation we need as we seek to regain recognition of our creditability and gain the access we have too long been denied. We the patients, afflicted with sensitivity to fragrance products, have known it to be true: Fragrance products can cause and/or exacerbate asthma—and in my case, other's fragrances set the stage for my "slide" beyond chemical-induced asthma, with which I lived most of my life, and into multiple chemical sensitivity (MCS).

We have been put through a living hell of disbelief and suffered the insensitivity of others—a hell that has been worse in many ways than our sensitivity to the chemical fragrance products used by them.

Perhaps now our health care practitioners, workplaces, schools, government agencies, family and friends will begin to listen and believe us. Perhaps now we will benefit from implementation of no-cost, fragrance-free accommodations. Perhaps now we will begin to see the burgeoning public health problem begin to slow, as people voluntarily refrain from wearing and using scented personal care and cleaning/maintenance products. Perhaps now we will see that people can help themselves maintain health as they accommodate others.

Oh to be sure, the ALA and the AMA have been concerned with asthma. We learned from them by way of the popular media that asthma was on the rise, as were asthma deaths. Calls went forth to take asthma seriously. We've been alerted to such dangers as paint, carpeting, furniture, adhesives and pesti-

cides. Ironically, they've also said to use vinyl-bedding protectors to control dust mites, and to use insecticides against the dreaded roach. (From ALA's page: "Cockroaches use insect sprays; but only spray when your child is outdoors. Air out your home for a few hours after spraying. Use roach traps.")

Patients and creditable researchers have long documented the numerous health hazards that the ubiquitous fragrance products pose. It is just a matter of time before the whole truth will be told. The ALA and AMA have not yet touched upon the whole story of synthetic fragrances, which are created from thousand of untested toxic chemicals. They have not informed us of the fact that fragranced personal care and cleaning/maintenance products are untested—untested for inhalation, untested for chemicals in combination within the product itself, and certainly untested for the new chemical compounds created when individual scents volatilize and combine.

As fragrances reportedly volatilize at about 90 degrees, it's understandable that warm, poorly ventilated rooms, occupied by fragrance users, creates a toxic chemical stew. Indoor air pollution (IAP) affects everyone—sooner or later.

Hair and Skin Care Products

Most hair care products contain chemicals. Some of those ingredients account for both immediate allergic reactions and cumulative toxicity leading to a decreased tolerance. The following are some frequently used chemical detergents to be *avoided*.

Sodium Lauryl Sulfate—A popular ingredient, commonly referred to in the trade as SLS. It is used

as a detergent, emulsifier and surfactant in over a thousand cosmetic products, toothpastes, lotions and creams. Many "natural" cosmetics include this ingredient even though it's not natural—it's produced synthetically, and is rarely made from coconut oil (even when the label says it is).

It is a primary irritant in high concentrations. It's a strong degreaser that dries the skin and hair, produces skin and hair damage and inflammation of the dermaepidermal tissue. Also, according to Dr. Keith Green at Georgia Medical School, sodium lauryl sulfate causes improper eye development in children, and cataracts in adults.

Olefin Sulfonate—Another name for deodorized kerosene

Propylene Glycol—Another name for antifreeze

Mureth Sulfate (PEG-1-4)—Derivative of lauryl alcohol

Ammonium Lauryl Surfate—Derivative of lauryl alcohol

Formaldehyde—This colorless, pungent, irritating substance is found in many preservatives, such as the hydantonins; it's also used as a disinfectant. It's acutely toxic when inhaled or swallowed, and 44% of all people whose skin is exposed to it get a toxic reaction.

At one point, the FDA banned formaldehyde from cosmetics, but it's now used in shampoos at concentrations of 0.1% to 0.2%. If its concentration is greater than 0.05%, the European Economic Community requires that formaldehyde be identified on a product's label—however, this labeling is not required in the U.S.

The common symptoms of formaldehyde toxicity include, but are not limited to, irritations of the skin, eyes, respiratory passages, acute headache, blurred vision and dizziness.

Formalin is a trade name for formaldehyde. Formaldehyde is also hidden under the name quaternium-15.

All the above detergents corrode the hair follicles, irritate the oil glands, dry out the scalp and cause premature hair loss.

Dandruff Shampoos

Dandruff shampoos are the most dangerous of all hair-care products because they contain highly toxic medications to prevent the scalp from peeling.

One popular anti-dandruff agent is **selenium sulfide,** which, if swallowed, can cause vital organs to degenerate.

Another ingredient common in dandruff preparations is **Recorcinol**. This highly toxic substance is easily absorbed through the skin and can cause the following symptoms:

- Inflammation of the inner eyelids
- Generalized skin irritation
- Dizziness
- Restlessness
- Unconsciousness and convulsions

In addition, many dandruff shampoos contain toxic cresol and polyvinylpyrrolidone plastic (PVP).

I know specifically of one company who manu-
factures hair care products made from organic
ingredients, without any added toxic substances—
Organic Excellence™. They avoid alcohol, artificial
scents and colors and harsh detergents. Because
Organic Excellence™ shampoo, conditioner and
hair spray are made from natural, certified organic
herbs in a chemical free base ingredients, they are
safe for the environment and the waste water sys-
tem. The hair care products do have a "hint of
mint" from certified organic herbs. This delicate
organic fragrance has not been a problem even
with my most sensitive clients.

Skin Care Products

There are a few good companies producing
organic skin care products, Organic Excellence™ is
one of those. In addition to not containing toxic
chemicals, most of its ingredients are certified
organic. They manufacture a line of face and body
cleanser and natural moisturizing cream. These
products are not artificially scented and have been
easily tolerated by most of my clients and me.

REDUCING YOUR TOXIC LOAD:
CLEANING PRODUCTS

It is difficult to ascertain which cleaning products
are the safest and less likely to produce an allergic
response—especially with the barrage of convincing
advertising.

In order to improve health, and prevent disease,
it is imperative to create a nontoxic environment,
both at home and in the workplace.

We have become "programmed" to use products containing ammonia, bleach, oven cleaners, furniture polish, scouring powder, disinfectant, glass cleaners, degreasers etc. We do not, however, take into consideration the toxic ingredients in those products—cleaning products are among the more hazardous products you can use in any environment. These cleaning products are a huge threat to our health and our environment—so much so that they are the only household products regulated by the Consumer Product Safety Commission under the 1960 Federal Hazardous Substance Labeling Act. This regulation means that cleaning products that can harm you must carry warnings on their labels.

The next time you buy cleaning products, pay close attention to the warnings:

- **Toxic/Highly Toxic**—Poisonous if you happen to drink it, breathe the fumes, or if it is absorbed through the skin
- **Extremely Flammable/Flammable/Combustible**— Can ignite if exposed to a flame or electric spark
- **Corrosive**—A substance that will eat away your skin or cause inflammation of mucous membranes
- **Strong Sensitizer**—May provoke an allergic reaction

Hazardous cleaning products must also prominently display the degree of toxicity with one of the following signal words:

- **Danger or Poison**—Marked with a skull and crossbones—identifies a product that can kill an adult if only a tiny inch is ingested
- **Warning**—Identifies a product capable of killing an adult if approximately a teaspoon is ingested

- **Caution**—Serves as a warning that the substance will not kill (under normal, healthy conditions) until an amount from 2 tablespoons to 2 cups is ingested

The challenge lies in finding a product that is safe and non-toxic; I have located such a product—Organic Choice™ all-purpose cleaner. This product:

- Is 100% readily biodegradable
- Effectively replaces Mineral Spirits, Petroleum Products and all Solvent Based Products
- Is 100% soluble in water and has no VOC's (Volatile Organic Compounds), it will not irritate skin, eyes or lungs
- It will not harm people, animals, plants, nor will it attack wax or paint
- Complies with all E.P.A., U.S.D.A. and MIOSHA regulations
- Has been approved in Canada for use in food areas
- Is compatible will all waste water treatment plants
- Will cut your cost for cleaners because this one product will replace the majority of cleaning products currently being used
- Will clean everything in your home from laundry, furniture and wood floors to washing your car's engine
- Will clean everything in your business from carpets to jet engines

Organic Choice™ has proven to be tolerated by most chemically sensitive individuals. It is safe, odorless and highly concentrated. For most indoor cleaning, 1 to 2 ounces diluted in a gallon of water is sufficient. For heavy degreasing use 4 ounces per gallon. Why use a toxic product when safe

options are not only available and cost-effective? This product is strong enough to effectively clean everything from greasy garage floors and stains in marble and tile. However, it is gentle enough to shampoo your hair or your pets. It's your health; it's your choice!

REDUCING YOUR TOXIC LOAD: HEALTHCARE

Hospitals and Emergency Care

Julia Kendall, a victim and activist for those with multiple chemical sensitivity passed away on July 12, 1997 of complications from leukemia. It is both sad and ironic that Julia, who sued Neiman Marcus "for continuing to pollute my mail with fragrance strips,"—was exposed to *scented* health care workers in the hospital before she died.

Some physicians and individuals are making a *huge* difference in their efforts to educate healthcare providers, governmental agencies and the general public regarding accommodations for people with multiple chemical sensitivities. Two of those physicians credited for awareness and activism are Ann McCampbell, M.D. Chair of the Multiple Chemical Sensitivities Task Force of New Mexico and Erica Elliott, M.D., Family Practice and Environmental Medicine, Santa Fe, New Mexico. The following is a summary of the healthcare guidelines recommended by these physicians; use it for your own education and share it with your family, friends/neighbors and healthcare providers. If your needs are known, appropriate accommodations can be requested so as to not add to your existing toxic load.

1 **Listen To The Patient**

Reassure the patient that you understand that he/she is chemically sensitive and will work with him/her in providing care

Communicate on an ongoing basis about the patient's environment, evaluation and treatment; be willing to answer detailed questions

Respect patient's concerns and limits

Remember patient sensitivities vary in kind and severity from person to person

2 **Clearly Flag Medical Charts That Patient Is Chemically Sensitive**

3 **Consult With Patient's Environmental Physician (when possible)**

4 **Protect The Patient From Air Pollution**

Assign to a private room with:

No pesticides, new paint or carpet, other recent remodeling

No perfume on care-givers (place specific sign on door)

Non-smoking care-givers (smoke lingers on hair, skin, clothing)

No strong cleaners, fragranced products, or disinfectants (place sign on door)

Allow patient to wear mask/respirator, use air filter, and open windows as needed

Keep door to patient's room closed

Reduce time patient must spend in other parts of the hospital by performing as many procedures and evaluations as possible in patient's room

5 **Use Patient's Medical Supplies and Equipment (whenever possible)**

Oxygen mask and tubing

Medications, food and water

Bedding, clothing and soap

6 **Keep Drug Use To A Minimum!**

Listen to patient's concerns about drug use and history of reactions

Avoid drug use if possible; otherwise administer low doses with caution

Use IV fluid bottled in glass without dextrose (many react to corn-based dextrose)

Use preservative-free formulations

Capsules are generally better than tablets (less binders, fillers and dyes)

Use short-acting regional, rather than general anesthesia, whenever possible

Try to avoid use of halogenated gas anesthetics

No one should be "scared to death" of calling 911 or of being taken to a hospital. The State of New Mexico has taken a pro-active role to correct fears through education of its health care providers. What is your community doing? It's easy to sit back and let others do the work; the only way to affect change is through education and involvement. Communicate with your EMT personnel, hospital, physicians and policy makers; education is the only key that unlocks the lock of prevention. Remember, multiple chemical sensitivities are an invisible illness (unless you're in the middle of an acute reaction). It's an illness that can suddenly appear (as after trauma, drug use or toxic environmental exposure), or it can slowly creep up on its victim as a result of an accumulated toxic load weakening the immune system. Educate yourself and others on the causes of this invisible illness; the next victim of MCS could be you!

Dentistry

According to Marshall A. Arbo, D.D.S., choosing a dental office for treatment once you have been diagnosed with multiple chemical sensitivities (MCS) or multiple allergic responses (MAR), requires the following considerations in addition to those recommended in the previous section on healthcare.

1 Approach dental care with caution. Many minerals/chemicals used in disinfection and treatment can be a potential lethal encounter.

2 Recognize that "usually" the big city dental offices are not equipped (mental attitude) for the treatment of patients with MCS/MAR.

3 Notify staff not to use perfumes and fragrances.

4 Before treatment is rendered, be sure the dentist is consulting/working with your primary physician. In patients with acute allergic responses it is advisable, if possible, to have your primary physician present at least at the first session, and in subsequent sessions if there exists a critical situation.

5 If possible, always use your own oxygen and apparatus/medications, etc.

6 If amalgams are being replaced, start with one to test your reaction level and tolerance. *Do not* agree to have a large number of amalgams replaced without clearance from your primary physician.

7 Understand that you will be expected to compensate the dentist and your physician for the added time and precautions. It is well worth it, especially considering the additional risk for the treating dentist.

8 Be sure the dentist is knowledgeable about protecting you, as much as possible, from breathing contaminated air. Have he/she use oxygen

and possibly nitrous oxide (if tolerated) during all procedures to provide an uncontaminated atmosphere.

9 Be sure the dentist understands the importance of *cutting out* amalgams, not grinding them for replacement. The dust from grinding can be extremely toxic to an already toxic patient.

10 Minimize the length of visits and medications used. Be sure the dentist *really* understands MCS/MAR, listens to your requests and takes all necessary precautions.

11 Arrange ahead of time for the dentist to order, and have available, any medications needed without preservatives.

12 Be sure the dentist uses a rubber dam whenever possible. This apparatus protects the chemicals and chemical dust from being inhaled. However, in extremely sensitive individuals, he/she must use a barrier between your face and the dam. A piece of paper towel or cloth can serve as an effective barrier. If you're sensitive to most fabrics, bring along your own piece of organic cotton for the dentist to use. Usually 1/4 yard will provide all the material needed for several visits. After the dentist cuts the fabric for the dam, you can take it home, launder it and have it ready for your next visit.

13 Be sure to notify the dentist if you're taking high doses of vitamin "C"; it acts as a blood-thinner, therefore, dosage needs to be agreed upon *prior* to your visit. Check with your primary physician.

14 Be sure to take with you any medications used for allergic reactions and discuss them with the dentist prior to having any work performed.

15 Most importantly, be sure the dental office you choose agrees to work closely with your primary physician; understanding that it is the primary physician experienced in MCS/MAR who is coordinating the treatment protocol.

It is imperative to select a dentist, and schedule a consultation, prior to needing his services. If, during your interview, it becomes evident he/she does not understand MCS/MAR, pay him/her for their time and find a new dentist.

Always remind everyone that has any contact with you in the dental office of your sensitivities. Do not allow a hygienist or assistant to proceed with procedures until you know she is knowledgeable about the necessary precautions—if in question,

FLASHBACK

I was in my dentist's office for a routine filling at the onset of my illness. I had been to this dentist for several years prior. My dental chart had been clearly marked that I was not to receive any anesthetic with epinephrine. On this particular day, the dentist proceeded to inject me, and I did not do my usual questioning before the injection. Within seconds of the injection, I felt as if I was having a heart attack and my face and neck became a mass of red welts. Having been in the dental field previous to being a naturopath, I was well aware that my reaction was that of epinephrine. When I alerted the dentist to my reaction, he stated that the dental assistant was new and she did not pay any attention to the warning on the front of my chart. She, therefore, did not bring to his attention my sensitivities, and he did not check the chart himself. I emphasize again, question, question, question *each and every time you are about to receive any substance. At times we may feel embarrassed at our repeated "interrogation", however, the consequences of not interrogating can be life-threatening!*

Fortunately, I was able to lessen the reaction with my homeopathic emergency kit; it was my last visit to that office.

insist on speaking to the dentist before any auxiliary personnel proceeds.

REDUCING YOUR TOXIC LOAD: NUTRITIONAL/SUPPLEMENTAL

Vitamin C: Not Just For Preventing a Cold!

Buffered Vitamin C has the ability to both reduce an allergic reaction and to assist the immune system by producing lymphocytes. It prevents free-radical damage and is used by the thymus gland (involved in immunity) to increase the mobility of phagocyte cells—cells that "eat" bacteria, viral cells and other harmful toxic substances.

At the first sign of an allergic reaction, I take a dose of from 2000 to 3000 mg. of buffered Vitamin C powder. When traveling, especially by aircraft, it is a preventive measure to consume doses of Vitamin C throughout the trip. I generally carry a small container in my carry-on baggage. I drink at least 16 oz. of water per hour of flight time, and always sprinkle Vitamin C powder in each serving. This maintains the highest level of immune boosting properties, while also reducing your risk of an allergic reaction from germ ridden re-circulated air containing chemicals, insecticides and pesticides.

Clinical findings from Gunnar Heuser, M.D., Ph.D., F.A.C.P., a specialist in Neurotoxicology and Immunotoxicology, has shown that in patients who have suffered injury from exposure to toxic chemicals, they often have low NK (killer cell) function and also low T and B cell function. In patients exposed to toxic chemicals, Dr. Heuser's findings

concluded that taking buffered Vitamin C powder enhanced NK activity and T and B cell function.

According to Dr. Heuser, it is now possible to test the functioning of the immune system through high-tech equipment, not available until recent years. This type of testing allows not only the counting of immune cells, but also the ability to measure their job performance. Dr. Heuser's research has proven that "NK function is decreased in a number of conditions including emotional and physical stress, chronic fatigue syndrome and in cancer."

Heuser further expresses his concerns that "many toxic chemicals are potential carcinogens and the mechanisms of carcinogenesis are not well defined. When NK function is studied after exposure to a number of toxic chemicals, it is often decreased, both in animals and in humans. Therefore, persistently low NK function as a result of chemical exposure has been proposed as one possible mechanism for chemically induced carcinogenesis."

AFTERWORD

Illness, especially when it's invisible, makes us question everything that is familiar, socially acceptable and comfortable.

Illness makes us re-examine our entire life, it's priorities, meaning and legacy.

Illness strips us of who we are, or at least who we perceive ourselves to be.

Illness leaves us exposed and naked, naked because everything familiar is now a potential enemy.

Illness forces us to delve into deeper layers, extracting the ideals we were raised with—ideals that hinder our emotional, spiritual and physical health along with those we accumulated along the way.

Illness involves a process of self-recovery—bursting out of old patterns and developing new ones that serve our newly created self.

Illness means seeing our cup of health challenges as half-full, not half-empty—recognizing that you will experience failed hopes and expectations, however, the experience serves to gain a new healthier perspective.

Illness forces us to fearlessly examine the things in our life that are not working—and then using that information to build and move on, not beating ourselves up for past choices.

Illness allows us the opportunity to recognize that true healing only comes when we fully love and respect who we are and, in turn, learn to set our own standards for what we will and will not accept in our lives.

Illness gives us the opportunity to test our creative navigation abilities—finding a new path when suddenly the road we're familiar with comes to a dead end.

Illness builds compassion and appreciation—you can't have true compassion and appreciation if you haven't experienced the loss of health.

Illness helps us recognize that the only thing we can't afford in life is to be around negative people—negativity is a contagious, oftentimes invisible, illness!

The Afterword is dedicated to the memory of my dear friend, *Tiffany Francis*, whose legacy will live for generations. Thank you for the coaching, love, generosity and graciousness you so selflessly gave. The consciousness you lived by will forever grace your students and the lives of those who were honored to be included as your chosen family. You are missed!

RESOURCES

Ordering Referenced Products

For your convenience, the professional products mentioned in this book may be ordered toll-free directly from Healthy by Design at: 1-877-862-5417. This service is provided **solely** for the purpose of ordering products referred to in this book.

Ordering Products and General Merchandise

To purchase a variety of quality air/water purification systems, supplements, domestics and books contact Nutritional Ecological & Environmental Delivery Systems (NEEDS) in the USA at 800-634-1380.

Consulting With Dr. Gilbère

To consult with Dr. Gilbère, either by telephone or at the Naturopathic Health & Research Center in northern Idaho, USA, you must call 208-267-5417 (PST), or fax a request for new client information to 208-267-0617. You may also email a request for new client forms, however, *email is **only** for the purposes of requesting new client information, please **do not email** for other questions or business*. New Client forms can also be downloaded and printed from Dr. Gilbère's web page at: www.drgloriagilbere.com.

After completing and signing the forms, they can be faxed or mailed along with a recent photograph (email photos acceptable). You may then call or fax the health center to schedule your consultation.

Arrangements for lodging, organic food, and therapies in various healing modalities in north Idaho are coordinated and monitored by the health center, upon request.

Because of the large volume of international telephone consultations, arrangements have been made to schedule consultations in various local time zones (Monday–Friday), to better accommodate the international client.

To purchase individual or bulk
copies of this book, contact the publisher,
Freedom Press at 800-959-9797
E-mail: info@freedompressonline
Website: www.freedompressonline.com
1801 Chart Trail, Topanga CA 90290

Support Groups and Websites
Fibromyalgia Coalition International
(913) 384-HOPE (4673)
www.fibrocoalition.org

Environmental Health Network of California

www.ehnca.org

Safe Schools
www.head-gear.com:88/SafeSchools/

**Support Groups and Websites for
victims of benzodiazepines and
prescription drug withdrawal syndrome**
International Benzodiazepine Awareness Network (BAN)
www.trans.org.au/
www.drugawareness.org
www.benzo2000.com.
www.benzodiazepines.net
www.benzodiazepines.org

Support in the U.K.
www.benzo.org.uk

Support in Australia
www.drugawareness.org
www.breggin.com

BIBLIOGRAPHY

Ahmed, A., *InuFlora: The Prebiotic of Choice*: Topanga, California, Freedom Press, 1999

Aoshima, H., et al. *"Potentiation of GABAA receptors expressin in Xenopus Oocytes by Perfume and Phytoncid."* Biosci Biotechnol Biochem. 1999 Apr;63(4):743-8.

Asterita, Mary. *"The Physiology of Stress with Special References to the Neuroendocrine System."* New York, Human Sciences Press, Inc., 1985.

Baily, L.H. *Encyclopedia of Horticulture*, New York, NY: Macmillan Co., 1939

Barkley, R. "A review of stimulant drug research with hyperactive children," *Journal of Child Psychology and Psychiatry*, 1977, 18, pp. 137-165.

Barkley, R. "A review of stimulant drug research with hyperactive children." *Journal of Child Psychology and Psychiatry*, 1977, 18, pp. 137-165.

Barnes, Broda O. & Lawrence Galton *"Hypothyroidism: The Unsuspected Illness,"* New York, N.Y: Harper & Row, 1976.

Barnes, Broda O. & Lawrence Galton. *"Hypothyroidism: The Unsuspected Illness."* New York, Harper & Row, 1976.

Batmanghelidj, F. Dr. *Your Body's Many Cries For Water,* Falls Church, VA, Global Health Solutions, Inc., 1997

Berger, Stuart M. *"How to be Your Own Nutritionist."* W. Morrow & Co., New York. 383 p. 1987.

Berkow, Robert, MD, Editor. "*The Merck Manual.*" 16th Ed. 2844 pp. 1992. Merck & Co., Inc. Rahway, M.J. (Request recent edition)

Bland JS. *A Functional Approach to Mental Illness—A New Paradign for Managing Brain Biochemical Disturbances. Townsend Letter for Doctors*, Reprinted with permission from *The Journal of Orthomolecular Medicine.* December 1994: 1336

Bland, J. *Lectures of Dr. Jeffrey Bland*, selected papers

Boris M. and Manuel F. *Foods and additives are common causes of the attention deficit hyperactive disorder in children*, Annals of Allergy, 1994; 72:462-468.

Borysenko, Joan "*Minding the Body, Mending the Mind,*" New York, N.Y.: Bantam, 1987

Borysenko, Joan. "*Minding the Body, Mending the Mind.*" New York, Bantam, 1987

Bragg, P. and P.C. *Water: The Shocking Truth*, Santa Barbara, CA, Health Science, Twenty-Eighth printing

Brenner, Arnold "The effects of megadoses of selected B-complex vitamins on children with hyperkinesis: controlled studies with long-term follow-up," *Journal of Learning Disabilities*, May 1982, 15, pp. 258-264.

Bushway, R.J. and Ponnampalam. "*a-Chaconine and a-Solanine Content of Potato Products and Their Stability During Several Modes of Cooking (they were stable).*" J.Agr.Food Chem. 29:814-817. 1981.

C.M. Carter, et al, *Effects of a few foods diet in attention deficit disorder*, Archives of Diseases in Childhood, 1993; 69:564-568.

Cabot, Sandra, "*The Healthy Liver and Bowel Book.*" Australia: WHAS, 1999.

Cabot, Sandra, *"The Liver Cleansing Diet."* Scottsdale, AZ: S.C.B. International, 1996.

Capra, Fritjof "The new physics: implication for psychology," *The American Theosophist*, Spring, 1980, pp 114-120

Capra, Fritjof "The Tao of Physics," Boulder, CO: Shambhala Publications, 1975

Chaube, S. and C.A. Swinyard. *"Teratological and Toxicological Studies of Alkaloid and Phenolic Compaounds From Solanum Tuberosum."* L. toxicol. Appl. Pharmacol. 36:227-237. 1976.

Cheeke, P.R. and Lee R. Shull. *"Natural Toxicants in (livestock) Feeds and Poisonous Plants."* Avi Publ. Co., 250 Post Rd., Westport, CT 06881. 1985.

Cheraskin, E., Ringsdorf, M., *"Prevalence of Possible Lead Toxicity as Determined by Hair Analysis."* Journal of Orthomolecular Psychiatry, Vol. 8 No. 2.

Childers, N.F. *"An Apparent Relation of Nightshades (Solanaceae) to Arthritis."* J. Neuro. Orthop. Med Surgery 14:227-231. 1993.

Childers, N.F. *An Apparent Relation of Nighshades (Solanaceae) to Arthritis, Internat.* J. Acad. Prev. Med. 7:3 31-37, 1982

Childers, N.F. *An Apparent Relation of Solanaceae (Nightshades) to Arthritis And Other Diseases*, Jr. Amer. Soc. Hort. Sci. In press. 1999

Childers, N.F. Dr. *Arthritis: Childers Diet That Stops It*, Gainesville, FL, Dr. Norman F. Childers Publications, 1999

Childers, N.F., *"An Apparent relation of Solanaceae (Nightshades) to Arthritis and Other Diseases."* Jr. Amer. Soc. Hort. Sci. In Press. 1999.

Childers, Norman F. *"A Relation of Arthritis to the Solanaceae (Nightshades) Internat."* J. Acad. Prev. Med. 7:3 31-37. 1982.

Chipra, Deepak *"Quantum Healing: Exploring the Frontiers of Mind/Body Medicine,"* New York, N.Y.: Bantam, 1989.

Chopra, Deepak. *"Quantum Healing: Exploring the Frontiers of Mind/Body Medicine."* New York, Bantam, 1989.

Christopher, John R. *"School of Natural Healing."* Provo, UT: BiWorld Publishers, Inc., 1976.

Colombel, et al., Lancet: 2, 43, 1987

Crook, Dr. William. *The Yeast Connection.* New York, NY: Vintage Books, 1986

Crook, W.G. "Can What a Child Eats Make Him Dull, Stupid, or Hyperactive?" *Journal of Learning Disabilities* 13, 1980: 53-58

Crook, William G. MD. *Nature's Own Candida Cure,* Burnaby, BC: Alive Books, 2000

Dong, C.H. and J. Banks. *"New Hope for the Arthritic."* T.Y. Crowell Co., New York. 268 p. 1975.

Dong, Collin H. and Jane Banks, *New Hope For The Arthritic,* New York, NY: Thomas H. Crowell Co., 1975: 269

Doull, John, et al., *"Toxicology—Basic Science of Poisons."* Macmillan Publ. Co. 866 3rd Ave., NY, NY 10022. (Phytotoxicology by J. Kingsbury, p.578-90). 778 p. 1980.

Dubick, M.A., *"Historical Perspectives on the Use of Herbal Preparations to Promote Health (garlic included)."* Journ. Of Nutr. 116:1348-1354. 1986.

Early American Horticulture, Grower Talks, Bicentennial Issue, West Chicago, Ill, George J. Ball, Inc.: 1976: 48

Edling C., Hellman B., Arvidson B., Andersson J., Hartvig P., Lilja A., Valind S., Langstrom B.: "*Do Organic Solvents Induce Changes in the Dopaminergic System? Positron Emission Tomography Studies of Occupationally Exposed Subjects.*" Int Arch Occup Environ Health 70, 180-186 (1997).

Edling C., Hellman B., Arvidson B., Johansson G., Andersson J., Hartvig P., Valind S., Langstrom B.: "*Positron Emission Tomography Studies of Healthy Volunteers-No Effects on the Dopamine Terminals and Synthesis After Short Term Exposure to Toluene.*" Human & Experimental Toxicology 16, 171-176 (1997).

Edling, C., Hellman, B., Arvidson, B., Andersson, J., Hartvig, P., Lilja, A., Valind, S., Langstrom, B. "*Do organic solvents induce changes in the dopaminergic system? Positron emission tomography studies of occupationally exposed subjects,*" Int Arch Occup Environ Health 70, 180-186, 1997

Edling., C., Hellman, B., Arvidson, B., Johansson, G., Andersson, J., Hartvig, P., Valind, S., Langstrom, B. "*Positron emission tomography studies of healthy volunteers-no effects on the dopamine terminals and synthesis after short term exposure to toluene,*" Human & Experimental Toxicology, 16, 171-176, 1997.

Faelten, Sharon and Eds. "*The allergy Self-help Book.*" Rodale Press, Minor St., Emmaus, PA 18049. 368 p. 1983.

Fredericks, Carleton, PhD. "*Arthritis—Don't Learn to Live With it.*" Gossett & Dunlap. New York. 221 p. Reprint 1987.

Fredericks, Carleton, PhD. *"Psycho-Nutrition."* Gosset & Dunlap Publ., New York. N>Y. 224 pp. 1976. (Plus 13 other health books cited)

Fuller, R., *Gut*: 32, 439, 1991

Gershon, Michael D. Dr. *The Second Brain*, New York, NY: Harper Collins, 1998

Gilbère Gloria Dr. *I was Poisoned by my body: The Odyssey of a Doctor Who Reversed Fibromyalgia, Leaky Gut syndrome, and Multiple Chemical Sensitivity*—Naturally, Lancaster, OH: Lucky Press, 2001

Gillie, Oliver, *"New Clues to Cancer."* Times (London). January, 1977.

Glassburn, Vicki *Who Killed Candida?*, Brushton, NY: Teach Services, Inc. 1991

Goodhart, R.S., MD, and M.E. Shils, MD. *"Modern Nutrition in Health and Disease."* Lea and Febiger, Philadelphia, Pa. 6th Ed. 1153 pp. 1978.

Gordon, P. *"Free Radicals and the Aging Process,"* in *Theoretical Aspects of Aging*, M. Rockstein, Ed. New York: Academic Press, 1974.

Gurskin, Benjamine, in the *American Journal of Surgery*, 49 (1940): 49.

Hagiwara, Yoshihide. *"Green Barley Essence: A surprising Source of Health."* Tokyo, Japan: Association of Green and Health Distributors, 1981.

Hagstadius S., Orbaek P., Risberg J., Llindgren M.: *"Regional Cerebral Blood Flow at the Time of Diagnosis of Chronic Toxic Encephalopathy Induced by Organic-solvent Exposure and After the Cessation of Exposure."* Scan J Work Environ Health 15, 130-135 (1989)

Hagstadius, S., Orbaek P., Risberg J., Lindgren M.: *"Regional cerebral blood flow at the time of diagnosis of chronic toxic encephalopathy induced by organic-solvent exposure and after the cessation of exposure."* Scand J Work Environ Health, 15, 130-135, 1989.

Hammer, D.I. *"Trace Metals in Hair are Easier to Study."* 1971, Jama 216(3):384.5.

Hansen, A.A. *Two Fatal Cases of Humans to Potato Poisoning,* Science 61:340, 1925

Heuser G., Mena I.: *"NeuroSPECT in Neurotoxic Chemical Exposure. Demonstration of Long Term Functional Abnomalities."* Toxicology and Industrial Health (in press).

Heuser, G., Mena, I. *"NeuroSPECT in neurotoxic chemical exposure: Demonstration of long-term functional abnormalities,"* Toxicology and Industrial Health, 2000.

Hoover, Richard. *"Cereal Grasses: A Complete Food."* Natick, MA: V.E. Irons Company, 1972.

Hotta, Yasuo. *"Preliminary Report on How the Juice of Young Green Barley Grass Plants Can Normalize and Rejuvenate Cells and Tissue, Can Repair Damaged DNA, Restore Cellular Activity, and Prevent Aging of Tissue."* Carson, CA: Green Foods Corporation, 1981.

Hughes, J.H., and Latner, A.L. *"Chlorophyll and Hemoglobin Regeneration After Hemorrhage,"* *Journal of Physiology,* 86 (1936): 388.

Hunsberger, Eydie Mae, and Loeffler, Chris. *"How I conquered Cancer Naturally."* San Diego: Production House, 1975.

Hutchinson, M.L. and H.N. Munro. *"Nutrition and Aging."* Academic Press, N.Y. 287 p. 1986.

Jadhav, S.J., R.P. Sharma and D.K. Salunkhe. *"Natural Occurring Alkaloids in Foods."* Critical review in Toxicology 9:21-104. 1981.

Jenkins, D.W. *"Biological Monitoring of Toxic Trace Metals."* 1980 E.P.A. (Pub. No. 600/3-8-089) Washington, D.C.

Jensen, Bernard. *"Chlorophyll Magic From Living Plant Life."* Escondido, CA: Jensen Publications, 1973.

K.S. Rowe and K.J. Rowe, *Synthetic food Coloring and behavior: A dose response affect in a double-blind, placebo-controlled, repeated measures study.* (Journal of Pediatrics, 1994; 125:691-8).

Jirovetz, L., et al. *"Investigations of Animal Blood Samples After Fragrance Drug Inhalation by Gas Chromatography/Mass Spectrometry With Chemical Ionization And Selected Ion Monitoring."* *Biol Mass Spectrom.* 1991 Dec;20(12):801-3.

Kabat-Zinn, J. *Full Catastrophe Living.* New York, NY: Delta Books, 1991

Katz, S. *"The Use of Hair as a Biopsy Material For Trace Elements in The Body."* Feb. 1979 American Laboratory.

Keeler, R.F. et al. *"Effects of Posonous Plants on Livestock."* Academic Press. New York. 600 p. 1978.

Keeler, R.F. et al. *Effects of Poisonous Plants on Livestock,* New York, NY:Academic Press, 1978: 600

Keller, R.F. et al. *"Spirosoline—Contained in Solanum species and Induction of Congenital Craniofacial Malformations."* Toxicoe 28:873-884. 1990.

Kingsbury, John M. *"Posionous Plants of USA and Canada."* Prentice Hall, Inc. Englewood Clliffs, N.J. 275-294. 1968.

Klevay, L.M. *"Hair as a Biopsy Material,"* Progress and Prospects, July 1978 Arch, Intern. Med. Vol 138.

Kloss, Jethro, *"Back to Eden."* California: Loma Linda, 1988.

Kohler, G.O., Elvehjem, C.A., and Hart, E.B., *"Growth Stimulating Properties of Grass Juice,"* Science, 83 (1936): 445.

Krook, L., R.H. Wasserman, K. McEntee, T.D. Brokken and T.B. Melbourne. *"Cestrum Diurnum Poisoning in Florida Cattle."* Cornell Veterinarian 65:557-575. October 1975.

Kubota, Kazuhiko. *"Anti-Inflammatory Effects of Green Barley Juice,"* address to annual meeting of the Japanese Pharmaceutical Society, April, 1980.

Kushi, Michio. Macrobiotics. Japan Publications, Inc., Tokyo, Japan 182 p. *"This Diet Also now Omits the Nightshades."* (See latest edition)

Lai, Chiu-Nan. *"Chlorophyll: The active Factor in Wheat Sprout Extract Inhibiting the Metabolic Activation of Carcinogens in vitro,"* Nutrition and Cancer, 1 (1978): 3.

Lake, Rhody, *Liver Cleansing Handbook*, Burnaby, BC: Alive Books, 2000

Lewis, W.H. PhD. *"Medical Botany—Plants Affecting Man's Health."* John Wiley and Sons, New York. 515 pp. 1977.

Lindlahr, H. *Natural Therapeutics* Vol. II Practice.London: The C.W. Daniel Co., Ltd, 1919

Locke, Steven & Douglas Colligan "*The Healer Within: The New Medicine of Mind and Body*," New York, N.Y.: E.P. Dutton, 1986.

Locke, Steven & Douglas Colligan. "*The Healer Within: The New Medicine of Mind and Body.*" New York, E.P. Dutton, 1986

Loes, M., Wilkholm, G., Shields, M., Steinman, D. *Arthritis: The Doctors' Cure*, New Canaan, CT, 1998

Lorig, T.S., "*EEG and ERP Studies of Low-level Odor Exposure in Normal Subjects.*" Toxicol Ind Health 1994 Jul-Oct;10(4-5):579-86.

Macfarlane, G., Cummings, H., *The Large Intestine: Physioilogy, Pathophysiology and Disease:* Phillips, et al. New York, NY, Raven Press, 1991

Macfarlane, G., Gibson, S., *Human Health: Contribution of Microorganisms*: London, Springer-Verlag, 1994

Malter, Richard F. "*Energy, stress, and 'burn-out': a new perspective on addictions,*" Unpublished paper, Malter Institute for Natural Development, Inc., Schaumburg, IL, August, 1985.

Malter, Richard F. "*Copper toxicity: psychological implications for children, adolescents, and adults,*" Unpublished paper, Malter Institute for Natural Development, Inc., Schaumburg, IL, April, 1984

Malter, Richard F. "*Implications of a Bio-Nutritional Approach to the Diagnosis, Treatment, and Cost of Learning Disabilities,*" Paper presented at the national convention, Association of Children with Learning Disabilities, Washington, D.C., February, 1983.

Malter, Richard F. "*Implications of a bio-nutritional approach to the diagnosis, treatment, and cost of learning disabilities,*" Somatics, Autumn-Winter, 1984-85, 34-43.

Malter, Richard F. *"Nutritional concerns in learning and psychological disorders,"* Paper presented to APA Div. 42, annual convention of the American Psychological Association, Los Angeles, CA, August, 1985.

Malter, Richard F. *"The cumulative toxic metal hypothesis and attention deficit disorders."* Unpublished paper, Malter Institute for Natural Development, Inc., March, 1990.

Malter, Richard F. *"Trace mineral profiles of hyperactive children,"* Unpublished paper, Malter Institute for Natural Development, Inc., Schaumburg, IL, April 1984.

Malter, Richard F. *"Copper Toxicity: psychological implications for children, adolescents, and adults."* Unpublished paper, Malter Institute for Natural Development, Inc., Schaumburg, IL, April 1984b.

Malter, Richard F. *"Energy, stress, and 'burn-out': a new perspective on additions."* Unpublished paper, Malter Institute for National Development, Inc., Schaumburg, IL: June. 1986.

Malter, Richard F. *"Implications of a Bio-Nutritional Approach to the Diagnosis, Treatment, and Cost of Learning Disabilities."* Paper presented at the national convention, *Association for Children with Learning Disabilities*, Washington, D.C., February, 1983.

Malter, Richard F. *"Implications of a bio-nutritional approach to the diagnosis, treatment, and cost of Learning Disabilities."* Somatics, Autumn-Winter, 1984-85, 38-43.

Malter, Richard F. *"The concept of a health-energy continuum: implications for maintaining health."* Unpublished paper, Malter Institute for Natural Development, Inc., Schaumburg, IL: August, 1987.

Malter, Richard F. *"Zinc/copper ratios and brain function: implications for educational and special education."* Unpublished paper, Malter Institute for Natural Development, Inc., Schaumburg, IL: April, 1988. Reprinted in Newsletter of Trace Elements, Inc., Dallas, TX: 1988.

Malter, Richard, Ph.D., *"Chaos Theory and Trace Mineral Analysis"*. Unpublished article. MIND, Hoffman Estates, Illinois, 1997; revised, September, 1999.

Malter, Richard, Ph.D., *"Trace Mineral Analysis and Psychoneuroimmunology"* J. of Orthomolecular Medicine, 2nd Qtr, 1994, Vol. 9, No. 2, 79-93. Reprinted in *The Townsend Letter for Doctors & Patients*, April, 1996.

Malter, Richard, Ph.D., *"Health History Checklist"* MIND, Bloomingdale, Illinois, 1995.

Mason, Karl E. *"A conspectus of research on copper metabolism and requirements of man."* Journal of Nutrition, November, 1979.

Maugh, T.H., *"Hair: A diagnostic Tool to Compliment Blood Serum and Urine,"* 1978 Science 202 (22):1271.3.

Mehta, S.W. & Eikum, R. *"Effect of estrogen on serum and tissue levels of copper and zinc."* Advances in Experimental Medicine & Biology. 258: 155-62,1989.

Merck Research Laboratories, Merck & Co., Inc., *The Merck Manual of Medical Information*, Whitehouse Station, N.J., 1997

Miller, Lois M. *"Chlorophyll for Healing,"* Science Newsletter, March 15, 1941.

Mindell, Earl, *Unsafe At Any Meal*, New York, NY, Warner Books, 1987

Mondy, N.L., M. Lega and B. Gosselin. *"Changes in Total Phenolic, Total Glycoalkaloids and Ascrobic Acid Content of Potato as a Result of Bruising."* Journ. of Food Science 52:631-633. 1987.

Morgan, W.S. *"The Clinical Use of Chlorophyll,"* Guthrie Clinical Bulletin, 16 (1947): 94.

Morishita, Keiichi, and Hotta, Kaneo, *"Medicine of Chlorophyll."* Tokyo, Japan: Association of Life Sciences Publishers, 1974 (translation).

Morris, S.C., T.H. Lee. *"Total toxicity and Terogenicity of Solanaceae Glycoalkaloids, particularly Those of Potato (Solanum tuberosum)."* A review of Food Technology in Australia. 36:118-124. 1984.

Morrow L.A., Callender T., Lottenberg S., Buchsbaum M.S., Hodgson M.J., Robin N.: *"PET and Neurobehavioral Evidence of Tetrabromoethane Encephalopathy."* Neuropsychiatry Clin Neurosci 2, 431-435 (1990).

Morrow, L.A., Callender T., Lottenberg S., Buchsbaum, M.S., Hodgson, M.J., Robin N. *"PET and neurobehavioral evidence of tetrabromoethane encephalopathy,"* Neuropsychiatry Clin Neurosci 2, 431-435, 1990

Mosby's Medical & Nursing Directory. 2nd edition: Princeton, NJ, The C.V. Mosby Company, 1986

Mun, A.m. et al. *"Teratogenic Effects in Early Chick Embryos of Solanine and Glycoalkaloids From Potato Infected With Late Blight. Phytophthera Infestans."* Teratol. 11:73-78. 1975.

Nasel C., Nasel B., Samec P., Schindler E., Buchbauer G., *"Functional Imaging of Effects of Fragrances on the Human brain After Prolonged Inhalation."* Chem Senses, 1994, Aug.; 19(4):359-64

Nelson, Norton, et al. *"Determining Cancer Risks From the Environment."* Supt. Of Documents. U.S. Gov'n. Printing Office (priced). Washington, D.C. 20402.

Nigg, H.N. and David Seigler, Eds. *"Phytochemical Resources for Medicine and Agriculture."* Plenum Press, New York, N.Y. 415 p. 1992.

Null, Gary. *No More Allergies*, New York, NY: Villard Books, 1992

Pagano, Dr. John O.A. *Healing Psoriasis*, Englewood Cliffs, NJ: 1991

Patek, A.J., and Minot, E.M. *"Bile Pigment and Hemoglobin Regeneration,"* American Journal of Medical Science, 188 (1934): 206.

Pfeiffer, C. & Mailloux, R. *"Excess copper as a factor in human diseases."* Journal of Orthomolecular Medicine, 1987, 2, no. 3, 171-182.

Pfeiffer, Carl C. PhD., MD. *"Mental and Elemental Nutrients,"* Keats Publ. Inc., 38 Grove St., New Caanan, CT 06840. 519 pp. 1975.

Pfeiffer, Carl. *"Mental and Elemental Nutrients: A physician's Guide to Nutrition and Health Care".* New Canaan: Keaats, 1975.

Pfeiffer, Carl. *"Nutrition and Mental Illness: An Orthomolecular Approach to Balancing Body Chemistry."* Rochester, VT: Healing Arts Press, 1987.

Pierro, L.J. et al. *"Terogenicity and Toxicity of Purified a-Chaconine and a-Solanine."* Teratology 15:31A. 1997.

Pihl R. & Parkes, M. *"Hair element content in learning disabled children."* Science, 1977, 198, 204-206.

Puhn, Adele. *Healing from the Inside Out*, New York, NY: Ballantine Publishing Group, 1998

Rafsky, H.A., and Krieger, C.I. *"Treatments of Intestinal Diseases with Solutions of Watersoluble Chlorophyll,"* Review of Gastroenterology, 15 (1948): 549.

Rapp, Dr. Doris. *Allergies and the Hyperactive Child*, New York, NY: Simon & Schuster, 1979

Rapp, Dr. Doris. *Allergies and Your Family*, New York, NY: Sterling Publishers, 1980

Renwich, J.H. *"Potato Babies."* Lancet 2:336. 1972.

Renwich, J.H. *Potato Babies*, Lancet 2:336, 1972

Rhodes R, Pflanzer R. *Human Physiology.* Second Edition. Philadelphia, PA: Saunders College Publishing, 1992

Rimland, B. & Larson, G. *"Hair mineral analysis and behavior: and analysis of 51 sutdies."* Journal of learning disabilities, May, 1983, 16, 279-285.

Robinson, Arthur. *"Living Foods and Cancer,"* Hippocrates Newsletter, march, 1984.

Rogers, Dr. Sherry. *The E.I. Syndrome: An Rx for Environmental Illness, Are You Allergic to the 21st Century?* New York, NY: Prestige Publishing, 1986

Rogers, Dr. Sherry. *Tired or Toxic.* New York, NY: Prestige Publishing 1990

Rosenbaum, Myron G., MD. *Understanding Arthritis*, St. Louis, MO.,1979: 102

Rudolph, Theodore, *"Nature's Green Magic."* Los Angeles: Rudolph Publishers, 1972.

Salaman, R. *History and Social Influence of The Potato*, Cambridge, England, Cambridge University Press, 1949: 684

Saunders, C.W., in *"Proceedings of the Society for Experimental Biology,"* 23 (1925): 788.

Schnabel, Charles. *"Grass: The Forgiveness of Nature,"* Acres USA, January, 1980.

Schroeder, H., *"Trace Elements and Man."* Deven Adair Co. Conn.

Scolnik, M., et al. *"Immediate Vasoactive Effect of Citral on the Adolescent Rat Ventral Prostate."* Prostate. 1994 Jul;25(1):1-9.

Seeley RR, Stephens TD, Tate P. op cit: 635

Simon, G.E., Daniell, Wl, Stockbridge, H., et al. "Immunologic Psychological and Neuropsychological Factors in Multiple Chemical Sensitivity: A Controlled Study," *Annals of Internal Medicine*, 119, 1993: 97-103

Smith, J. *"Remarks Upon the History, Chemistry, Toxicity, and Antibacterial Properties of Watersoluble Chlorophyll Derivatives as Therapeutic Agents,"* American Journal of Medical Science, 207(1944): 649.

Sneath PHA, Mair NS, Sharpe ME, Holt JG. *Bergey's Manual of Systemic Bacteriology*. Volume 2. Baltimore, MD, Williams & Wilkins, 1986: 1217

Steven, D.J., *"Determination of Aluminum, Copper and Zinc in Human Hair."* 1983 Atomic Spectroscopy, Vol. 4 No. 5.

Strong, F.M. et al. *"Toxicants Occurring Naturally in Foods."* National Academy of Sciences 2nd Ed. Washington, D.C. 624 p. 1973.

Strong, F.M. et al. *Toxicants Occurring Naturally in Food,* National Academy of Sciences., Second Edition. 1973: 624

Theodosakis, Jason, Brenda Adderly and Barry Fox. *"The Osteoarthritis Cure."* Martins Press, New York. 203 p. 1997.

Thrash, A. and C. Thrash. *"Home Remedies."* Thrash Publications. Rt. 1, Bx 273, Seale, AL 36875. 174. 1981.

Townsend Letter for Doctors, selected articles

Trace Substances in Environmental Health VIII," Edited by D. Hemphill. Proceedings of the University of Missouri's Annual Conference on Trace Substances in Environmental Health, June 1974.

Vanderhaeghe L., Bouic, P.J.D. *The Immune System Cure*, New York, NY: Kensington Books, 1999

Varney N., Morrow L., Pindston J., Wu J.: *"PET Scan Findings in a Patient with a Remote History of Exposure to Organic Solvents."* Applied Neuropsychology 5, No. 100-106 (1988).

Varney, N., MorrowL., Pindston, J., Wu, J. *"PET scan findings in a patient with a remote history of exposure to organic solvents,"* Applied Neuropsychology 5, No. 2, 100-106, 1998.

W. Shaw, E. Chevis, and M. Luxem. *Abnormal urine organic acids associated with fungal metabolism in urine samples of children with autism: preliminary results of a clinical trial with antifungal drugs.* Annual meeting of The Autism Society of American, Greensboro, NC, 1995.

Warburg, Otto. *"On the Origin of Cancer Cells,"* Science, 123 (1956).

Wasserman, R.H. et al. Calcinogenic factor (D3) in *Solanum malacoxylon*. Science 194:853-54, 1976

Watson, George *"Nutrition and Your Mind"* New York: Harper & Row, 1972.

Watts, D.L. *"Nutritional interrelationships: minerals-vitamins-endocrines."* Journal of Orthomolecular Medicine, 1990.

Watts, D.L. *"The nutritional relationships of copper."* Journal of Orthomolecular Mecicine. 4, 2, 1989.

Watts, D.L. *"Trace elements and neuropsychological problems as reflected in tissue mineral analysis (TMA) patterns."* Journal of Orthomolecular Medicine, 5, 3, 1990.

Wigmore, Ann, *The Wheatgrass Book*, New York, NY, Avery Publishing 1985

Young, R.W., and Beregi, J.S., *"Use of Chlorophyll in the Care of Geriatric patients,"* Journal of the American Geriatric Society. 28/1 (1980): 46-47.

ABOUT THE AUTHOR

Gloria Gilbère, N.D. D.A.Hom., Ph.D.

Dr. Gilbère is a doctor of naturopathy and natural health, Member—American Academy of Environmental Medicine, Diplomate—Academy of Homeopathy, Fellow—The American Naturopathic Medical Association, Fellow—American Society of Safety Engineers, eco-ergonomist, medical writer and researcher.

She is a general partner in the consulting firm, Global Integrated Health, an international health-consulting firm made-up of a network of highly trained and specialized naturopaths, integrative medical doctors and professionals in various modalities of natural and integrative health—providing consulting and referral sources to clients worldwide. Dr. Gilbère also maintains a private practice in northern Idaho as Director of the Naturopathic Health & Research Center. The center is located 30 miles south of the Canadian Border, 120 miles northeast of Spokane, Washington and 90 miles north of Coeur d'Alene, Idaho. Her services include clinical work, telephone consultations (nationally and internationally) with clients, researchers, and physicians.

She teaches, lectures and consults worldwide, writes numerous articles for newspapers, health magazines and trade journals, including a regular column, "Second Hand Reactions," published in the U.S. and Canada.

Dr. Gilbère is a keynote presenter and has conducted seminars on varied disciplines of wholistic health, multiple chemical sensitivities, leaky gut and chemically induced immune system disorders. Her work has taken her throughout the U.S., Canada, China, Argentina, Spain, England, Switzerland, S. Korea and Greece.

As a consultant, educator, and trainer in preventive environmental health-care and EcoErgonomics, her client list includes Fortune 500 companies, universities, hospitals, health-care organizations, government agencies, school districts, corporations, and professional associations.

She is internationally respected as a natural-medicine researcher, environmental health consultant, writer, and an authoritative influence in the discovery of the causes, effects, and natural solutions for leaky gut syndrome and chemically induced immune system disorders.

*For information regarding her consulting services, speaking engagements, or interviews, call
(208) 267-5417 (PST) or Fax: (208) 267-0617
Email: doctorg@drgloriagilbère.com, visit her web site at: www.drgloriagilbère.com or write to:
Dr. Gloria Gilbère*

*Director, Naturopathic Health & Research Center
P.O. Box 3220, 7098 Ash Street
Bonners Ferry, Idaho 83805-3220 USA*